Conservation Research 1996/1997

STUDIES IN THE HISTORY OF ART • 57 •

Monograph Series II

Conservation Research 1996/1997

National Gallery of Art, Washington

Distributed by the University Press of New England
Hanover and London

Editorial Board
ROSS M. MERRILL, *Chairman*
SHELLEY STURMAN
E. RENÉ DE LA RIE
SHELLEY FLETCHER

Managing Editor
CAROL LEHMAN ERON

Manuscript Editor
ANN HOFSTRA GROGG

Editorial Coordinator
JANICE GRUVER

Production Editor
ULRIKE MILLS

Designer
CAROL BEEHLER

This publication was produced by the Editors
Office, National Gallery of Art, Washington
Editor-in-Chief, Frances P. Smyth

The type is Trump Medieval, set by Artech
Graphics II, Inc., Baltimore, Maryland

The text paper is 128 gsm Japanese matt

Printed in China

Distributed by the University Press of
New England, 23 South Main Street,
Hanover, New Hampshire 03755

Abstracted and indexed in BHA
(Bibliography of the History of Art)
and Art Index

Conservation Research is a periodic
publication of the National Gallery of Art,
Washington. The primary objective of
Conservation Research is to report regularly
on the research and technical studies pursued
by the conservation division of the National
Gallery of Art

ISSN 0091-7338
ISBN 089468-264-4

Cover: Kazimir Malevich, *Vanity Case,* detail,
1913, oil on wood. State Tretiakov Gallery,
Moscow

Contents

Preface

During the course of development of the conservation division of the National Gallery of Art, scientific research has gained an important role. The scientific research department was established with the initial goal of assisting conservators with analytical support. As analytical services to conservation treatment became routine, conservation scientists expanded their activities to study the materials and construction of works of art, producing technical and scientific studies about the Gallery's collections or works on loan.

For the conservators and other staff members motivated to learn more about the objects they work with, their research, in some cases, has been conducted as an extension of their regular responsibilities. Additionally, both conservation scientists and conservators are increasingly incorporating their knowledge of art history into the methodology of their investigations.

The essays in this volume address a range of subjects that have been under recent study by the conservation division. Barbara H. Berrie and Suzanne Quillen Lomax collaborated to apprise conservators of the properties of azo pigments, which are widely used in artists' materials and commercial applications. Of interest to both specialists and the museum visitor is Mary Bustin's investigation of the frame elements and construction of a trecento altarpiece by Agnolo Gaddi, as well as Penelope Edmonds' discussion of the conservation of a Renaissance polychrome and gilt terra-cotta relief. Lisha Deming Glinsman's report on the results of x-ray fluorescence analysis highlights a unique pattern in Matteo de' Pasti's casting materials of portrait medals. The painterly techniques of Kazimir Malevich are discussed by Ann Hoenigswald, and those of Jan Steen are presented by Michael Palmer and E. Melanie Gifford.

Although the publication of research results may be routine in many other fields, the role of author is relatively new to many conservators. As the part played by conservation in the museum environment grows and matures, conservators and conservation scientists increasingly will make their research available to a wider audience through publications such as this.

ROSS M. MERRILL
Chief of Conservation, National Gallery of Art

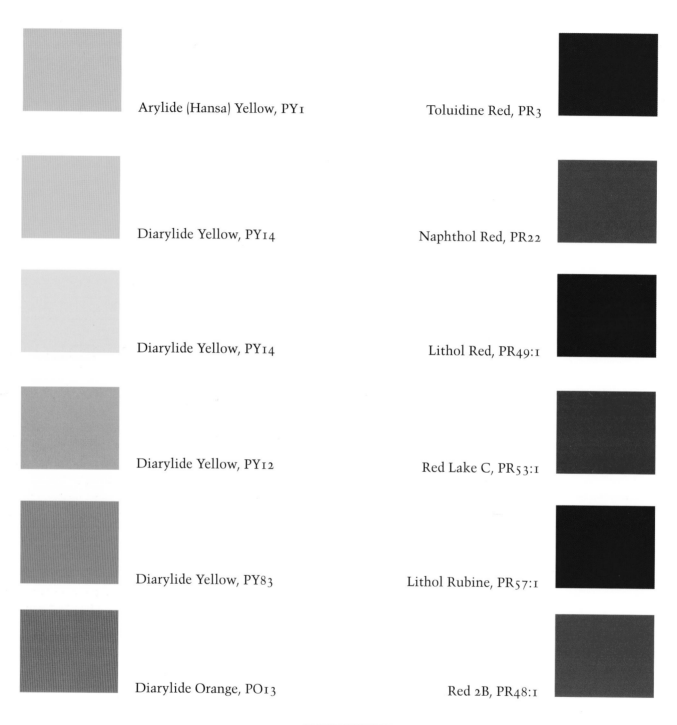

Arylide (Hansa) Yellow, PY1

Toluidine Red, PR3

Diarylide Yellow, PY14

Naphthol Red, PR22

Diarylide Yellow, PY14

Lithol Red, PR49:1

Diarylide Yellow, PY12

Red Lake C, PR53:1

Diarylide Yellow, PY83

Lithol Rubine, PR57:1

Diarylide Orange, PO13

Red 2B, PR48:1

BON Red C, PR52:1

BARBARA H. BERRIE and SUZANNE QUILLEN LOMAX

Azo Pigments: Their History, Synthesis, Properties, and Use in Artists' Materials

In this century synthetic organic pigments have dominated the colorant market. Thousands of such pigments have been prepared, some designed for specific applications, and it has been estimated that by 1971 synthetic organic pigments occupied a 49 percent market share of artists' pigments.[1] About 80 percent of the manufactured pigments are azos,[2] those that contain the azo linkage (—N=N—).

Representatives of azo dyes and pigments appear throughout the color spectrum, although most are red, orange, or yellow (fig. 1). They are used as pigments in printing inks (both flexographic and gravure), paints (architectural, automotive, general industrial, and artists'), plastics, rubber, textiles, crayons,[3] and colored chalks.

Understanding the properties of these colorants is important in choosing the most appropriate techniques for conservation, exhibition, and preservation of works of art, since the stability and light sensitivity of these materials must be considered.

A great deal of information concerning azo pigments exists in the chemical and industrial literature, but it is not readily available to conservators. The aim of this essay is to present a summary of this information, with an emphasis on pigments used in artists' materials. (See appendix 1 for a glossary of terms.) Since contemporary artists use a wide range of products not limited to traditional or even nontraditional artists'

materials, general information on azo pigments and dyes is included; however, our focus is primarily on the azo pigments that are more widely used and are employed in manufacturing artists' materials.

Azo pigments containing one —N=N— group are called monoazo pigments, while those with two azo linkages are called disazo pigments. Pigments with three azos are properly called trisazo, and those with four are tetraazo compounds, although sometimes both are called disazos. Structural studies have shown that some solid state azo pigments exist exclusively in a ketohydrazone form;[4] however, they are conventionally represented by the azo form.

The classical azo pigments, which have provided bright colors at low cost, are characterized by relatively poor lightfastness or stability to heat and solvents. High-performance azo pigments have been introduced since 1960 to meet the demands of more stringent applications. However, the possible presence of classical azo pigments, many of which are used today, on numerous works of art should be taken into account when considering their conservation and exhibition. A description and discussion of the general synthesis of the azo pigments and their properties with respect to their structural similarities and differences follow. In addition, a brief history of the subclasses of azos and notes on their uses and permanence are given.

1. Selected masstone azo pigment color chips
Dominion Colour, Inc., Atlanta, Georgia

Terminology and Nomenclature

Azo colors were first developed for dyeing (fig. 2). They were sometimes called ice colors because ice was used during their synthesis to keep the reaction mixture cold. Azo dyes, which are prepared from primary aromatic amines such as aniline, were also known as aniline colors. Compounds from coal tar were used in the manufacture of azos, so they were sometimes called coal-tar colors. Investigation of the chemical structures of these materials has led to the general term "azo" pigments, now in use.

As pigments are introduced to commerce, they are assigned a *Colour Index*[5] generic name and number as well as a five-digit *Colour Index* number. The *Colour Index* generic name relates to the application of the colorant; for example, P stands for pigment, along with a description of the hue, such as Y for yellow or R for red.[6] A sequential number, referred to as the generic number in the *Colour Index*, is also assigned to each colorant. For example, Hansa Yellow G is assigned the generic name and number PY1, while Orthonitroaniline Orange is assigned the name and number PO2.

The *Colour Index* number indicates the chemical classification of the pigment or dye, as series of numbers have been assigned to particular colorants that are chemically related. Monoazo pigments and dyes have *Colour Index* numbers between 11000 and 19999, while disazo colorants have *Colour Index* numbers between 20000 and 29999. *Colour Index* numbers between 30000 and 34999, and 35000 and 36999, have been assigned to trisazo and polyazo colorants, respectively.

The trade name of a pigment sometimes bears reference to its class, property, or color, but often it is an arbitrary name given by the discoverer or the manufacturer.[7] In this essay, brand names or trade names of pigments have been capitalized; many of these products have registered trademarks or copyrights. The letter or letters that may follow the name usually refer to the shade, with the number of letters indicating the degree of that shade. Sometimes, however, the letters refer to the composition of a dye or its class; for example, D stands for direct dye, and F for fastness. A list of *Colour Index* generic names corresponding to manufacturers' names

can be found in the *Colour Index*.[8]

Commercial products, including artists' materials, are often described by vague terms, such as "azo yellow" or "gamboge hue." It is usually possible to discover the precise identity of the colorants from the

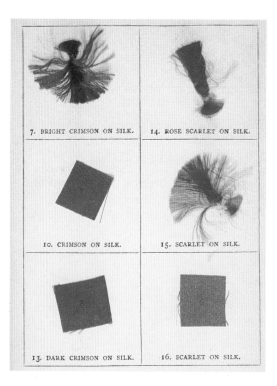

7. BRIGHT CRIMSON ON SILK. 14. ROSE SCARLET ON SILK.

10. CRIMSON ON SILK. 15. SCARLET ON SILK.

13. DARK CRIMSON ON SILK. 16. SCARLET ON SILK.

2. Silk swatches, five of which are colored with azo dyes:

no. 7, bright crimson, with Violamine A 2 R (Meister, Lucius, and Bruning)

no. 10, crimson, with Azo-Rubine S (Actien. Anilin. Fabrik. Berlin)

no. 13, dark crimson, with Bordeaux S. (Actien. Anilin. Fabrik. Berlin)

no. 14, rose scarlet, with Brilliant Croceine M O O (L. Cassella and Co.)

no. 15, scarlet, with Crystal Scarlet 6R (L. Cassella and Co.)

no. 16, scarlet, is dyed with the nonazo dye, Ponceau 4RB (Actien. Anilin. Fabrik. Berlin)

From George H. Hurst, *Silk Dyeing, Printing, and Finishing* (London, 1892), pl. 2

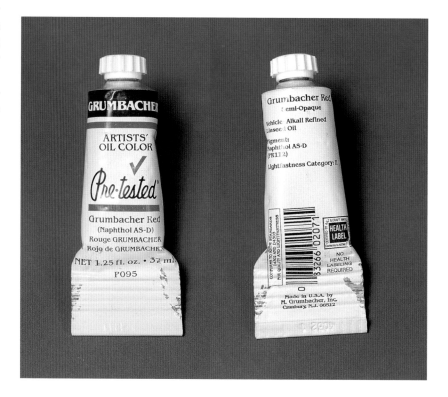

3. Sample tube of Grumbacher Red. The azo pigment in the oil paint is Naphthol AS-D (PR112) and is labeled to indicate that the paint conforms to ASTM standards for quality and lightfastness

tube and from technical sheets provided by artists' materials suppliers (fig. 3). Current requirements for conformance to American Society for Testing and Materials (ASTM) protocols require the common name of a pigment to be prominently included on the front of the tube, which, in our example, is Naphthol AS-D, PR112.

A comparative lightfastness rating of the products is generally given in the technical literature. If a paint bears the *Colour Index* numbers on the tube, it is possible to locate the properties of the material in the *Colour Index* or in handbooks such as Steven L. Saitzyk's *Art Hardware*, Michael Wilcox's *Wilcox Guide to the Best Watercolor Paints*, and Mark David Gottsegen's *Painter's Handbook*.[9]

General Synthesis of Azo Pigments

Azo pigments are formed by a two-step reaction referred to as diazotization and coupling.[10] An example of the diazotization and coupling reactions is shown in figure 4 for the synthesis of the red pigment Lithol Rubine. The first step, diazotization, is the reaction of a primary aromatic amine with nitrous acid to form a diazonium salt. The amine is dissolved or suspended in dilute mineral acid, and sodium nitrite is added. The diazonium salt is formed at low temperatures to prevent its decomposition. The second step, coupling, occurs by the reaction of the unisolated diazonium salt with the coupling component. Changing the coupling component produces different subclasses of azo pigments that are generally known by the chemical identity of the coupling agent. Coupling components include arylides of acetoacetic acid, 3-hydroxy-2-naphthoic acid or its arylide, 2-naphthol, benzimidazoles, and pyrazolones. The subclasses of the azo pigments are described.

Brief History of Azo Pigments and Dyes

Synthetic organic colorants, dyes, and pigments have been produced for nearly 150 years.[11] August Wilhelm Hofmann, sometimes called the father of the dye industry, was the first to obtain and identify the aromatic amine aniline from coal tar in about 1843.[12] Aniline was the most frequently used starting amine in the synthesis of azo compounds. In 1858, Johann Peter Griess discovered the way to form a diazonium salt from the amine, and in 1870, August Kekulé and a colleague named Hidegh were the first to investigate the reactions between diazonium salts and so-called coupling agents that give rise to azo colorants.[13] William Henry Perkin's serendipitous synthesis of Mauve (mauveine) in 1856 had already led to the development of numerous organic dyes for the textile industry. Lakes of these dyes were the first synthetic organic pigments. Soon after, it was found that insoluble salts of azo dyes provided a wide range of suitable pigments.

The first azo pigment, tartrazine yellow, PY100, which is still used in artists' paints, was patented in 1884.[14] β-naphthol azo pigments were first introduced from 1895 to 1911, and they are still in production. The first Hansa yellow, PY1, was patented in 1909, and the first diarylide was synthesized in 1911. Because their importation from Germany was forbidden during World War I, American manufacturers began to study azo dyes in depth. Benzimidazolone pigments were first prepared in 1960, the same year that the class of disazo condensation pigments was introduced to the United States. Azo pigments have become the largest class of

4. General synthesis of azo compounds for Lithol Rubine: (a) diazotization, (b) coupling, and (c) lake formation

Table 1
Applications of Azo Pigments

Azo Class	Plastics	Rubber	Automotive Finishes	Architectural Paints	Artists' Paints	Crayons, Pencils, Chalk	Textiles	Printing Inks	Other Coatings
Pyrazolones	Ø	●	Ø	●	●	Ø	●	Ø	●
Naphthol reds	●	Ø	●	●	Ø	Ø	Ø	Ø	●
β-naphthols	●	●	Ø	●	Ø	●	Ø	●	●
Arylide (Hansa) yellows	Ø	Ø	Ø	●	●	●	Ø	●	Ø
Diarylides	●	●	Ø	●	●	Ø	Ø	●	Ø
Nickel-azo yellow	Ø	Ø	●	Ø	●	Ø	●	Ø	Ø
Disazo condensation pigments	●	Ø	●	Ø	Ø	Ø	●	●	●
Benzimidazolones	●	Ø	●	Ø	●	●	Ø	Ø	Ø

● Frequently used
Ø Less commonly used

synthetic organic pigments because of their ease of preparation and wide range of colors.

General Properties

Within the broad category of azo pigments are subclasses identified by the chemical character of the coupling moiety. By changing the coupling component, many subclasses have been created; within each subclass, adding or changing substituents produces many pigments. There is a great deal of variability in chemical and physical properties among the classes, and even within a subclass pigments can have significantly different properties. However, in general, pigments that are in the same subclass have similar trends and consistencies in behavior. Corresponding to the order of discussion that follows, table 1 lists azo pigment subclasses and their most common uses and applications. Table 2 lists the *Colour Index* name and number for azo pigments that are known to have been used in artists' materials. Table 3 lists some properties of various classes of azo pigments. The heat stability, lightfastness, weatherfastness, and migration of azo pigments have been discussed elsewhere[15] and are only summarized here.

Physical Properties

Azo pigments are formed by precipitation, designed to produce submicron crystallites.

R. B. McKay[16] has estimated from transmission electron micrographs the sizes of crystals of PY1, PY4, PR3, and PR112. The first three of these pigments consist of short rods ranging from 0.19 to 0.34 micrometers, while long PR112 crystals are plates with lengths ranging from 0.21 to 0.25 micrometers.

The crystalline material that forms after the coupling reaction can be modified in several ways during and after the reaction process for ease of use. These modifications may alter the brightness, shade, and color strength of the pigments; thus pigments that have the same chemical composition can have different colors, making it difficult to identify azo colors solely on the basis of their appearance. The hiding power and tinting strength of pigments are related to particle size as well as refractive index. For example, the arylide yellow PY74 is available in a variety of grades, which have surface areas from 12 to 70 m^2g^1. The grades with a high surface area have a higher tinctorial strength and transparency than low surface area grades, which have a redder undertone and are also more lightfast. (In general, however, properties such as fastness are related more to the chemistry of the material than to its particle size.)

In addition to being dependent on particle size, the appearance of a pigment depends on tautomerization between an azo form and a hydrazone form. The different forms have different colors, tinctorial strengths, and proper-

Table 2
Azo Pigments Frequently Found in Traditional Artists' Paints, by *Colour Index* (1971) Name and Number

Pyrazolone	CI No.	Naphthol	CI No.	β-Naphthol	CI No.	Arylide (Hansa)	CI No.	Diarylide	CI No.	Nickel-Azo Yellow	CI No.	Benzimidazolone	CI No.
PO13	21110	PO38	12367	PO2	12060	PO1	11725	PY12	21090	PG10	12775	PBr25	12510
PY100	19140	PR1	12070	PO5	12075	PY1	11680	PY13	21110			PO36	11780
		PR2	12310	PO17	15510	PY3	11710	PY14	21095			PO60	11782
		PR5	12490	PR3	12120	PY4	11665	PY17	21105			PO62	11775
		PR7	12420	PR4	12085	PY5	11660	PY55	21096			PR171	12512
		PR8	12335	PR6	12090	PY9	11720	PY81	21127			PR175	12513
		PR9	12460	PR48	15865	PY65	11740	PY83	21108			PR176	12515
		PR12	12385	PR49	15630	PY73	11738					PYI51	13980
		PR14	12380	PR52	15860	PY74	11741					PYI53	48545
		PR17	12390	PR53	15585	PY75	11770					PYI54	11781
		PR18	12350	PR57	15850	PY97	11767					PYI75	11784
		PR22	12315	PR60	16105	PY98	11727						
		PR23	12355										
		PR31	12360										
		PR112	12370										
		PR119	12469										
		PR146	12485										
		PR170	12475										
		PR187	12468										
		PR188	12467										

Note: Shading indicates pigment groups

Sources: 1995 Annual Book of ASTM Standards, vol. 6.02 (1995); D. A. Crown, *The Forensic Examination of Paints and Pigments* (Springfield, Ill., 1968); Mark David Gottsegen, *The Painter's Handbook* (New York, 1993); Willi Herbst and Klaus Hunger, *Industrial Organic Pigments: Production, Properties, and Applications* (Weinheim, Germany, 1993); Naoka Sonoda, Jean-Paul Rioux, and Alain René Duval, "Identification des matériaux synthétiques dans les peintures modernes, Part 2: Pigments organique et matière picturale," *Studies in Conservation* 24 (1993); Society of Dyers and Colourists, *Colour Index*, 3d ed. (Bradford, England, 1971); Gerhard Talsky and Maja Ristic-Solajic, "Higher Resolution/Higher Order Derivative Spectrophotometry for Identification and Estimation of Synthetic Organic Pigments in Artists' Paints," *Analytica Chimica Acta* 196 (1987); Michael Wilcox, *The Wilcox Guide to the Best Watercolor Paints* (Perth, Australia, 1991); Winsor and Newton technical literature

ties. In general, the ketohydrazone form of an azo pigment is cooler in tone and has a higher tinctorial strength than the azo form.[17]

The surface characteristics of azo pigments play a large role in the quality of the paint owing to the interaction between the pigment and the vehicle and solvent. Azos are used with a number of vehicles, including oils, latex, alkyds, acrylics, and gums. To improve the product, azo pigments can be coated with rosin during the manufacturing process to give them a softer texture. The coated pigment has smaller and more controlled particle sizes, resulting in improved color strength and transparency; it is also more easily dispersed in the medium. Rosin coating is commonly used for the laked azo pigments such as Lithol red, Red Lake C, and Lithol Rubine types. Amines can be also used to coat azo pigments. Arylide yellow pigments that have been treated with amines are used in air-drying paints. Amine-treated benzidine yellows are mostly used in toluene-based rotogravure.

Lightfastness and Weatherfastness

Lightfastness refers to the ability of a pigment and binder system to retain its color when exposed to light; unfortunately, the presence or absence of an ultraviolet component in this light is not always specified. Weatherfastness is the tendency of the system to withstand the chemical and physical factors inherent in outdoor exposure.[18] Both are system properties of the paint and depend on the type of pigment and the binder used.

Nonetheless, it is possible to discuss the lightfastness of pigments in a comparative way. In general, the lightfastness of azos is better at masstone than in tints. For a specific series of pigments, there is a correlation between the lightfastness and weatherfastness and the substitution pattern on the aromatic rings of the components.[19]

The first azo dyes and pigments to be synthesized had brilliant colors but were notoriously fugitive. There was so much concern about the instability of the newly discovered synthetic dyes and pigments that many painting manuals advised artists to eschew all synthetic organic pigments. More stable organic pigments have been continuously introduced, however, and many improved azo pigments that are extremely stable to both light and heat have been devised, although few rival the qualities of quinacridones and phthalocyanines.

Lightfastness is a surprisingly difficult property to quantify. A small change in a pigment's chemical constitution, such as changing a substituent, can have a significant effect on the lightfastness. However, even chemically identical pigments can behave differently owing to different particle sizes, dilution with white pigments, and variations in binding medium. To address these issues, the ASTM subcommittee on artists' materials has written specifications designed to allow comparative evaluation of products. Standard D4303 specifies three test methods for determining lightfastness of pigments and paints (see appendix 2). The paints are prepared and exposed to light following one of the methodologies given in D4303. A relative lightfastness for the pigment-binder system is obtained by measuring the color changes after exposure to light. The values range from *I* (excellent) to *V* (very poor) according to the numerical value of the change in color, expressed in CIE L∗a∗b units. To conform to ASTM standards, the labels of artists' materials should specify the lightfastness numerical rating as determined by testing according to Standard D4303:

Rating	I	II	III	IV	V
$\Delta E*ab$ CIE L∗a∗b	$\Delta E<4$	$4<\Delta E<8$	$8<\Delta E<16$	$16<\Delta E<24$	$\Delta E>24$

Table 3 includes data on the relative fastness of the classes of azo pigments. The lightfastness data are presented using the Blue Wool scale (1–8), which is the method used by the *Colour Index*. Eight Blue Wool references are produced in both Europe and the United States. Although these controls were initially used for natural aging, the current standards specify xenon arc irradiation. In addition to ASTM D4303, several ASTM specifications have been adopted to assess the stability of artists' paints, including ASTM D4302-93 (for oil, resin-oil, and alkyd paints), ASTM 5098-94 (acrylic emulsion paints), ASTM D5067-93 (watercolors), and ASTM D5724-96 (gouache paints). The pigment tests utilize both natural and artificial light sources. Appendix 2 summarizes these testing protocols.

Solvent and Migration Fastness

Solvent fastness refers to the extent to which a pigment tolerates a solvent, and it is dependent on the pigment-binder system. In general, increasing the molecular weight of an azo pigment improves its solvent fastness; this property is clearly demonstrated by comparison of the solvent fastness of chemically related monoarylide and diarylide pigments. Substituent groups such as amide, nitro, and chloro may decrease the solubility of azo pigments in organic solvents. Conversely, substituents such as long-chain alkyl, alkoxy, or alkylamino or sulfonic acid groups increase the solubility of azo pigments in organic solvents.[20] The ionic character of lakes or metal complexes increases the solvent and migration fastness of azos. Understanding solvent fastness of paints made with azo pigments is very important for conservators to consider when choosing solvents for removing coatings from works of art or cleaning uncoated objects (see Implications for Conservation, below).

Toxicity

Most azo pigments are nontoxic. Some of them, for example tartrazine yellow, have been designated for use as food and dye colorants, and many are safe enough to be used in cosmetics. Concern has been expressed, however, about the relationship of diarylides to the known carcinogen benzidine. The Occupational Safety and Health Administration now classifies the salts of 3,3'-dichlorobenzidine as cancer suspect agents.[21] No carcino-

Table 3
General Properties of the Classes of Azo Pigments

Azo Class	Solvent Resistance[a]			Heat Stability	Lightfastness	Compatibility[a]			
	Ethanol	Cello-solve	Xylene	°C	Blue Wool Standard[b]	Water	Linseed Oil	Sodium Carbonate, 5%	Hydrochloric Acid, 5%
Pyrazolones	4	1–3	1	to 150	6	5	n.a.	4–5	4–5
Naphthol reds	4–5	n.a.	2–4	to 160	6	4–5	3	4–5	4–5
β-naphthols									
Di- and ortho-nitroanilines	2	2	2	to 150	6	4	4–5	4–5	4–5
Para red	1–2	2	1–2	to 120	3	4	2–3	4–5	4–5
Chlorinated para red	1	1	1	Good	6	5	4–5	4–5	4–5
Toluidine red	2–3	1	2	to 150	5–6	5	4–5	5	5
Lithol reds	2–3	2–3	3–4	to 150	4–5	5	3–4	3	4
BON pigments	4	4	4	to 130	6	5	4	3	3
Red Lake C and Clarion red	4	1–2	5	to 150	4	5	4–5	4–5	5
Arylide (Hansa) yellows	3	3	3	to 150	6	5	4	4	5
Diarylide oranges	4–5	4	2–4	to 150	2	4–5	5	2	4
Diarylide yellows	4	3–4	2–4	to 150	4	5	5	4–5	5
Nickel-azo yellow	1	n.a.	5	Good	8	5	5	4–5	5
Disazo condensation pigments	4	4	3	to 180	6	5	4	5	5
Benzimidazolones	4–5	3–4	4–5	≥ 200	8	5	5	5	n.a.

Sources: Society of Dyers and Colourists, *Colour Index*, 3d ed. (Bradford, England, 1971), vols. 3 and 5
n.a.=data not available
a. Evaluated on a scale where poor=1 and excellent=5
b. Blue Wool is the standard used in the *Colour Index*: excellent=8, very good=6, and good=4

genicity was reported, however, for certain diarylides in a two-year oral-feeding study on rats and mice.[22] Para red is known to be weakly mutagenic when activated by a mixed-function microsomal system.[23]

Nontoxic artists' materials will carry the Seal of the Art and Creative Materials Institute (formerly the Art and Craft Materials Institute, Inc.) on the product.[24] The Approved Product (AP) and Certified Product (CP) seals certify that the materials have been reviewed by a toxicologist and found not to be harmful, based on ASTM specification D4236 (Standard Practice for Labeling Art Materials for Chronic Health Hazard).

Implications for Conservation

Azo pigments have been widely available since the 1920s and still are used as ingredients in artists' materials, in addition to many other applications. Conservators of contemporary art are well aware of the enormous differences in caring for and treating these objects compared to traditional works of art. Much of their knowledge, however, is based on empirical observation and there is little concrete, readily accessible information on the properties of modern paint systems. A difficulty for the conservator is that artists may have used products that were not designed to be long lasting. It is especially important, therefore, for conservators to try to identify the occurrences of azo pigments, because a work that contains them could be damaged by usual and customary treatment procedures or even by displaying it.

Some azo pigments are sensitive to solvents that conservators consider "mild," such as xylene, and the effects of solvents on pigments may be overlooked. The effect of water on azo pigments is usually slight, although

conservators have noted that some modern paints are sensitive to water; when they are, it is often because the medium is sensitive to water. One azo pigment, tartrazine yellow, commonly found in watercolors and oil paints, is water soluble.

Azo pigments are found in a variety of materials used by artists, including paints, wax crayons, colored pencils, chalk, plastics, printing inks, and paper. As more stable azos have been developed, they are more frequently encountered in artists' materials. Many collections contain objects such as costumes, magazines, and posters that may contain less lightfast azo pigments. When planning conservation and exhibition strategies, conservators need to be aware that these pigments may be present in a variety of media.

As properties vary substantially among the different classes of azo pigments and somewhat within each class, it is useful to know which azo pigment is found on a given work of art. A knowledge of the time period of the work may be helpful to establish which pigments might have been used. Ideally, the pigments would be identified via chemical analysis before treatment or exhibition, although identification can be very difficult.

As a class of chemical compounds, azo pigments exhibit a wide range of lightfastness. Monoarylide yellows have better lightfastness than diarylides. Françoise Flieder and Martine Maraval found that the light stability of yellow inks used in four-color printing, which included a study of the diarylides PY12 and PY13, was less than satisfactory.[25] The lightfastness of β-naphthol and Naphtol AS[26] pigments is not as good as that of the monoarylides. Toners of β-naphthols are generally less lightfast than the β-naphthols themselves. However, benzimidazolones and disazo condensation pigments usually have very good lightfastness.

Data from the relative lightfastness of several classes of pigments in specific media have been compiled by Joy Turner Luke.[27] According to ASTM specifications, a number of azo pigments that were or are used in artists' materials fall below the standards, including the class para reds PR1, PR4, and PR6; Toluidine red PR3; metallized monoazo reds PR48, PR49, PR52, PR53, PR57, and PR60; naphthol reds PR2, PR22, PR23, and PR31; Pyrazolone orange PO13; tartrazine yellow PY100; and diarylide yellow PY55.

Other pigments that have not been specifically tested in artists' materials may also have inadequate lightfastness and fade on exposure in gallery lighting.

The solubility of many azo pigments may be problematic for conservators. The relative resistance of azo pigments to various solvents is given in table 3. Since the solvent fastness of a paint is dependent on the whole paint system, and not its separate ingredients, it is difficult for the conservator to plan cleaning strategies. There is greater potential for bleed in works of art on paper and objects made with plastics because pigments with small particles are used for these applications. The arylide yellows, which include the Hansa yellows that are frequently used in artists' paints, are soluble in a variety of organic solvents, except aliphatic hydrocarbons. The solvent resistance of β-naphthol and Naphtol AS pigments is poor; however, toners of these pigments are generally less sensitive. Diarylides bleed less than monoarylides due to their higher molecular weight. Benzimidazolones possess high solvent fastness, while disazo condensation pigments are usually fast to alcohols and hydrocarbons, but they may bleed in ketones and esters. PO13, pyrazolone orange, which is used in artists' paints, is extremely sensitive to xylene. In general, azo pigments are more sensitive to alkali than to acid. Conservators need to consider alkali sensitivity when cleaning paintings with ammonia or resin soap mixtures, as well as when wetting works of art on paper that have an alkaline reserve or treating paper with an alkali. Further specific examples of the properties of individual pigments in works of art will be found in the descriptions of subclasses of azos that follow.

Description of Subclasses of Azo Pigments

The following discussion introduces the various subclasses of azo pigments, characterized by the chemical identity of the coupling component, and provides a brief description of the properties of each class. We have chosen to follow the classifications used by Peter Lewis, Willi Herbst and Klaus Hunger, and Robert M. Christie,[28] who are considered major reference sources. The subclasses are given in the general order of introduction and/or production of the first member of their class: pyrazolones, naphthol reds, β-

naphthols, arylides, diarylides, nickel-azo yellow, disazo condensation pigments, and benzimidazolones.

Pyrazolone Pigments

Tartrazine lake, PY100, is one of the earliest synthetic organic pigments. It is the barium lake of tartrazine, Acid Yellow 23. It was patented in 1884 and is still used in artists' materials and as a food colorant (FD & C Yellow 5). In 1900, the high price of the barium lake of sodium tartrazine discouraged its use in favor of less expensive alternatives.[29] Other pyrazolones were developed as early as 1910, but commercial application did not occur for almost twenty years.[30] Pyrazolone pigments are derived by condensation of an amine with a pyrazolone derivative. They may also be synthesized by an alternate path involving reduction of the diazo intermediate to a hydrazine followed by ring-closure of the condensation product to yield the pyrazolone. Figure 5 shows the general structures of (a) the monoazo and (b) the disazo pyrazolones. Disazo pyrazolones are also used in artists' materials and include PO13 (see fig. 1), PO34, PR37, PR38, PR41, and PR111.[31]

There are many pyrazolone pigments, but few find commercial use today; they have been used for architectural finishes, artists' colors, and for coloring rubber and textiles.

5. General structure of pyrazolones: (a) monoazo, and (b) disazo

Their general properties were described by Leonard Shapiro,[32] who indicated that the only pyrazolone colors still in production are PY60, PO13, PO34, PR38, and PR41.

The pyrazolone pigments are redder than azo pigments derived from acetoacetarylamide coupling agents but have similar fastness properties. Pigment Chrome Yellow, also a pyrazolone, is widely used (it is obtained from o-toluidine and 3-methyl-1-phenyl-pyrazolone). Despite one of its common names, diarylide orange, PO13 (also known as benzidine orange and pyrazolone orange), may be classed as a pyrazolone pigment. This pigment, discovered in 1910,[33] finds wide usage in artists' paints, as do the Hansa yellow pyrazolones (such as PY10). Hansa Yellow R is the most widely used monoazo pyrazolone (it is obtained from 2,5-dichloroaniline and 3-methyl-1-phenyl-5-pyrazolone).

PO13 has fair lightfastness, while PO34 (sometimes also referred to as diarylide orange, another orange pyrazolone) has good lightfastness. Both pigments have reasonable solvent fastness in many applications; however, the solubility of PO13 in xylene may be problematic for conservators.[34] The lightfastness of tartrazine is about equal to that of diarylide yellows. Although it is not solvent resistant and is even sensitive to water, its heat resistance and high transparency make it useful in metal coatings and nitrocellulose lacquers.[35]

Whitaker determined the single crystal structure of PY10.[36] The compound was shown to have the hydrazone structure, ending debate on the structure from the infrared and ultraviolet spectra.[37] The molecule exists as the hydrazone tautomer rather than pyrazolone. Spectroscopic evidence can be interpreted as showing that the pyrazolone azo dyes are actually hydrazones, containing the N—N=C group.

Naphthol Reds

The naphthol reds are a class of about eighty 2-hydroxy-3-naphtharylide azo pigments. The basic structure of this group is shown in figure 6. The group is also called the Naphtol AS pigments. In 1985, these pigments represented about 6 percent of all organic reds manufactured.[38]

To improve lightfastness, a chloro or nitro

group is generally found on the diazonium salt, and a methyl or methoxy group on the naphtharylide coupling component.[39] Some naphthol reds contain an amide or sulfonamide group on the diazo component to provide stability. The addition of an amide group on the diazo-derived portion adds solvent resistance and heat stability.[40] Lightfastness is improved when intramolecular hydrogen bonding can occur. Important members of this class include the reds PR2, PR5, PR7, PR9, PR10, PR14, PR15, PR17, PR22 (see fig. 1), PR23, PR31, PR112 (see fig. 3), PR146, PR147, PR170, PR184, PR187, PR188, and PR210,[41] and the oranges PO24 and PO38.

The first naphthol reds were patented as Grela Reds in 1911.[42] The method for their formation was developed by Schopf in 1892.[43] The coupling component of these pigments is 2-hydroxy-3-naphthoic acid, known as Naphtol AS. Due to their high cost, these pigments were not commercially successful until the 1930s, when they were produced by IG Farben. A series of naphthol reds, called American Naphthol Reds, was introduced to the United States in the 1940s. The first sulfonamide substituted β-naphthol, PR5, known as Permanent Carmine FB or Naphthol Red ITR, was introduced just before World War II.

PR170, PR187, and PR188 are especially solvent and heat resistant, due to the presence of additional amide groups in the diazo component. Generally, the naphthols are more lightfast and solventfast than the pigments in the toluidine and BON red subclasses, but they are not as lightfast as the nonazo quinacridones or perylenes. As a class, naphthols are extremely resistant to acids, alkalis, and soaps.[44] They possess high tinting strength and are relatively inexpensive. The naphthols are used as pigments for plastics, automotive finishes, architectural paints, and, to a lesser extent, in colored chalk, pencils,

crayons, watercolors, artists' paints, and printing inks.[45] PR170, which is one of the most important naphthol reds in terms of production volume, has very good lightfastness and is a brilliant color. It was developed in the 1960s and exists in two forms that have different colors. PR188 is a yellowish red shade that also has excellent fastness properties and is used in paints and wax crayons. PR7, while possessing good lightfastness, is not resistant to solvents. PR112, a bright yellowish red pigment patented in 1939, is used extensively, including in artists' colors. PR22, a yellowish red, is used in paints, including artists' colors, and colored pencils. PR146 is a bluish red pigment also used in artists' colors, as is PO38, which has a yellowish red color.[46]

β-Naphthol Pigments

The β-naphthol azos are a series of red pigments representing about one-half of all synthetic red pigments.[47] They are one of the oldest groups of synthetic colorants. The β-naphthols can be divided into two groups—pigments, and salts or lakes. The pigments are based on the coupling of a substituted aniline with β-naphthol. The position and number of auxochromic substituents determine the shade of the pigment. These pigments are generally used in latex paints and paint for outdoor posters and for coloring some plastics. One of the reds examined from Mark Rothko's (1903–1970) *Untitled (Harvard Mural) (Rothko number 6006.60)*, 1961, in the collection of the National Gallery of Art (fig. 7), was identified by solution spectrophotometry[48] as a β-naphthol pigment.

The second group, the salts or lakes, contain a sulfonate or carboxyl group, allowing for formation of metal salts. They are prepared by metallization of the diazo product. The coupling component can either be β-naphthol or a substituted β-naphthol. Structures of representative members of these two groups are shown in figure 8.

β-Naphthol Pigment Group
This group includes dinitroaniline and orthonitroaniline oranges, Para red, chlorinated para reds, and Toluidine red.

Dinitroaniline and orthonitroaniline oranges.
Dinitroaniline orange, PO5, an intense orange pigment first patented in 1909,[49] is prepared

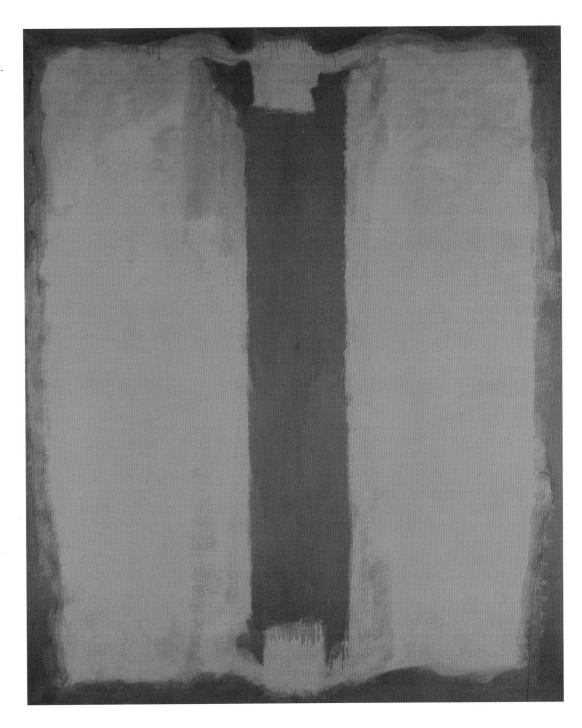

7. Mark Rothko, *Untitled (Harvard Mural) (Rothko number 6006.60)*, 1961, oil and mixed media on canvas. Three samples were taken from the left edge of the painting

National Gallery of Art, Washington, 1986.43.168, Gift of The Mark Rothko Foundation

by coupling diazotized 2,4-dinitroaniline with β-naphthol. PO5 is used in about 30 percent of applications of synthetic orange pigments.[50] It has good lightfastness in masstone, but, as is common for the azo pigments, its lightfastness is much poorer in tints. It also tends to darken and is only moderately bleed resistant. PO5 is used especially for textile printing, in architectural paints and printing inks, and for coloring plastics and rubber. It can be found mixed with inorganic pigments, for example, molybdate orange.[51] PO5 is also used as a colorant in artists' paints.

Orthonitroaniline orange, PO2, is a coupling product of β-naphthol with the diazonium salt produced from orthonitroaniline. The pigment was first prepared in 1895 but was not introduced to the United States until the 1940s.[52] This pigment is used in crayons, artists' colors, colored paper coatings, and

M = Ba, Ca, or Mn

Toluidine red. Toluidine red, PR3 (see fig. 1), once one of the most widely used red pigments, is the coupling product of the diazonium salt of 2-nitro-4-toluidine with β-naphthol. It was first synthesized in 1905. Because it has poor tint lightfastness, the current production of PR3 is now less than one-half of the amount that was produced at the height of its popularity in the late 1970s.[57] PR3 is used in the coatings industry[58] and has been used to color wax crayons, pastels, and watercolors. It is very sensitive to organic solvents, especially esters and ketones, but is resistant to alkalis, soaps, and acids. A bluer-toned pigment can be obtained by using 2-nitro-4-anisidine as an accessory amine in the diazotization.

β-Naphthol Salts and Lakes Group
The second group of β-naphthol pigments includes Lithol red, BON pigments that include Lithol Rubine, Permanent Red 2B, Lithol Maroon, Red 2G, Yellow BON Maroon and BON Maroon, Red Lake C and Clarion red, and Pigment Scarlet.[59]

Lithol reds. The lithol reds, PR49 (see fig. 1), include the sodium, barium, calcium, and strontium salts of the azo compound formed from coupling 2-naphthylamine-1-sulfonic acid with β-naphthol. These pigments were discovered in 1899.[60] The barium and calcium salts are now the most common; they are widely used in the United States but less frequently in Europe.[61] The barium salt is lighter and more yellow than the calcium salt. The pigments can be coated with rosin in manufacturing, a process that improves wettability and gives a smaller particle size. The resinated calcium salt has a bright maroon shade.

The lithols are characterized by relatively poor lightfastness, inadequate for artists' materials stability, but, except for the sodium salt, they are bleed resistant. They are among the least expensive of the organic reds and find use as pigments in inks, wax crayons, and chalk. Lithol red was used by Mark Rothko in Harvard University's *Harvard Murals* and is fugitive.[62]

BON pigments. The BON pigments (reds and maroons) were given the name because of the use of BON (3-hydroxy-2-naphthoic acid)

water-based inks. It has poor bleed resistance and is not recommended as a paint due to poor fastness to light and solvents.[53]

Para red. Para red, PR1, is an intense, bluish red pigment. It is the coupling product of β-naphthol with the diazonium salt of 4-nitroaniline. Prepared in 1895, it was the first azo red synthesized. Although it has good chemical resistance, its lightfastness and bleed and heat resistance are poor. Production of PR1 is very low today due to its poor lightfastness, although it is sometimes used to tone iron oxide-based paints. In the past, PR1 was extensively used for industrial and machinery finishes.

Chlorinated para reds. The chlorinated para reds are PR4 (chlorinated para red) and PR6 (parachlor red). They are isomers, differing only in the position of the nitro and chloro substituents. PR4 is formed by a coupling of the diazonium salt of 2-chloro-4-nitroaniline with β-naphthol, while PR6 is the coupling product of the diazonium salt of 4-chloro-2-nitroaniline with β-naphthol. Parachlor red was discovered in 1906, and a year later chlorinated para red was first prepared.[54] Both have poor bleed resistance. PR6 has better lightfastness, although both pigments have poor lightfastness in tints. PR4 and PR6 are used in latex paints and in paints for outdoor signs.[55] PR4 has been used in wax crayons, colored pencils, and artists' colors.[56]

as the coupling component of various diazotized amines bearing salt-forming groups. BON was first synthesized in 1887 by Schmitt and Burkart, and, from 1893, it has been used as a coupling component.[63] The most common metal salts are calcium, barium, or manganese. Five of the most frequently used pigments of this class are Lithol Rubine, PR57 (see fig. 1); Permanent Red 2B, PR48; Red 2G, PR52 (also known as BON Lake Red C); Yellow BON Maroon, PR55; and BON Maroon, PR63. These pigments are used primarily in ink formulations, although some are also used in exterior coatings, plastics, and artists' watercolors and chalks.

Lithol Rubine is a salt of the diazo formed from coupling 2-amino-5-methylbenzenesulfonic acid with BON. The pigment exists as a dimer.[64] It was first synthesized in 1903 by Gley and Siebert at AGFA,[65] and although it has poor lightfastness, it has good bleed resistance. Lithol Rubine is a dark blue-red pigment and is used primarily in printing inks.[66] It is the most important magenta printing ink pigment.

Permanent Red 2B is the metal salt of the diazo produced from 1-amino-3-chloro-4-methylbenzenesulfonic acid (2B acid) with BON. The barium salt is a clean, yellow hue, while the calcium salt has a bluer hue.[67] The manganese salt has the best lightfastness; the other salts have only fair lightfastness.[68] The Permanent Reds were first synthesized in the 1920s and are more expensive compared to other similar reds. The calcium salt of PR48 was adopted by Gravure Technical Association in the United States for the standard process red.[69]

Red 2G, also known as BON Lake Red, is the manganese or calcium salt of the diazo produced from 1-amino-4-chloro-3-methylbenzenesulfonic acid with BON. The maroon manganese salt has superior lightfastness to the calcium salt and is suitable for exterior coating applications in full strength.[70] However, the lightfastness is not as good in tints, and in nonprotective media, such as gouache, it is extremely poor. BON Lake Red was first produced in 1910,[71] although it was not commonly used until the 1950s.

Yellow BON Maroon is the manganese salt of the diazo resulting from coupling of 4-chloroanthranilic acid with BON. It is sufficiently lightfast to be used for automotive applications. BON Maroon is the salt of the diazo product of 2-naphthylamine-1-sulfonic acid with BON. The pigment was first prepared in 1906 and patented a year later. The manganese salt is the most important of the metal salts, although the calcium salt is also prepared.

Red Lake C and Clarion red. Red Lake C, PR53 (fig. 1), is a yellowish red salt prepared by metallization of the azo pigment formed by coupling of 2-amino-5-chloro-4-methyl-benzenesulfonic acid with β-naphthol. The barium salt is the most common. Red Lake C was discovered by K. Schirmacker and produced in 1902 by the German chemical company Meister, Lucas, and Bruning.[72] Clarion red (PO46) is a homologue of Red Lake C, with the methyl group being replaced by an ethyl group. It possesses poor light and solvent fastness.[73] These pigments and other members of the β-naphthol group are used in artists' watercolors and chalks.

Pigment Scarlet. Pigment Scarlet (PR60) is a true lake, where alumina (Al_2O_3) is used as a substrate for the barium salt of the diazo produced from 2-aminobenzoic acid and 2-naphthol-3,6-disulfonic acid. It is a blue-red pigment with moderate lightfastness and thermal resistance.[74] The pigment is employed extensively in the coloration of plastics and cellulosics and in printing inks.

Arylide (Hansa) Yellows

Arylide yellows frequently appear in artists' paints. They were, and to some extent still are, known as Hansa yellows. However, Hansa is the trade name that the German company Hoechst gave its arylide yellows when they were first introduced, and although it is not correct to call arylide yellows "Hansas," many manufacturers continue to do so. Other terms used for these pigments are acetoacetarylide, monoarylide, and acetoacetarylamide.[75] The ASTM subcommittee refers to these pigments as arylides. All these names have been found on artists' tube paints.

Arylide yellows are generally monoazo pigments, which derive from aniline-based diazonium salts and acetoacetarylide coupling components, although there are some named exceptions. PY1, also known as Hansa Yellow G (see fig. 1), was the first arylide yellow and

was patented in 1909 by Hoechst and commercially introduced in 1915.[76] PY3, known as Hansa Yellow 10G, was introduced in 1928.[77] These two pigments have been used to a great extent in artists' paints and are still in use. Half of all arylide yellows have been introduced in the past twenty years. By varying the substituents on the aromatic rings, other members of the class have been devised, although none has yet rivaled PY1 in importance.

The general structure of arylide yellows is shown in figure 9. Most arylides in commercial use contain an ortho nitro group on the aromatic ring deriving from aniline to improve their lightfastness. In addition to PY1 and PY3, other arylide yellows include PY2, PY4, PY5, PY6, PY9, PY65, PY73, PY74, PY75, PY97, PY98, and PY116. In measure of volume produced, the two most popular arylide yellows in the United States are PY73 and PY74, while PY1 and PY3 remain the most popular arylide yellows in Europe.[78] The arylide yellows PY1, PY3, PY4, PY5, PY9, PY65, PY73, PY74, PY75, and PY98 are used in artists' tube paints.

Arylide yellows have been found to be reasonably lightfast even in exterior applications.[79] A nine-month Florida weathering test suggested that arylide yellows are equal in lightfastness to chrome yellows.[80] The lightfastness decreases when the pigments are used as tints. Arylide yellows are resistant to water, oil, acids, and bases, making them suitable for many paint media. These pigments are not bleed resistant, and they are only heat stable to 150°C.[81] Some arylide yellows have high solubility in many organic solvents, which can lead to a recrystallization of the pigment that may cause a change in color.[82] Arylide yellows are used in printing inks and both architectural and artists' paints.[83] They are not used to color plastics because solubility gives them a tendency to migrate.

Arylide pigments PY73 and PY74 are significantly more lightfast than PY1 or PY3 in addition to other improvements. PY74 has especially high color intensity.[84] PY97, which was introduced in the United States in the late 1950s,[85] also has good lightfastness[86] and better solvent resistance compared to other pigments in the series; it is utilized in decorative paints. PY116 also has improved

9. General structure of arylide (Hansa) yellows

10. General structure of a diarylide compound

solvent resistance, heat stability, and lightfastness compared to the monoarylide yellows that were developed earlier.[87]

Diarylides

Diarylides have been known since 1911,[88] but they were not widely used until almost twenty-five years later. At that time, they were sold as pigments for rubber under the trade names Vulcan Fast Yellows and Oranges. Diarylides are an important class of azo pigments and now account for approximately 80 percent of all yellow pigments.[89] They are primarily used in printing inks, where twenty-five thousand metric tons were used in 1989.[90] Diarylides have approximately twice the tinting strength of monoarylides and show improved bleed resistance and thermal stability due to their higher molecular weight. The lightfastness of the diarylides is insufficient, however, for many applications, such as paints and plastics, especially in exterior applications.

Diarylides are formed by the coupling of tetraazotized benzidines with acetoacetarylides. They are disazo compounds with a backbone structure based on 3,3'-dichlorobenzidine.[91] The general structure of these compounds is shown in figure 10. PY16, which is also classified as a diarylide, has a slightly different structure.[92]

Many of the other diarylides have been produced for their specific color or because of economic factors. The most common diarylide yellows include PY12 (also known as Benzi-

dine Yellow AAA, for acetoacetoanilide), PY13 (Permanent Yellow GR or AAMX Yellow), PY14 (known as Benzidine Yellow AAOT, for acetoacetorthotoluidine), PY17 (also known as Benzidine Yellow AAOA, for acetoacetorthoanisidine), and PY83 (HR Yellow) (see fig. 1). The diarylide oranges include PO14, PO15, and PO16 (dianisidine orange).

PY12 is a very frequently used organic pigment, accounting for 60 percent by weight of all applications of synthetic yellow pigments.[93] It is important because of its shade, intense color strength, and relatively low cost.[94] In addition, PY12 does not sublime, which makes it useful for applications involving heat, such as in sterilized food containers. PY14 is second in importance and is slightly greener and slightly more lightfast compared to PY12. PY13 has a higher tinting strength than PY12 due to its smaller particle size.[95] Because of its high cost, use of PY15 is limited in commercial applications. PY17 is a greenish yellow diarylide.[96] PY83, also known as Permanent Yellow HR, is more nonbleeding and lightfast than other diarylide yellows.[97] It was introduced in 1958 by Hoechst[98] and is a reddish yellow pigment used in plastics, printing, and artists' colors.[99] The only commercially important orange diarylide pigment is PO16.

Flieder and Maraval examined the stability of the four inks, including the yellows PY12 and PY13, used in four-color printing.[100] The inks were placed on the paper via the offset process, and their stability was tested. Moist heat aging did not have a large effect, but the yellows were especially sensitive to light compared to the other colors tested.

Asymmetric diarylides constitute a newer group of diarylide pigments. The most widely used asymmetric diarylides are PY106, PY114, PY126, and PY127.[101] They are not, however, found in artists' paints. The so-called mixed coupling that produces the asymmetric diarylides leads to modified color properties. The performance of the mixed couple does not always equal the sum of the characteristics of the individually coupled products.[102] Asymmetric diarylides have better lightfastness and improved heat stability compared to a diarylide such as PY12.[103] In addition, the average particle size is smaller, increasing the tinting strength. These "improved performance" diarylides were first synthesized in 1963.[104]

Nickel-Azo Yellow

Nickel-azo yellow, PG10, is the single member of its class. It is a metallized monoazo pigment derived from 4-choroaniline and 2,4-dihydroxyquinoline with the structure shown in figure 11. The pigment was developed in 1940 by Woodward and Kvalnes and was patented in 1946.[105] At first, its high price limited its use, but its good properties, such as excellent lightfastness in tints and masstone, low bleed, transparency, and low toxicity, have made it a widely used pigment despite its cost. It is used in artists' materials, automotive paints, and textile dyeing. In artists' paints the pigment is often mixed with blue to provide greens. A special property of nickel-azo yellow makes it retain its place in artists' paints (that is, it is difficult for manufacturers to replicate its properties). When it is diluted with white, it changes tone; other products do not.

Disazo Condensation Pigments

Disazo condensation pigments form a class of more than ten thousand pigments that are prepared by the condensation of two equivalents of an acid chloride substituted β-naphthol–based monoazo with a diamine.[106] They were initially synthesized in Europe,[107] where they became available in 1957, and introduced in 1960 to the United States. There are yellow, orange, brown, red, and violet pigments in this class. The general structures for representatives of this class are shown in figure 12.

The aromatic rings are usually substituted with chloro, methyl, methoxy, or ester groups. Common representatives of this class

include the yellows PY93, PY94, PY95, PY128; the oranges PO31 and PO55; the reds PR139, PR140, PR141, PR142, PR143, PR144, PR165, PR166, PR214, PR217, PR218, PR220, PR221, PR242, and PR248; and the brown PBr23.

The high molecular weight of the disazo condensation products, frequently ranging between 750 and 1500, decreases their solubility and increases their lightfastness.[108] Many disazo condensation pigments are used for printing inks and paints as well as occasionally for coloring plastics. PBr23, a reddish brown pigment, is used in architectural paints and wood stains.[109] PR214 and PR242 are used in high-quality industrial finishes.[110]

Benzimidazolones

Benzimidazolone pigments are monoazos that contain the benzimidazolone moiety as part of the coupling component. There are two general groups, shown in figure 13: (a) the acetoacetylarylamide types called Hansa yellow type, and (b) Naphtol AS types. The benzimidazolones contain structural similarities to the Hansa and naphthol subgroups but are classed as benzimidazolones because they possess the functionality given above. The structure has been investigated using x-ray powder diffraction.[111]

The first benzimidazolone pigment was patented in the United States in 1960.[112] As the benzimidazolone ring of the coupling component imparts significant lightfastness, a number of pigments have been synthesized to provide a broad color range for this subclass. The acetoacetylarylamides cover the color range from greenish yellow to orange, whereas the Naphtol AS types are red, carmine, violet, and brown. This class of azo pigments includes the yellows PY120, PY151, PY154, PY156, PY175, PY180, PY181, and PY194; the oranges PO36, PO60, and PO62; the reds PR171, PR175, PR185, and PR208; the brown PBr25; and the violet PV32.

Benzimidazolone pigments have outstanding bleed resistance, lightfastness, and moderate heat resistance.[113] In fact, the lightfastness of some benzimidazolones approaches that of quinacridones and phthalocyanines.[114] Benzimidazolones also possess high heat stability (usually to 260°C, although some members of this class are stable only to 200°C); some are among the most heat stable organic

pigments. Benzimidazolones are used in artists' paints, for coloring plastics, in automotive coatings, and in colored pencils and wood stains.

PY154, introduced in the mid-1970s, is the most lightfast and weather-resistant yellow benzimidazolone. It is a greenish yellow and is used in artists' oil colors.[115] PO62 is a highly opaque brilliant yellowish orange pigment, while PO36 and PO60, which are orange benzimidazolones, are extremely lightfast and stable. PR185, a polymorphic pigment, is the most important of the red benzimidazolones, and PV32 is an extremely durable violet benzimidazolone. PBr25, a reddish brown pigment with good heat stability, is used in artists' oil paints and watercolors.[116] PR175, PR185, and PR208 are used in printing applications.[117]

Methods of Analysis

Analysis of azo pigments is often difficult due to the presence of large amounts of fillers and extenders. The high tinting strength of azos means that they are often present in much smaller quantities than filler materials such as barium sulfate or calcium carbonate. In general, a sample removed for organic pigment analysis from a work of art needs to be larger than one removed for mineral pigment identification. As conservation scientists become more familiar with the chromatographic and spectroscopic properties of azo pigments, it is becoming easier to characterize them. Until recently, most analyses of

12. General structure of disazo condensation pigments: (a) yellow series, and (b) brown, red, and violet series

13. General structure of two groups of benzimidazolones: (a) acetoacetylarylamide, and (b) Naphtol AS

these pigments have been on bulk samples; but now more investigators are identifying these materials in works of art.

Many analytical techniques have been used for the identification and characterization of azo pigments. Raman microscopy and spectroscopy[118] have been used to examine azo pigments including Orange II (Acid Orange 7) and Para red, PR1. R. Davey and co-workers using Raman microscopy identified a Hansa yellow in ink on a 1948 lithograph by the British artist Victor Pasmore (b. 1908).[119] Many azo pigments are soluble and can be characterized using solution spectrophotometry. Fred W. Billmeyer Jr. and co-workers used this technique to identify colorants found in artists' tube paints. This technique was also used for the identification of pigments in artists' tube paints dating from 1977 to 1980.[120] Higher resolution–higher order derivative spectrophotometry was used to examine twenty-two pigments common in artists' paints, including eleven azo pigments.[121] Using this method of analysis, the authors were able to differentiate between the structurally similar arylide yel-

lows PY1 and PY3, a difficult distinction. Visible spectroscopy was used to identify the fugitive pigment on Mark Rothko's *Harvard Murals* (Harvard University) as Lithol red.[122] For the soluble azo pigments, spot tests can indicate the presence of an azo in a pigment. A spot test has been reported for the identification of nickel-azo yellow.[123]

Procedures for identifying an unknown material with high-performance liquid chromatography (HPLC) were developed by J. W. Wegener and co-workers, who were able to identify several azo pigments in cosmetics.[124] Thin-layer chromatography (TLC) has been used to examine pigments, including azos.[125] TLC in combination with derivative spectrophotometry has been used to identify the organic pigments used by several Eastern European artists, including Nadeža Petrovic and Milan Konjović.[126] In this study, the solubility of samples from artists' commercial paints were examined in increasingly polar solvents, leading to classification into pigment groups that were then examined by thin-layer chromatography. Pyrolysis gas chromatography has also been used to characterize many azo pigments.[127] The pyrograms of the azo pigments are distinct; in fact, it is possible to obtain information regarding the subclass of an azo pigment from the retention time of the principal peak alone.

Fourier transform infrared spectroscopy (FTIR) has been used to identify azo pigments in various works by the Canadian artist Alfred Pellan (1906–1988).[128] Pigments identified with this technique include chlorinated para red, Toluidine red, Hansa Yellow G, Hansa Yellow 10G, Para red PR1, and PO15 (a diarylide yellow). Analysis by infrared spectroscopy is often difficult due to interferences from fillers. It is sometimes possible to remove these fillers by centrifugation.

Most azo pigments are crystalline, so it is theoretically possible to identify them using x-ray powder diffraction (XRD) methods. This method does not usually distinguish variants (such as chloro derivatives), but it does provide data to determine the subclass of azo pigment. Analysis of azo pigments by XRD is often complicated by the presence of fillers and extenders. It is usually possible to remove these filler pigments by dissolving the sample in an appropriate organic solvent followed by centrifugation. Alternatively, the

14. Barnett Newman, *Dionysius*, 1949, oil on canvas
National Gallery of Art, Washington, Gift of Annalee Newman

authors have found that the solution can be passed through a small silica gel column to remove the inorganic fillers. It is sometimes possible to carry out analyses such as XRD in the presence of these extender pigments, as the resulting diffraction pattern is the sum of the individual patterns.

Data for powder diffraction patterns of more than fifty azo pigments have been published in the *JCPDS International Centre for*

Diffraction Data, which gives a compilation of diffraction data.[129] The XRD patterns of some diarylide pigments have been published,[130] and A. Whitaker[131] has used XRD to examine polymorphism of several azo pigments. Crystallographic data have also been compiled on various other azo pigments, including Para Red PR1[132] and PY10.[133] Michael Palmer identified by its diffraction pattern Hansa Yellow 10G, PY3, mixed with titanium dioxide, in a small sample from the yellow component of the green paint in *Dionysius* (1949) (fig. 14) by Barnett Newman (1905–1970).[134]

Three samples from Mark Rothko's *Untitled (Harvard Mural) (Rothko number 6006.60)* (fig. 7), all from the left edge, were investigated. The samples were three different hues of red and can be described as maroon, purple, and bright red. The bright red was identified by XRD as a cadmium red. XRD patterns of the red components of the maroon and purple paints were obscured by the barium sulfate filler. The maroon paint was further characterized using solubility tests according to Billmeyer and co-workers.[135] The solubility of the sample in carbon tetrachloride and methanol indicated the presence of a β-naphthol pigment. Red crystals that had recrystallized from a mixture of carbon tetrachloride and methanol were examined using XRD. The pattern obtained could not be further identified, although the presence of Lithol red was ruled out by comparison to the XRD patterns of the calcium and barium salts of that azo pigment. Additionally, the pattern did not match those for standard samples of PR3 or PR6. The purple sample was not characterized due to the small sample size. This example illustrates the difficulties that still exist in fully characterizing azo pigments in works of art. As our experience and knowledge increase, these difficulties will lessen.

Summary

Azo pigments constitute the largest class of synthetic organic pigments. Thousands have been introduced in the twentieth century, tailored to various applications based on their color and properties, and a number of them have been used in traditional artists' materials. In addition, many azo pigments are employed in coloring plastics and in printing inks, materials that are also found in contemporary works of art.

Many azo pigments are sensitive to light. Most are less light sensitive when used at masstone than when diluted with white pigments such as titanium dioxide. Azos are also frequently sensitive to solvents such as xylene, used by conservators, but only a few, including tartrazine yellow, PY100, are sensitive to water. This property has important consequences regarding the use of solvents for cleaning works of art that contain azo pigments. Generally, the more sensitive materials are less expensive and are used in media such as chalks, crayons, and inexpensive lines of watercolors. These less stable materials are also used for coloring paper.

Identification of the pigments in museum objects is important, as the light and solvent fastness properties can vary among the different subclasses of azos. Knowledge about these pigments and their properties ought to play a critical role in decisions involving exhibition and cleaning. Several analytical methods, discussed earlier, are available to characterize the azo pigments that may be found on a museum object. Azo pigments have such small particle sizes and similar optical properties that optical microscopy is less useful for their identification.

This review has introduced the general properties of the subclasses of azo pigments and their most usual applications. Conservators can use this information to infer which azo pigment subclasses might be present and thus plan appropriate exhibition conditions and treatment strategies. Although it is difficult to fully characterize azo pigments, the information here offers help in the treatment and preservation of the diverse objects in which they have been used.

NOTES

1. Henry W. Levinson, "Pigmentation of Artists' Colors," in *Pigment Handbook*, ed. Temple C. Patton, vol. 2 (New York, 1971), 423–434.

2. R. Lambourne, ed., *Paint and Surface Coatings: Theory and Practice* (New York, 1988), 167.

3. Various products, including colored pencils, pastels, and wax crayons are called "crayons." We use the term strictly as in the original sources, without identification of the exact nature of the product implied.

4. Robert M. Christie, *Pigments: Structures and Synthetic Procedures* (Wembley, England, 1993), 11–29; J. Keleman, S. Moss, H. Sauter, and T. Winkler, "Azo-Hydrazone Tautomerism in Azo Dyes, 2: Raman, NMR, and Mass Spectrometric Investigations of 1-phenylazo-2-napthylamine and 1-phenylazo-2-naphthol Derivatives," *Dyes and Pigments* 3 (1982), 27–47.

5. The *Colour Index* system of nomenclature will be used in this essay. Society of Dyers and Colourists, *Colour Index*, 3d ed. (Bradford, England, 1971), 3:3267–3333, 9:5109–5516.

6. Ruth Johnston-Feller, "Standard Specifications of Pigment Composition and Color," in *Artists' Pigments: A Handbook of Their History and Characteristics*, ed. Robert L. Feller, vol. 1 (Washington, 1986), 299–300.

7. Charles E. Pellew, *Dyes and Dyeing* (New York, 1921), 49–50.

8. See *Colour Index*, vol. 5, for indices of generic names and commercial names.

9. Steven L. Saitzyk, *Art Hardware* (New York, 1987), 163–199; Michael Wilcox, *The Wilcox Guide to the Best Watercolor Paints* (Perth, Australia, 1991); Mark David Gottsegen, *The Painter's Handbook* (New York, 1993), 151–183.

10. Herman F. Mark, Donald F. Othmer, Charles G. Overberger, and Glenn T. Seaborg, eds., *Kirk-Othmer Encyclopedia of Chemical Technology*, 3d ed., vol. 3 (New York, 1982), 387–433.

11. The development of the chemical pigment and dye industry is described in S. N. Boyd, "Mechanisms of the Diazotization and the Azo Coupling Reaction," in *The Chemistry of Synthetic Dyes and Pigments*, American Chemical Society Monograph Series, no. 127, ed. H. A. Lubs (New York, 1955), 96–174, and in Anthony S. Travis, *The Rainbow Makers* (Bethlehem, Pa., 1993), 13–159.

12. Travis 1993, 34–41.

13. Boyd 1955, 97.

14. David A. Crown, *The Forensic Examination of Paints and Pigments* (Springfield, Ill., 1968), 67.

15. Willi Herbst and Klaus Hunger, *Industrial Organic Pigments: Production, Properties, and Applications* (Weinheim, Germany, 1993), 20–22.

16. R. B. McKay, "Crystal Size and Shape of Monoazo Pigments and Rheology of Decorative Paints," *Surface Coatings International* 75 (1992), 177–183.

17. Paul F. Gordon and Peter Gregory, *Organic Chemistry in Colour* (Berlin, 1987), 96–97.

18. Herbst and Hunger 1993, 90–91.

19. In general, electron-accepting groups, such as halogen atoms, nitro groups, and carboalkoxy groups on the diazo component improve the light- and weatherfastness of the pigment. Fastness is further enhanced by electron donors such as methoxy or methyl groups on the coupling component. Properties tend to improve for the substituent pattern meta > para > ortho. Furthermore, introduction of amide groups improves the lightfastness of azos, as does metallization.

20. Herbst and Hunger 1993, 22.

21. Occupational Safety and Health Administration (OSHA), Safety and Health Standard 29, CFR 1910.1007.

22. F. Leuschner, "Carcinogenicity Studies on Different Diarylide Yellow Pigments in Mice and Rats," *Toxicology Letters* 2 (1978), 253–260.

23. Paul Milvy and Kingsley Kay, "Mutagenicity of Nineteen Major Graphic Arts and Printing Dyes," *Journal of Toxicology and Environmental Health* 4 (1978), 31–36.

24. Art and Craft Materials Institute, Inc., "What You Need to Know about the Safety of Art and Craft Materials" (Boston, 1995).

25. Françoise Flieder and Martine Maraval, "The Stability of Printing Inks," *Restaurator* 14 (1993), 141–170.

26. The term "Naphtol" is a trademarked variant of naphthol.

27. Joy Turner Luke, *Test Methods for the Determination of the Relative Lightfastness of Pigments Used in Artists' Paints*, American Society for Testing and Materials Research Report D-1 1036, Standard Practice D4303 (Philadelphia, 1994).

28. Peter A. Lewis, ed., *Pigment Handbook*, vol. 1 (New York, 1988); Peter A. Lewis, *Organic Pigments* (Philadelphia, 1988); Herbst and Hunger 1993; Christie 1993, 11–29.

29. Francis H. Jennison, *The Manufacture of Lake Pigments from Artificial Colours* (London, 1900), 32.

30. Herbst and Hunger 1993, 214.

31. Herbst and Hunger 1993, 265.

32. Leonard Shapiro, "Pyrazolone-Based Pigments," in Lewis, *Pigment Handbook*, 1988, 1:547–554.

33. Crown 1968, 67.

34. R. A. Pizzarello, "Pigmentation of Textiles," in Patton 1971, 2:335–353.

35. Walter Sichel, "Tartrazine Yellow Lake," in Lewis, *Pigment Handbook*, 1988, 1:517–519.

36. A. Whitaker, "CI Pigment Yellow 10, 4-[2',5,'-(dichlorophenyl)hydrazono]-5-methyl-2-phenyl-3H-pyrazol-3-one," *Acta Crystallographia*, C: Crystal Structure Communications, C44 (1988), 75–78.

37. Richard A. Parent, "Synthesis and Infrared Characterization of a Series of Pyrazolone Colorants," parts 1 and 2, *Journal of the Society of Dyers and Colourists* 92 (1976), 368–370, 371–377.

38. Lewis, *Organic Pigments*, 1988, 15.

39. Rainer P. Schunck and Klaus Hunger, "Naphthol Reds," in Lewis, *Pigment Handbook*, 1988, 1:453–462.

40. Lewis, *Organic Pigments*, 1988, 16.

41. S. A. Faterpeker, "Comparative Evaluation Based on Science, Technology, and Applications of the Pigments, 3," *Paintindia* 39, no. 5 (1989), 15–17.

42. Hoechst AG, German patent 256,999, cited in J. Lenoir, "Organic Pigments," in *The Chemistry of Synthetic Dyes*, ed. K. Venkataraman, vol. 5 (New York, 1971), 365.

43. Herbst and Hunger 1993, 281.

44. Lewis, *Organic Pigments*, 1988, 16–17.

45. Schunck and Hunger 1988, 462.

46. Herbst and Hunger 1993, 302–303.

47. Lenoir 1971, 356.

48. Fred W. Billmeyer Jr., Romesh Kumar, and Max Saltzman, "Identification of Organic Colorants in Art Objects by Solution Spectroscopy," *Journal of Chemical Education* 58 (1981), 307–313.

49. German patent 217,266, cited in Lewis, "Orthonitroaniline and Dinitroaniline Oranges," in Lewis, *Pigment Handbook*, 1988, 1:438.

50. Lewis, *Pigment Handbook*, 1988, 1:437–440.

51. Herbst and Hunger 1993, 277–278.

52. Lewis, *Pigment Handbook*, 1988, 1:438.

53. Lewis, *Organic Pigments*, 1988, 33.

54. Suresh Potdar, "Toluidine, Para and Chloronitroaniline Reds," in Lewis, *Pigment Handbook*, 1988, 1:441–452.

55. Potdar 1988, 1:443.

56. Herbst and Hunger 1993, 279.

57. Lewis, *Organic Pigments*, 1988, 14.

58. Potdar 1988, 447.

59. S. A. Faterpeker, "Comparative Evaluation Based on Science, Technology, and Applications of the Pigments, 4," *Paintindia* 39, no. 5 (1989), 17–19.

60. Charles A. Lawson, "Lithol Red," in Lewis, *Pigment Handbook*, 1988, 1:473–486.

61. Herbst and Hunger 1993, 316.

62. Paul Whitmore, "Appendix: Notes on the Technical Analyses," in *Mark Rothko's Harvard Murals*, ed. Marjorie B. Cohn (Cambridge, Mass., 1988), 61–62.

63. Herbst and Hunger 1993, 323.

64. Christie 1993, 14.

65. AGFA, U.S. patent 743,071, cited in Louis Pepoy, "Rubines," in Lewis, *Pigment Handbook*, 1988, 1:488.

66. Lewis, *Organic Pigments*, 1988, 14.

67. Lewis, *Organic Pigments*, 1988, 13.

68. P. A. Wriede, "Permanent Red 2B," in Lewis, *Pigment Handbook*, 1988, 1:499–504.

69. Herbst and Hunger 1993, 327.

70. Lewis, *Organic Pigments*, 1988, 14.

71. Lewis, *Organic Pigments*, 1988, 14.

72. Louis Pepoy, "Red Lake C," in Lewis, *Pigment Handbook*, 1988, 1:463.

73. Pepoy 1988, 466.

74. Lewis, "Pigment Scarlet," in Lewis, *Pigment Handbook*, 1988, 1:509–511.

75. Lambourne 1988, 167.

76. H. D. Schaefer, D. Hammer, and G. Wallisch, "Hansa Yellow Pigments," *Paint and Resin* 53 (1983), 29–37.

77. Rainer P. Schunck and Klaus Hunger, "Hansa Yellows and Oranges," in Lewis, *Pigment Handbook*, 1988, 1:429–436.

78. Schunck and Hunger, "Hansa Yellows and Oranges," 1988, 431.

79. Alfred M. Keay, "Exposure Studies of Organic Yellow Pigments in Exterior Architectural Paints," *Journal of Coatings Technology* 49 (1977), 31–37.

80. Joseph A. Bauer, "Organic Yellow Pigments as Replacements for Chrome Yellows," *Journal of Paint Technology* 47 (1975), 75–79.

81. Lenoir 1971, 343.

82. Schaefer, Hammer, and Wallisch 1983, 33.

83. Schunck and Hunger, "Hansa Yellows and Oranges," 1988, 434–435.

84. Christie 1993, 12.

85. U.S. patent 2,644,814, cited in Lewis, *Organic Pigments*, 1988, 28.

86. Georg Geissler, "New Organic Yellow Pigments with High Fastness to Light and Weathering," *Pigment and Resin Technology* 6 (1977), 10.

87. Lewis, *Organic Pigments*, 1988, 28.

88. German patent 251,479, cited in Lenoir 1971, 346.

89. George H. Robertson, "Diarylide Yellow and Orange Pigments," in Lewis, *Pigment Handbook*, 1988, 1:535–546.

90. Herbst and Hunger 1993, 147.

91. Lewis, *Organic Pigments*, 1988, 29–31.

92. Herbst and Hunger 1993, 263.

93. S. A. Faterpeker, "Pigments for Paints, Inks, and Plastics: A Comparative Evaluation Based on Science, Technology, and Applications of the Pigments, 9," *Paintindia* 39, no. 10 (1989), 15–16, 18.

94. Lenoir 1971, 347.

95. Byron G. Hays, "Particle Sizes of Some Diarylide Yellow Pigments," *American Ink Maker* 69 (1991), 38–53.

96. Faterpeker 1989, part 9, 39, no. 10, 15–17.

97. Geissler 1977, 7.

98. Hoechst AG, German patent 921,404, cited in Lenoir 1971, 347.

99. Herbst and Hunger 1993, 346.

100. Flieder and Maraval 1993, 141–170.

101. Hoechst AG, U.S. patent 3,361,736, cited in Lewis, *Pigment Handbook*, 1988, 1:535.

102. Herbst and Hunger 1993, 240.

103. J. C. Leveque, "Stabilité thermique des jaunes en encre heat set," *Double Liaison* 32 (1985), 317–330.

104. Rainer P. Schunck and Klaus Hunger, "Improved Performance Diarylide Yellows," in Lewis, *Pigment Handbook*, 1988, 1:555–560.

105. P. A. Wriede, "Nickel Azo Yellow," in Lewis, *Pigment Handbook*, 1988, 1:513–515.

106. H. Breitschmid, "Disazo Condensation Pigments," in Lewis, *Pigment Handbook*, 1988, 1:561–572.

107. M. Schmid, "Neue organische Pigmentfarbstoffe, ihre Herstellung und Anwendung," *Deutsche Farben-Zeitschrift* 9 (1955), 252.

108. Joachim Richter, "Color It Azo," *Plastics Engineering* 35 (1979), 37–40.

109. Herbst and Hunger 1993, 384.

110. Lewis, *Organic Pigments*, 1988, 22.

111. Herbst and Hunger 1993, 346.

112. Hoechst AG, U.S. patent 3,124,565, cited in Rainer P. Schunck and Klaus Hunger, "Benzimidazolone Pigments," in Lewis, *Pigment Handbook*, 1988, 1:533.

113. Joachim Richter, "Azopigmente mit verbesserten Echtheitseigenschaften und höherem Deckvermögen für die Kunststoffeinfärbung," *Plastverarbeiter* 4 (1979), 193–196.

114. Geissler 1977, 9.

115. Herbst and Hunger 1993, 354.

116. Herbst and Hunger 1993, 365–366.

117. Lewis, *Organic Pigments*, 1988, 21.

118. A. J. Barnes, M. A. Majid, M. A. Stuckey, P. Gregory, and C. V. Stead, "The Resonance Raman Spectra of Orange II and Para Red: Molecular Structure and Vibrational Assignment," *Spectrochimica Acta* 41 (1985), 629–635.

119. R. Davey, D. J. Gardiner, B. W. Singer, and M. Spokes, "Examples of Analysis of Pigments from Fine Art Objects by Raman Microscopy," *Journal of Raman Spectroscopy* 25 (1994), 53–57.

120. Joy Turner Luke, Fred W. Billmeyer Jr., Treva Pamer, and Romesh Kumar, "Identification of Pigments in Artists' Paints, 1977–1980," Inter-Society Color Council, Report of Project Committee 37, Artist's Materials, Technical Report 90-2 (Princeton, 1990; reprint, 1994), 15–18.

121. Gerhard Talsky and Maja Ristic-Solajic, "Higher-Resolution/Higher-Order Derivative Spectrophotometry for Identification and Estimation of Synthetic Organic Pigments in Artists' Paints," *Analytica Chimica Acta* 196 (1987), 123–134.

122. Whitmore 1988, 61–62; Crown 1968, 152–153.

123. Fritz Feigl, *Spot Tests in Organic Analysis* (New York, 1975), 283, 666–667; Matthijs de Keijzer, "Microchemical Analyses on Synthetic Organic Artists' Pigments Discovered in the 20th Century," *ICOM Preprints*, 9th Triennial Meeting, International Council of Museums Committee for Conservation, Dresden (Los Angeles, 1990), 220–225.

124. J. W. Wegener, J. C. Klamer, H. Govers, and U. A. Brinkman, "Determination of Organic Colorants in Cosmetic Products by HPLC," *Chromatographia* 24 (1987), 865–874.

125. Irmgard Strauss, "Übersicht über synthetisch organische Künstlerpigmente und Möglichkeiten ihrer Identifizierung," *Maltechnik Restauro* 90 (1984), 29–44.

126. Maja Ristic-Solajic, "Die Palette von Nadeža Petrovic," *Katarina Ambrozic Nadeža Petrovic* and "Palette de Milan Konjović," *Katarina Ambrozic Milan Konjović* (Munich, 1985), cited in Talsky and Ristic-Solajic 1987.

127. Naoka Sonoda, Jean-Paul Rioux, and Alain René Duval, "Identification des matériaux synthétiques dans les peintures modernes, 2: Pigments organique et matière picturale," *Studies in Conservation* 24 (1993), 99–127.

128. Marie-Claude Corbeil, Elizabeth Moffatt, and David Miller, "A Study of the Materials and Techniques of Alfred Pellan," *CCI Newsletter*, no. 14, September 1994, 13; Marie-Claude Corbeil and Elizabeth Moffatt, Canadian Conservation Institute, personal communication to Barbara H. Berrie, 5 October 1995.

129. *JCPDS International Centre for Diffraction Data* (Swarthmore, Pa., 1994), file nos., beginning with the most recent: 44-1911, 44-1548, 44-1547, 40-1549, 40-1548, 40-1547, 39-1564, 39-1563, 39-1562, 38-1554, 38-1553, 38-1552, 38-1551, 36-1877, 36-1876, 36-1875, 36-1872, 36-1868, 36-1867, 36-1866, 36-1862, 36-1860, 36-1859, 36-1858, 36-1857, 36-1856, 36-1855, 36-1854, 36-1806, 36-1805, 36-1804, 36-1803, 36-1802, 36-1801, 36-1800, 36-1797, 36-1796, 36-1795, 36-1793, 36-1792, 36-1791, 36-1789, 36-1788, 36-1787, 36-1786, 36-1785, 36-1764, 35-1772, 35-1771, 33-1985, and 32-1720.

130. R. B. McKay, "Physical Characteristics and Performance of Yellow 13-Type Pigments in Litho-

graphic Inks," *Surface Coatings International: Journal of the Oil and Colour Chemists' Association* 76 (1993), 292–297; C. J. Curry, D. F. Rendle, and A. Rogers, "Pigment Analysis in the Forensic Examination of Paints, 1: Pigment Analysis by X-Ray Powder Diffraction," *Journal of the Forensic Science Society* 22 (1982), 173–177.

131. A. Whitaker, "The Value of X-Ray Powder Diffraction Analysis in Colour Chemistry," *Journal of the Society of Dyers and Colourists* 102 (1986), 66–75.

132. C. T. Grainger and J. F. McConnell, "The Crystal Structure of 1-p-nitrobenzeneazo-2-naphthol (Para Red) from Overlapped Twin-Crystal Data," *Acta Crystallographia B* 25 (1969), 1962–1970.

133. Whitaker 1988, 75–78.

134. Michael Palmer, conservation scientist, scientific research department, National Gallery of Art, Washington, report on Barnett Newman, *Dionysius*, 8 October 1993.

135. Billmeyer, Kumar, and Saltzman 1981, 307–313.

APPENDIX 1

Glossary of Technical Terms

amide: an organic compound that contains O=C—NH$_2$ substituent.

amine, primary: a compound containing an NH$_2$ group.

aromatic ring: an unsaturated six-carbon ring with delocalized electrons; sometimes referred to as a benzene ring.

arylide: a compound formed by the reaction of an aniline moiety with an organic acid, forming an aryl amide. These arylides can be used as coupling components, forming azo compounds such as the arylide yellows or naphthol reds.

auxochrome: secondary functional groups that modify the color of a pigment.

azo: a dye or pigment having an —N=N— group as a chromophore, produced by diazotization and coupling reactions.

bleed: the migration of a pigment from its application medium. The composition of the binder as well as the solvent or solvents used for application are important in assessing the bleed tendency of a pigment.

chromophore: a characteristic arrangement of atoms that imparts color to a compound.

coupling component: an organic molecule that combines with a diazonium salt to form an azo pigment.

D4302-93: ASTM procedure *Standard Specification for Artists' Oil, Resin-Oil, and Alkyd Paints*. A specification that establishes requirements for composition, physical properties, performance, and labeling of these paints. Provides list of suitable pigments based on lightfastness.

D4303-93a: ASTM procedure *Standard Test Methods for Lightfastness of Pigments Used in Artists' Paints*. A description of three test methods consisting of exposure to light (natural or simulated sunlight) filtered through glass. The methods are: exposure under glass to the sun, exposure to irradiance from artificial daylight fluorescent lamps, and exposure in xenon-arc lightfastness apparatus.

D5067-93: ASTM procedure *Standard Specification for Artists' Watercolor Paints*. A specification that establishes requirements for composition, physical properties, performance, and labeling of artists' watercolors. Provides list of suitable pigments based on lightfastness.

D5098-94: ASTM procedure *Standard Specification for Artists' Acrylic Emulsion Paints*. A specification that establishes requirements for composition, physical properties, performance, and labeling of artists' acrylic paints. Provides list of suitable pigments based on lightfastness.

D5724-95: ASTM procedure *Standard Specification for Gouache Paints*. A specification that establishes requirements for composition, physical properties, performance, and labeling of gouache paints. Provides list of suitable pigments based on lightfastness.

diazotization: the process of reacting a primary aromatic amine with nitrous acid in the presence of a mineral acid to produce a diazonium salt.

disazo: compound with two azo linkages. Distinct from a diazo compound, Ar—N=N—X (Ar=aromatic ring, X=halogen or nitrate).

hydrazine: an organic compound with the N—N link in it.

ketohydrazone: the structural tautomer of a hydroxy azo pigment. Azo pigments with hydroxy groups adjacent to the azo exist exclusively in the ketohydrazone form in the solid state:

$$
\begin{array}{c}
\quad\; O \\
\quad\; \| \\
R-C-C=N-N-H \\
\;\;\; | \qquad\quad | \\
\;\;\; R' \qquad\; R''
\end{array}
$$

lake: a pigment consisting of an organic dye complexed with an inorganic ion, often Al^{3+}.

lightfastness: the ability of a pigment and binder system to retain its initial color when exposed to daylight. Lightfastness is dependent upon the vehicle, the pigment volume concentration, the thickness of the paint, and any additives.

polymorphism: the existence of a substance in two or more forms, which have differing physical and possibly different chemical properties.

solvent resistance: the extent to which a given pigment tolerates solvent, generally organic solvents, although water is also considered a solvent. The solvent resistance of a pigment depends on the method of processing as well as its medium. Substituents such as long chain alkyl, alkoxy, alkylamino, or sulfonic acid tend to increase solubility. Substituents that decrease solubility include carbonamide, nitro, and chloro groups.

sulfonamide: an $SO_2(NR_2)$ substituent.

substituent group: a functional group that replaces a hydrogen atom in an organic molecule. In general, *R* denotes an organic substituent, while *X* and *Y* denote all other groups.

tautomerization: a form of isomerization in which the structures, called tautomers, are related by movement of a hydrogen atom.

weatherfastness: the tendency of the pigment and binder system to withstand the chemical and physical factors inherent in outdoor exposure, including sunlight, temperature fluctuations, condensation, rain, and salts.

APPENDIX 2

Brief Summary of American Society for Testing and Materials Methods

Standard Test Methods for Lightfastness of Pigments Used in Artists' Paints—D4303-93a

This test is designed to indicate the approximate color changes in artists' pigments that can be expected over time through indoor exposure. The color changes produced by accelerated aging through high exposure to light do not necessarily duplicate the changes that occur through natural aging, but the relative rates of change should be comparable.

The three test methods are exposure under glass to sun, exposure to irradiance from artificial daylight fluorescent lamps, and exposure in a xenon-arc apparatus.

Color is measured, including specular reflectance, and the change in color after exposure is calculated by the L*a*b difference method to give the change in color difference units. Based on the change in color, pigments are assigned a lightfastness grade (given below) determined by the size of the average color change.

Lightfastness I—$\Delta E^*_{abs} \leq 4.0$

Lightfastness II—$4.0 \leq \Delta E^*_{abs} \leq 8.0$

Lightfastness III—$8.0 \leq \Delta E^*_{abs} \leq 16.0$

Lightfastness IV—$16.0 \leq \Delta E^*_{abs} \leq 24.0$

Lightfastness V—$24.0 \leq \Delta E^*_{abs}$

Standard Specification for Artists' Oil, Resin-Oil, and Alkyd Paints—D4302-93

This specification establishes requirements for the composition, physical properties, performance of artists' paints, including pigment identification, lightfastness, and drying time. This specification lists some of the pigments that meet the specifications; many azo pigments are included. Naphthol red does not meet the specifications, although certain other naphthols do.

This specification requires that the ingredients of a paint be listed, and, if a paint is colored by a substituted pigment, the word "hue" must be added to the name.

Standard Specification for Artists' Watercolor Paints—D5067-93

This specification establishes requirements for the composition, performance, vehicle, lightfastness, and labeling of watercolors.

Standard Specification for Artists' Acrylic Emulsion Paints—D5098-94

This specification stipulates the requirements for performance, composition, and labeling of emulsion paints designed for artists' use. The performance criteria include lightfastness, bleed, drying time, and consistency. Composition requirements address the pigments, vehicle, and additives.

Standard Specification for Gouache Paints—D5724-95

This specification stipulates the requirements for composition, physical properties, performance, and labeling of gouache paints. The specification includes pigments, vehicles, and additives and lists some pigments meeting lightfastness requirements.

MARY BUSTIN

Recalling the Past:
Evidence for the Original Construction of
Madonna Enthroned with Saints and Angels
by Agnolo Gaddi

It is rare to find an intact Florentine altarpiece of the trecento in its original setting. The few that remain create flamboyant displays with their painted images surrounded by three-dimensional golden colonnades and spires. These architectonic constructions complement their ecclesiastical settings. Their shapes echo motifs within the building, while their gilded surfaces respond to diurnal shifts in the intensity and direction of light—both natural and artificial—to produce a range of visual stimuli throughout the working day of the church (fig. 1). Sadly, many altarpieces are now in completely different surroundings.[1] By removing an altarpiece from its setting, the interactions among image, frame, and architectural environment are lost, and the altarpiece functions on a different level.

Furthermore, despite the intimate linking of painting support with frame prior to gessoing, gilding, and painting, it is common to find that an altarpiece has been disassembled into individual paintings, often losing important frame components in the process.[2] In consequence, the internal spatial relationships created by the artist between painted and sculpted areas are no longer apparent.

Madonna Enthroned with Saints and Angels by Agnolo Gaddi (fig. 2)[3] (hereafter referred to as *Madonna Enthroned*) is an example of an altarpiece transformed through disassembly and relocation to a different environment.[4] Its original setting is unknown, but the scale of *Madonna Enthroned* suggests that it was painted for a side altar; the triptych currently measures 204 by 240.4 by 12 centimeters.[5] It is in very good condition, but several key features are missing. While components that were fixed to the support before painting took place are still present, the majority of the gilded accessories whose attachment marked the culmination of the commission are lost. The most important of these are the predella box on which the altarpiece stood and the pilasters that supported it on either side.

Technical evidence of the construction process, including the carpenter's notations discovered during the recent conservation treatment, held implications for the redisplay of the altarpiece.[6] Since a frame's shape and proportion were commonly established at the design stage and, as a result, often influenced the very composition of the painted areas,[7] recovery of key frame components can bring an altarpiece one step closer to its original appearance. Some changes, however, are irreversible, notably the loss in mirrorlike qualities of the gilding. It is difficult to recreate some of the visual effects because of the dissimilarities between an art museum setting and a chapel.

As part of this study, reference was made to contemporaneous altarpieces. Despite the integral role that the frame plays in the conception of an altarpiece, there is little published comparative technical evidence concerning the intricacies of construction styles and techniques. The lack of information may

1. View of the apse, Santa Croce, Florence. Center: Rinuccini polyptych, 1379; left: *Madonna and Child with Four Saints*, 1372, both by Giovanni del Biondo
Photograph: Scala/Art Resource, New York

2. Agnolo Gaddi, *Madonna Enthroned with Saints and Angels*, c. 1380/1390, tempera on wood panel (after conservation treatment, 1992, before attachment of new framework)
National Gallery of Art, Washington, Andrew W. Mellon Collection

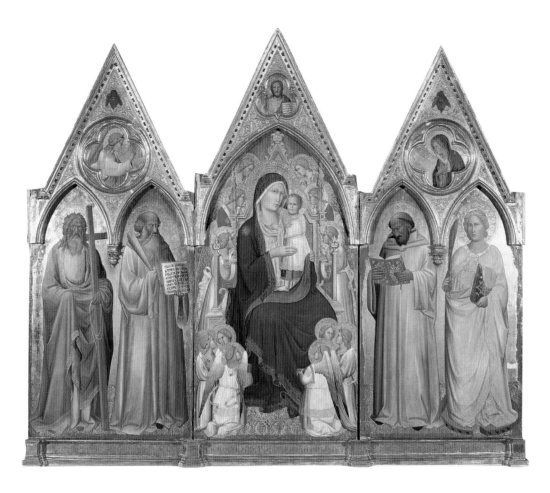

reflect the rarity of complete altarpieces. Previous studies of individual panel paintings have drawn on technical information to match families of panels from dismembered altarpieces. Emphasis was placed on matching features of the supports, wood grain, marks left by a saw or chisel, or the attachment of battens on the reverse to establish links between paintings. Technical evidence was used to identify the original means of presentation of a painting within a framework and thereby illuminate relationships between the painting and its original site, and vice versa. Multidisciplinary studies of the altarpiece in relation to its setting, liturgical significance, iconography, patronage, design and materials, and methods of painting have intensified during the past thirty years. Coupling the historical research with physical evidence should make it possible eventually to resolve outstanding structural questions during the restoration of altarpieces. In this study, to identify the style of the framing elements missing from *Madonna Enthroned*, other altarpieces were examined

in situ and the evidence was compared with published studies and photographs. Where possible, reference was made to original source material to ensure that primary evidence alone was used, rather than secondary characteristics from schemes of later modernization or restoration. It was also necessary to focus on original sections of altarpieces, knowing that other parts had been changed.[8]

Evidence of original altarpiece designs is found in painted images. The Stefaneschi altarpiece (fig. 3) is a prime example. This altarpiece, painted by Giotto (c. 1266–1337) in 1320, is now displayed in a simple modern framework that contrasts with the elaborate altarpiece depicted in the painting. The pope is shown with his hands covered in a white cloth offering the altarpiece in miniature to Saint Peter.[9] The painted triptych describes the original format in detail, showing spires and pinnacles. Owing to its portrayal in three-quarter view, it is possible to discern the relative proportions and depth of the altarpiece as a whole.

The possibility of artistic license, however,

cannot be overlooked. An altarpiece depicted in a cycle of frescoes in the Capella Castellani, Santa Croce, Florence, contains minimal information. In the scene from the Story of the Bad Debtor (the Deceitful Creditor and the Jew), the artist painted a half-length panel of Saint Nicholas in a simple triangular-topped altarpiece with inscription board, positioned on top of the altar. It forms an essential part of the composition, yet contains little detail.

Construction Elements of *Madonna Enthroned*

Madonna Enthroned is an example of construction typical of the late fourteenth century. The solid format has a practical significance as the painting was large, heavy, and meant to be balanced on top of an altar, not hung on a wall. For internal strength, the construction relies upon thick, solid base panels that run the length and breadth of this section of the altarpiece. Each base panel is linked to its neighbors by battens that brace the whole structure. The framework is superimposed onto these panels in layers and as such has no independent strength. It can be divided into two types: framework fixed before painting, and frame ornaments attached after the painting was completed.

Painting Support and Engaged Frame

It is likely that the support was not built by the artist but by a specialist carpenter.[10] Precedents for such a division of labor may be found in several contracts of the period including a letter dated 7 September 1342(?), in which Agnolo's father, Taddeo Gaddi, agreed to paint a panel made by a carpenter.[11] In addition, the artist who designed the wooden support was not necessarily the same as the one who painted the image. The time between manufacture of the support and selection of the artist could be lengthy—four years in the case of an altarpiece commissioned by the nuns of Santa Felicità in Florence.[12] Even a timely commission could attract separate artists for each stage of the process, as occurred with the large project for San Pier Maggiore, which employed Niccolò di Pietro Gerini for the design and Jacopo di Cione (fl. 1365–1398) as the painter.[13] A few extant documents relating to Agnolo Gaddi record his work as a designer. In 1383, Gaddi

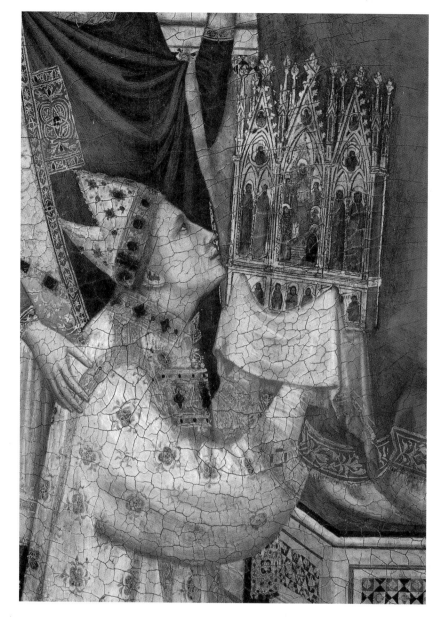

3. Giotto di Bondone, detail of Stefaneschi altarpiece, 1320, tempera on panel Pinacoteca, Vatican Museums, Rome; photograph: Scala/Art Resource, New York

was paid for designs of sculpture for the Loggia dei Lanzi, Florence,[14] later executed by Jacopo di Piero Guidi, while in 1387 he provided designs for the Duomo in Florence. It is rare to find a drawing associated with a contract, but Filippo Lippi (c. 1406–1469), in a letter of 20 July 1457, sketched a triptych complete with ornaments around the perimeter.[15] The lack of documents relating to *Madonna Enthroned* leaves the question of who designed the support unanswered.

The existing support panels of *Madonna Enthroned* were built with two varieties of wood. Poplar (*Populus* sp.) was used for the bulk, flat planes, and simple molding, while lime (*Tilia* sp., also known as linden or bass-

4. Diagram of the construction of *Madonna Enthroned* showing grain orientation (arrows) and applied elements. Also shown are a side view of the base, frame, and dentil molding on panel C (right panel), and a detail profile of the dentil molding

5. *Madonna Enthroned*, reverse, photographed in raking light, composite. The battens are nineteenth-century additions that were screwed in the channels cut for the two original battens. The three grooves cut at the center are not original but relate to a later form of support. The uneven surface of the wood was created when the tree was sawn into planks. The passage of the saw remains visible

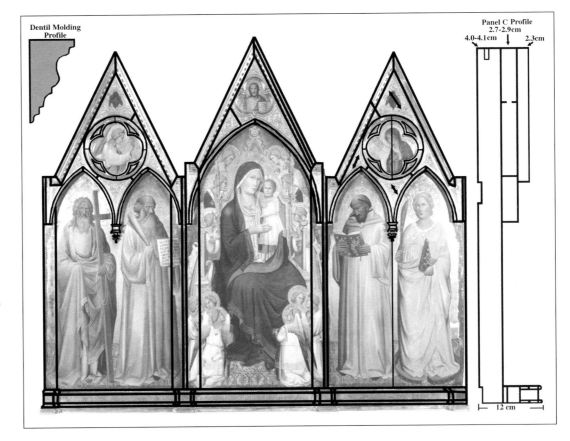

wood) was used for the carved and bentwood pieces, which include the capitals and ogee molding around the arches.[16] Poplar was used extensively for paintings at this time.[17] Both white poplar (*Populus alba* L.) and black

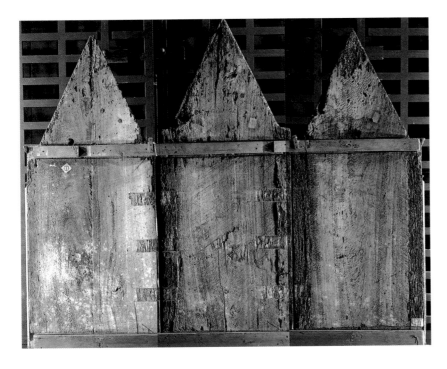

poplar (*Populus nigra* L.) were available. The black poplar may grow to a height of 30–35 meters, while the white poplar reaches a height of about 18–25 meters. Both varieties reach an average diameter of 0.9 to 1.2 meters.[18] The support panels for this altarpiece are 80 centimeters wide and were assembled from wide planks, which would have been among the largest available. They would have been cut from as near the pith as possible, making them the best tangential sections. Lime may grow 40 meters high with a diameter of up to 1.2 meters. It has a straight, fine, uniform grain, making it suitable for carving and moderate bending.

The three main support panels range from 4.0 to 4.5 centimeters thick. The frame supplies an additional thickness of 2.7 to 2.9 centimeters for the upper flat layer and 2.3 centimeters for the dentil molding. The pedestals at the base are 12 centimeters deep (fig. 4). This bulk ensured that the painting, although top heavy, had sufficient internal strength for independent display at the back of the altar. Any evidence of installation is not apparent on the reverse of *Madonna Enthroned*, but examples of display tech-

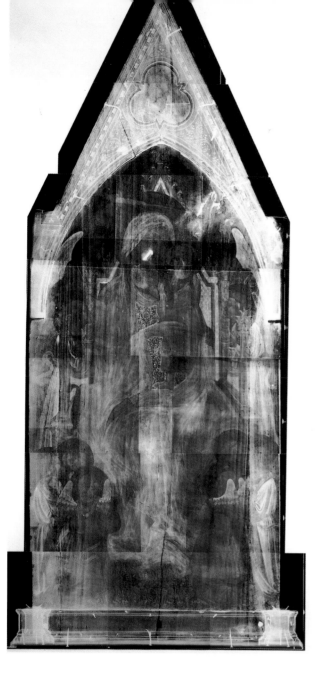

6. *Madonna Enthroned*:
(a) x-radiograph composite
of panel B, and (b) detail of
x-radiograph

niques illustrated in other paintings show altarpieces supported by buttresses or, as is more likely for Gaddi's more modest altarpiece, by metal struts linking the altarpiece to the floor or wall behind.[19] The reverse of the triptych (fig. 5) was neither decorated nor finished to any degree after the assembly stage, providing evidence that it was never intended to be viewed once the altarpiece had been installed.

The three panel sections were assembled from wide planks of rough-sawn poplar. The presence of knots visible on the x-radiographs (fig. 6) and the annular ring pattern indicate that each plank is a tangential cut. The left panel (A) and the center panel (B) are each a composite of a wide central plank flanked on

both sides by narrow strips to make a panel of 80 centimeters in width. The right panel (C) is 80.4 centimeters wide and is constructed from two planks of equal width. Since the x-radiographs reveal a repetition of the pattern of knots across the painting, it is tempting to equate the wood with four planks taken from around the heartwood of the same tree.

The assembly followed basic design principles that balanced a need to accommodate the inevitable movement of the wood with a desire to minimize the work involved in carving the complicated design elements. Assembly of the structure was systematic. Emphasis on preparation of the key features at the expense of hidden areas indicates a fast, sparing workmanship with an economy of labor expended on the reverse. The base panels were assembled with butt joins. Thin, regular glue lines are visible on the x-radiograph. Analysis of glue found between the framework and the base panel established that casein with a bulking agent was employed.[20] The thickness of the glue line at the join suggests that casein was also used there. While the front of each panel was planed, the reverse was left rough. It bears the independent saw marks of the first hewing made prior to assembly. No attempt was made to equalize these levels (see fig. 5). An exposed section of wood on the front on the left shoulder

of panel B reveals a barely smooth surface, in accord with Cennini's description: "The flat of the ancona must never be too much smoothed down."[21] Sufficient tooth in the wood was needed to provide a key for subsequent layers of preparation.

The shape of the upper portion of the panels was defined and cut, and then horizontal grooves were carved into the reverse to receive two battens, located at shoulder and foot (see fig. 5), which were to be added later. The purpose of the battens was manifold. Nailed but not glued—unlike other cross-grain joins—they were a means of linking individual units to make one large object. They established the relationship of the panels to one another and locked them into position. By preventing twisting of the structure, they added structural stability to a complex multicomponent assemblage intended for placement on top of an altar. In the single, rigid unit format thus created, handling,

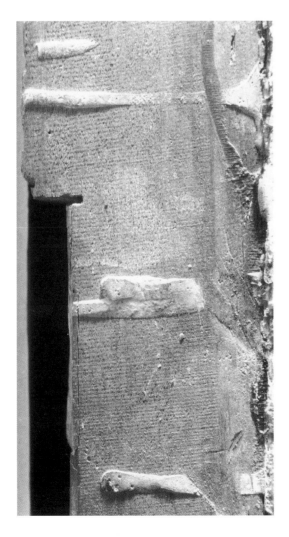

7. *Madonna Enthroned*, detail, panel B, showing dribbles of gesso, applied while the panels were lying flat, that ran across the left edge. The drips have a polished surface. Similar features are present on the outer edges of panels A and C

maneuvering, and installation of the altarpiece were simplified.

The three panels were fixed to the battens with nails. While the original battens are now missing, remnants of the nails are visible in the x-radiograph as long, fat tails. They are by far the largest of the nails used in the altarpiece. They lie at regular intervals, located in the center of each panel and at each edge. Since some of the nails are missing and those remaining do not have pronounced heads, it appears that the battens were nailed onto the three panels after the panels were primed and presumably after the decoration was completed. Given the size of the panels, it is logical that the artist would prime, gild, and paint each panel individually before assembly. Certainly the three panels were not tightly abutted at the moment the gesso was applied since trails of gesso were discovered on the sides of each section. While the drips could have flowed into a gap, under the circumstances it is likely that the gesso would have adhered to both wood surfaces and subsequently sheared as the wood warped on aging. The drips present on *Madonna Enthroned* have smooth surfaces that were probably polished to a flattened form when they were pressed against another surface after drying (fig. 7).

This evidence of possible assembly sequence raises the question of the distance that the altarpiece had to travel between artist's studio and church. Transportation was undoubtedly easier with the altarpiece in small sections, ready to be assembled on site. Precedents for this method date from the early decades of the fourteenth century. The polyptych that Ugolino di Nerio (fl. 1290–c. 1339) created for the high altar of Santa Croce, Florence, in the late 1320s, which measured 419.2 centimeters wide, was transported to Florence in eight sections roughly measuring from 246 by 57 centimeters to 300 by 79 centimeters each and including a predella box that was 435.8 centimeters long.[22] Assembly was simplified by a series of interlocking battens built into the system before travel and locked in position on arrival by pegs.[23] Documentation of the export of altarpieces was kept by the Pratese merchant Francesco di Marco Datini, with whom Agnolo Gaddi had strong ties (Agnolo's brother, Zanobi, ran the Venetian branch of Datini's business). Datini appears to have

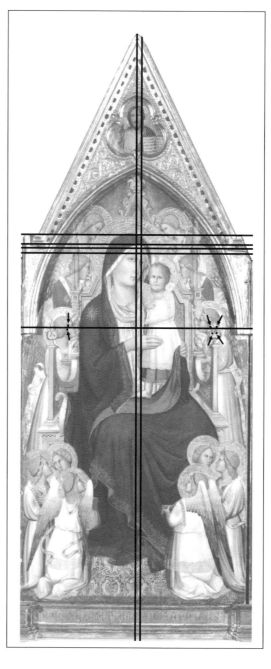

dealt in a range of sizes of altarpieces from the small domestic variety to larger-scale pieces. In one letter dated 9 July 1392, he specified the care of two boxes containing an altarpiece due to be transported by ship, instructing his officers in Pisa to handle them gently.[24]

An alternative for the artist was to work on site as Taddeo Gaddi and his assistants did when completing the altarpiece for San Giovanni Fuorcivitas, Pistoia, c. 1353. Although the altarpiece was not unusually large, an area in the church was cordoned off for the duration of the painting so the artist and his assistants had space to work.[25]

Attachment of battens from the reverse was risky. If the nails were too long, they would pierce the paint layers on the front. This may have occurred with *Madonna Enthroned*, as the nail behind the Madonna's face has disrupted overlying paint. All the other nails were positioned behind areas covered by the upper framework (see fig. 6).[26]

To determine the size and position of the framework for the altarpiece, Gaddi's carpenter subdivided the base panel into areas to be painted and those to be covered by the frame by scoring ruled lines directly into the surface of the wood with a stylus.[27]

Score lines are visible (fig. 8) on exposed surfaces of the base panel—on panel B, where the upper framework is delaminating from the base, and at the shoulders, where the overlying wood has been depleted by woodworm. Score lines can also be seen on the x-radiograph (see fig. 6) as faint white lines with soft, rounded edges, in contrast to lines known to be scored into the gesso or paint, which present a harsher profile. Only the lines filled with gesso are visible on the x-radiograph. The network of lines lying

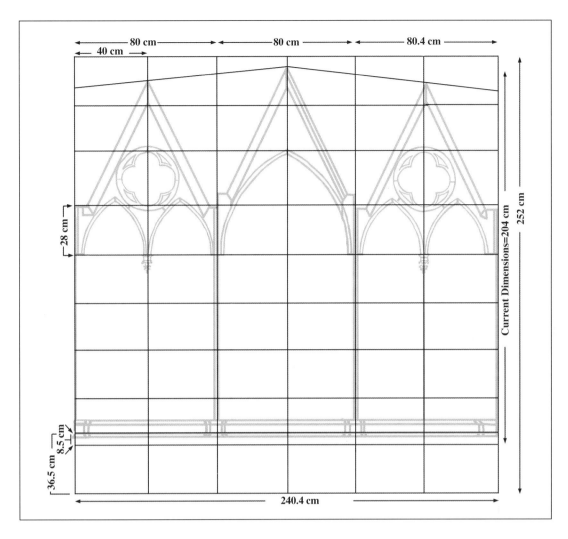

between wood layers is not detectable by x-radiography.

At the shoulders where precise measurements could be taken directly from the wood, it was found that the carpenter had marked divisions 4.5 centimeters wide, approximately 1 *crazia* (4.86 centimeters),[28] which were further subdivided (fig. 9). These divisions correspond to the width of the lowest point of the arch overframe and the width of the capitals and columns (the latter was duplicated by the artist after gessoing). The correspondence suggests that the carpenter subdivided the panel to establish the size of the columns and capitals that were to be carved. He drew the outline of the many layers of framing onto the picture base: the width of the dentil molding is indicated, even though it was separated from the base panel by an intermediate layer of wood.

The double vertical line at the center of

panel B (see fig. 9) may be linked to adjustments made to the height of the altarpiece. An additional length of wood 1.7 centimeters wide was nailed onto the right incline of the base panel, behind the framework. This wood strip infills a gap that was left behind the engaged frame and appears to be correcting a mistake in an earlier calculation, although the vertical lines shift the center point of the panel 1.25 centimeters to the left rather than to the right, as might be expected. The line is bisected by horizontal lines set at the shoulder and at the lowest point of the frame (see fig. 8). On this lower line, pinholes left by the points of compasses are visible (see figs. 6b and 9). From these points the shape of the arch was devised.[29] Four points are visible on the right and two on the left on panel B. The reason for so many marks is unclear unless they were part of the method used to indicate the width of

the ogee molding around the arch. This method is consistent with incisions that mark the width of the dentil molding running around the top edge.

The score marks illustrate that a method of geometric division of the wooden surface was applied. By taking the current measurements of the panels, it is possible to estimate the original dimensions of the altarpiece, although the measurements are not perfect multiples of the Florentine unit of measurement, the *braccio*. The center panel is 3.5 *braccio a panno* high; the shoulder of panel A is 2 *braccio a panno* from the inscription board; and the current width of the altarpiece is 4 *braccio a panno*, 2.5 *crazie*. If the panel is subdivided into rectangles, it may be seen that the proportions generally conform to the $1:\sqrt{2}$ ratio, or the relationship of the side of a square to its diagonal (fig. 10). This system was published by Matthäus Roriczer in 1486 but had been known at least since the time of Vitruvius (first century B.C.).[30] If the width of one panel of *Madonna Enthroned* (80 centimeters) is divided in half (40 centimeters), the ratio of this measurement to the height of an arch (28 centimeters) is $1:\sqrt{2}$. If the system is applied further, and extrapolated beyond the current boundary of the painting, the resulting estimated original height of the entire altarpiece is 252 centimeters. This height would accommodate a deep predella box, approximately 36.5 centimeters in height, and an acanthus bud antefix on the center panel.

Fabrication of the Engaged Framework

The framework was prefabricated before it was attached to the base panels. Each frame section was constructed from two lengths of poplar oriented so that the grain runs parallel to the outer diagonal edges (fig. 11; see also fig. 4). This construction formed a smooth outer edge, a feature also seen in *Coronation of the Virgin*, 1390 (Courtauld Institute, London), by Lorenzo Monaco (c. 1370–1422/1425).[31] By positioning the join across the quatrefoil, the carpenter simplified fabrication of the lunette. A basic roundel was cut in three sections. It was then joined at narrow points in the frame. Movement at the joins was anticipated, as is seen in the careful preparation of the area before the gesso was applied and in the cross pinning of the

11. *Madonna Enthroned*, detail, panel C, showing the join in the framework on the edge. Seen from the reverse, the join is sandwiched between the base panel and the upper dentil molding

12. *Madonna Enthroned*, x-radiograph of the lunette on panel A. Large nails secure the frame to the base panel. The carved molding is pinned with short headless nails at the center of each section

butt joins with nails in the panel A lunette (fig. 12). Later tracery within the roundel was cut in four sections and affixed to the base panel with pins. No sample could be taken for wood analysis from this area, but it is likely that the finer-grained wood, lime, was used, owing to the deep carving required. The ogee molding around the arch (made of lime) was attached over a rabbet cut along

13. *Madonna Enthroned*, detail, panel B, showing the top of the arch. When a section of the ogee molding was removed for repair during conservation treatment, nail holes from the area of attachment were visible. The inside of the rabbet is gessoed and partially covered with bole. The degree of smoothness of the wood left by the carpenter in readiness for coating with layers of cloth and gesso became evident when the bare wood of the framework was exposed

the forward edge of the frame (fig. 13). This rabbeting created a groove probably intended for the insertion of a wooden tracery[32] similar to the scalloping depicted in Niccolò di Pietro Gerini's fresco *Madonna and Child*, 1390, in the Duomo, Prato, on the Monte Oliveto altarpiece by Lorenzo Monaco,[33] and in the Rinuccini polyptych by Giovanni del Biondo (fl. c. 1350–1400) (fig. 1). The frame of *Madonna Enthroned* was finished with pre-carved dentil strip molding (made of poplar) arranged around the upper perimeter and linked with mitered joins; placement of the crenellations at the joins is haphazard.

On panel B the trefoil was created differently from the other lunettes. It was carved out of the body of the frame so that it would lie in a solitary plane. The grain of the frame, which is continuous across the trefoil, can be seen in the x-radiograph of the area (fig. 6a). Thus the frame has three flat painted planes: the lowest (farthest from the viewer) depicts the Madonna and Child, saints, and Annunciation; the middle depicts Christ in Benediction; and the upper (closest to the viewer) contains the seraphim.

As mentioned, there is evidence that the frame structure had been prefabricated before attachment to the base panel. In the gap between the base and the frame of panel B, one long nail holding the molding in place has not pierced the base panel; instead, it lies flat against the reverse of the frame. Either the nail was deflected by the second layer of wood or it had been hammered flat behind the frame. The latter would imply that the frame had been assembled into a single component prior to attachment to the base. If the framework had been assembled on top of the base panel, it would have been logical to anchor the upper layers of wood directly to the base with nails driven straight down. But they were not. Instead, the long, large-head nails were driven at an angle across the joins in the frame from each side, indicating that the major sections were linked in advance.

Only a few nails were used to attach the framing to the base panel. The principal means of attachment was casein glue, which was found spread liberally between the base and frame on panel B in a glue line that is, on average, 1 millimeter thick. The use of nails to augment the glue may be seen as a

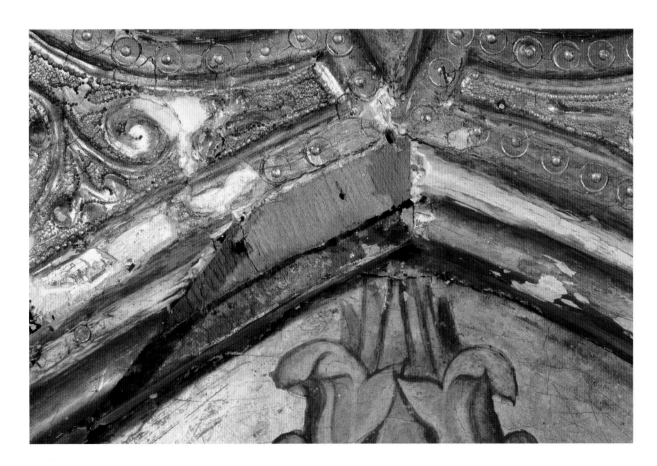

precaution intended to counteract opposing forces concentrated at joins where the grain runs in different directions, whether at end-to-side as in the frame or at overlays of wood where the frame and main panel overlap. Over time—as the panel warped and the glue line failed—the nails have maintained the bond between the separate layers.

Preparation of the Support for Painting

After the carpenter had secured the framing to the base panels, the main structure, along with the pilasters and predella box, would have been passed to the artist for decoration. For *Madonna Enthroned*, the finishing elements of the frame that were due to be attached to the triptych after painting were probably also delivered at this time.[34]

Descriptions of the components of an altarpiece are sometimes found in contracts. In 1346, the company of Gesù Pellegrino at Santa Maria Novella ordered three parts of a retable: *tavola* (panel), predella, and columns, which cost five florins.[35] In *Il Libro dell'Arte*, ornaments are described as an integral part of the altarpiece to be decorated by the artist. In his preparations of the wood, Cennini included "wooden figures, or leaves" in addition to the "flats" to be checked for flaws before priming. And, later, in a description of the application of parchment size to the bare wood, he wrote, "Apply this size to your ancona, over foliage ornaments, canopies, little columns, or any sort of work which you have to gesso."[36] The carving of the two original capitals situated between the saints in panels A and C have a rough finish. A loss of the gold and gesso from the capital on panel C exposed a coarse, faceted surface (fig. 14). Evidently the coating of gesso had served to refine the carving, thus producing the final smooth profile. Because the artist traced the ornament shapes onto the panel, we know these ornaments were made before the painting of the panel commenced. The artist used one capital, a spiral column, and its foot to mark out the area of the picture plane intended to be covered by the frame prior to starting the underdrawing.

When the wood was prepared for painting, three procedures were carried out: nails, which had been countersunk, were covered with plugs of putty that are more cream-colored than the gesso; knots were filled, for

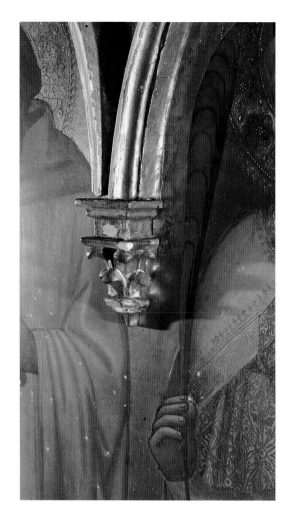

14. *Madonna Enthroned*, detail, panel C, showing original capital between saints (during treatment)

example in the area behind the face of the uppermost right angel on panel B; and uneven and weak sections of the wood were faced with fibers, probably of flax or hemp. The fibers, which were laid in bunches over knots, across joins, and at the boundaries of both picture plane and *pastiglia*-bearing framework (fig. 6), have blunt-cut ends and measure approximately 50 millimeters in length.[37] By lying across the irregular grain, these fibers would help to diffuse local concentrations of stress. This system was not entirely effective at the knots. The angel's face in the top right corner of panel B has been scarred by movement of the underlying support.[38] The reason for reinforcement of the panel edges is unclear unless the fibers were intended to dissipate shock from the attachment of columns. The columns were secured with nails hammered through the gesso and paint layers or through the gaps between the panels.

Strips of finely woven cloth, "old linen

cloth, white threaded,"[39] were laid on top of the fibers in strips, fully covering all of the picture planes, including the lunettes, and roughly over sections of the frame where *pastiglia* was to be modeled. A small corner of the cloth was visible in a damaged area on the edge of panel C. It was still flexible and had considerable strength for its age.[40] The role of the cloth strips appears to have been different from that of the fibers; each strip acts as an anchor for the thick gesso rather than as an agent to suppress movement of the wood.

Two distinct varieties of gesso are present; the lower layer is more coarse than the upper layer.[41] The difference in texture was apparent when observed under low magnification in areas of damage below the capitals where three thin, skim layers of fine gesso (*gesso sottile*) had sheared away from a coarser layer (*gesso grosso*). The final surface of the gesso is smooth, although slight ripples are apparent in raking light near the junction of flat and frame where the path of the knives used to smooth and shape the planes is visible. The gesso covered all forward surfaces. Application had to be carried out while the panels were lying flat, since the *gesso sottile* was so thin and liquid that it ran freely and dribbled down the sides in trails (see fig. 7).[42]

To complete the preparatory layers, *pastiglia* forms were modeled on top of the smoothed surface in liquid gesso toned with an admixture of bole. This pink tinge made the modeling material more visible as the artist built successive layers into three-dimensional forms with successive applications of gesso.[43] (For further discussion of Gaddi's application of paint and the surface coating on *Madonna Enthroned*, see the appendix.)

Gilding

The various planes of the altarpiece were gilded, from the flat plane behind the figures to modeled pediments and carved ornaments. The highly reflective surfaces were critical to the lighting schemes. It is likely that when designing the image and surface texture and forms the artist considered the ambient lighting conditions in the church, including both the natural light that shifted during the day and the effect of candlelight. In variable lighting conditions, the reaction to light of the highly reflective multifaceted surface of a painting will vary according to fluctuating display conditions, the time of day, and neighboring artifacts—a fact presumably considered by an artist when modeling forms in paint and when building three-dimensional features (fig. 1). In his discussion of the optimum lighting conditions for drawing or copying in churches, Cennino Cennini made a point of exhorting the reader to follow "the lighting whichever side it comes from, apply your relief and shadow according to this system. . . . And if the light shines from one window larger than the others in these places, always follow the dominant lighting; and make it your careful duty to analyze it, and follow it through." Later, Cennini discussed the spectral response of his surfaces when tooling flat gold. The gold surface was to be "as even as a mirror." Correctly burnished, it becomes "almost dark from its own brilliance." Stamping the surface made it lighter, and, by adjusting the pressure of the punch tool and the density of the punchmarks, gradations were obtainable.[44] The manipulation of the surface to make it react to light was not restricted to the image but also extended to the frame, which—in the late trecento, as exhibited by *Madonna Enthroned*—could be a densely modeled and tooled region of gold. The frame ornaments took the idea a step further with columns carved in the round into spirals and organic finials, all of which were gilded and burnished.

Gold leaf was expensive and often warranted a clause in a contract stipulating that only the best materials were to be used and that the use of gold leaf (along with the expensive pigment ultramarine) would be at additional cost to the patron. Cennini specified that to be certain of the quality of the gold, the artist should obtain it from a good goldbeater. One of Agnolo Gaddi's suppliers is known from the financial accounts of his work on the frescoes in the Capella della Sacra Cintola, Duomo, Prato. It was a large commission, for which he was paid 535 florins plus the cost of gold leaf,[45] tin, and blue pigments.[46] Even when working in Prato, Gaddi sent his assistants to Florence to purchase gold leaf from "Maffio, *battiloro*" (goldbeater).[47] The best gold, Cennini wrote, is "rippling and mat, like goat parchment." The

three thicknesses that Cennini mentioned had specific applications. "Gold for the flat wants to be rather dull. . . . On moldings or foliage ornaments you will make out better with thinner gold; but for the delicate ornaments of the embellishment with mordants it ought to be very thin gold, and cobweb-like."[48] To economize, Gaddi applied gilding only to the areas that would be visible when all the framing was present and the painting was mounted on the altar. The upper edge of the sill was also left ungilded, even though the neighboring areas of the brocade floor and the inscription board bear gold.

Gilding on *Madonna Enthroned* does not cover the full face of the picture plane. There is a border of exposed, ungilded bole to the left and right of each panel (see fig. 2). These areas were covered by the original framing ornaments. Undecorated edges of panels are frequently found in contemporaneous altarpieces; for example, the area behind the capitals is bare on *Trinity with Saints Romuald and John the Evangelist* by Nardo di Cione (fl. 1343/1346–d. 1365/1366) and on altarpiece panels depicting Mary Magdalene, Saint Nicholas of Bari, Saint John, and Saint George, 1425, by Gentile da Fabriano (c. 1370–1427),[49] in which areas destined to be covered by capitals and columns or pilasters are left ungilded. In *Coronation of the Virgin*, 1402, by Lorenzo di Niccolò (fl. fifteenth century) in the Chiesa di San Domenico, Cortona, the edges of bare gesso were used as a test area for colors; red brush strokes lie to the left of Saint John the Baptist's head.[50] This certainty that the edge would not be visible in *Coronation of the Virgin* may be explained by the style of columns. A pilaster lies behind the spirals, and therefore the area is completely masked. In contrast, in *Madonna Enthroned* the panel edge area was coated with bole. This coating suggests that the area would have been partially visible, making it necessary to tone the white gesso to prevent it from being espied between the columns.

Within the images on *Madonna Enthroned*, in keeping with the technique of the period, the gilded areas are discrete entities. Unless the gold was meant to be visible or had a practical role in creating a particular effect, it was not applied to areas intended to be painted. This practice was, however, less an economic measure than a recognition of the specular nature of a gilded surface, which could be manipulated to provide a contrast to the effects of matte white gesso.

Evidence for the Missing Ornamentation

Gaddi used the frame to augment his pictorial illusion. Since the frame was to cover part of the image, it was necessary to establish the extent to which it impinged upon the pictorial space. Using the frame ornaments that were to be affixed to the panel after it had been painted, Gaddi marked out their intended location on the gesso. This step enabled him to take their eventual presence into consideration as he laid out the composition, with the result that the image employs the physical depth of the arched colonnade in place of illusory depth; angels were deliberately drawn, for example, so that they knelt behind the columns. The information was also used to save the artist effort. Where a halo would be covered by a column, the gilder left the punched design incomplete knowing that it would eventually be hidden. In panel B the angel on the lower right is truncated by the edge of the panel. If complete, its robe would fall behind the triple columns with only glimpses of color perceptible through the bars. This design plan is also seen in the upper left and right angels' wings, which disappear behind the arch, as does Saint Andrew's cross in panel A. The arch and columns had been established as architectural elements through which the tableau is viewed.

The artist took the columns fitted with capitals and bases and placed them over the left and right edges of panel C. He then ran a stylus around the forms and down the spiral, leaving a broken incised line in the gesso (fig. 15a). A row of arcs resulted from tracing around the columns. From this, it appears that an estimate of the amount of frame overlap on the panel was taken. Accordingly, on panels A and B, reserved areas at the edges are marked with a ruled line for the column and with angular steps for the base and capitals. Inscribed in the gesso and later infilled partially with bole and gold leaf, the arcs describe the shape of a spiral column surmounted by a capital supported on a base. These marks lie toward the edge of the gilded ground in direct line with the edge of the upper framework and the first step of the

15. *Madonna Enthroned*: (a) schematic diagram of lines inscribed into the gesso and subsequently covered by bole and gold leaf; (b) detail, panel C, showing gilding and incised line near the bottom of the sleeve. The ripples in the tracing relate to a ridge running down the spiral column

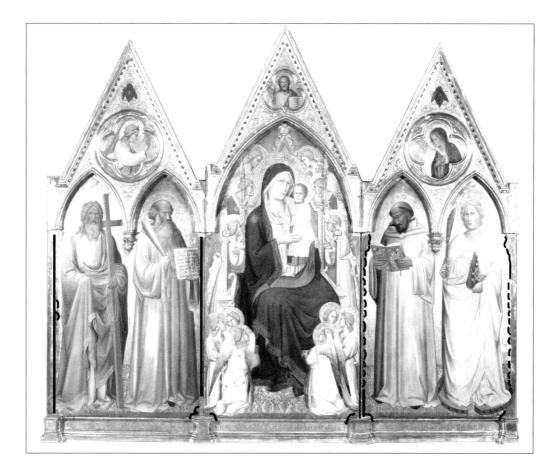

base. The arcs bear slightly different characteristics that can be related to S- and Z-twists, indicating that the artist alternated the spirals. The position of the S- and Z-twists, if extrapolated across to the center panel, results in twists running downward toward the Madonna and Child, S to the left, Z to the right. Gaddi was not consistent with this format in other paintings, however, as can be seen in his frescoes, for example in his rendering of Saint Lawrence in the Capella Castellani, Santa Croce, Florence, where S- and Z-twists are painted at random. In *Madonna Enthroned*, the incised design on the left of panel C (fig. 15b) is more detailed than that on the right to the extent that it describes the full length including leaf shapes on the capitals and ridges on the twists. In contrast, the lines on the right side of panel C define the top of the capital and the central section of the column. If these features are compared to the painted columns of the throne, the leaves correlate with the pendulate curves of the Corinthian capital and the ridges with the ribbons of molding running around the spirals. A simi-

lar style of column is seen frequently in Florentine paintings. It was used throughout Lorenzo di Niccolò's *Coronation of the Virgin* in the Chiesa di San Domenico in Cortona.

The column style used in *Madonna Enthroned* is also featured in Agnolo Gaddi's frescoes in the Capella Castellani, Santa Croce, in which saints are depicted in architectural settings. Each saint is standing below a fictive stone canopy with finials that rise to the same level as the antefix that crowns the apex of the loggia. Saint Louis of Toulouse stands below an arched canopy decorated with a looped trellis. A rectangular pilaster runs alongside a spiral column and changes into a finial as it rises above the capital. Similarly, Saint Lawrence stands on his gridiron beneath a canopy. Each vertical post of his shelter has an accompanying spiral column with encircling capital. The pointed arch above the saint contains the scrolled-leaf crockets with a bud stretching out in the form of a cross at the apex. In style, the existing frame of *Madonna Enthroned* makes a direct reference to the painted image of the Madonna's triangular-topped throne with its stone spiral columns and finials (fig. 16). The capitals on the throne are close pictorial representations of the two remaining original capitals placed between the saints on panels A and C.

Reconstructing the Missing Frame Ornaments

Columns, pilasters, predella, and probably finials are missing from *Madonna Enthroned*. It has been possible to ascertain the shape of some of these by examining structural clues on the altarpiece. The pedestals that lie between each panel along the present base of the altarpiece originally supported columns (fig. 17). When aligning the frame, score marks, and pedestal, it became clear that a single column would need to be unusually wide to cover the gap between the panels, even taking into consideration the effects of warping of the altarpiece over time. The width of the gap is governed by the moldings running along the inscription board and around the pedestals. Mitered ends of adjacent sections of these moldings meet snugly. The inscription board and moldings with their horizontal alignment of grain have more or

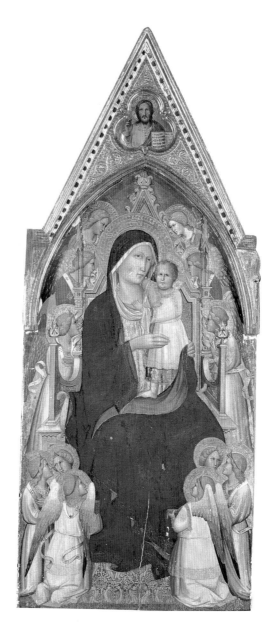

16. *Madonna Enthroned*, detail, panel B (during treatment)

less maintained their original conformation. Only slight bending has been imposed by the warping of the main support panels to which the overlays of wood are firmly attached with long nails. Originally, the relationship between the panels would probably have been as close as the moldings, but as the panels warped, the gap had increased in size. An estimate of the original gap between the panels was therefore assumed from the current position of the moldings.

To produce the slender, delicate quality of columns used in contemporary altarpieces, a cluster formation would have been necessary.

17. *Madonna Enthroned*, detail, showing pedestals of panels B and C (after treatment)

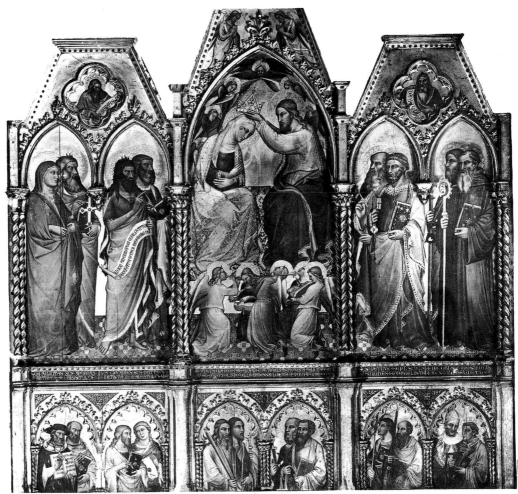

18. Spinello Aretino, Niccolò di Piero (also called Niccolò di Pietro Gerini), Lorenzo di Niccolò, *Coronation of the Virgin with Saints Felicità, Andrew, John the Baptist, Peter, Giocomo, and Benedetto*, 1401, tempera on panel
Galleria dell'Accademia, Florence; photograph: Alinari/Art Resource, New York

Thus, considering the double-stepped pedestal design, it is likely that a triple set of columns existed at the central joins and a double set at the edges. Capitals and feet would have been fused in a style similar to that seen on

Niccolò di Pietro Gerini's *Coronation of the Virgin with Saints* (fig. 18).[51]

Evidence for the pilasters is limited. The outer pedestals in *Madonna Enthroned* are truncated. Wood at the outer edge of the

altarpiece was not intended to be visible: it remains unprimed; dribbles of gesso run across the bare wood. It is certain that another element of the altarpiece had existed at the outer edges of panels A and C because dribbles of gesso in these locations have been compressed between two surfaces (see fig. 7). Spiral columns would have been positioned in a corner created between the flat surface of the panel and a projecting pilaster, now missing, that abutted the front of the panel. The pedestal and upper framework are slightly inset from the edges of the outer panels to accommodate the inner edge of the missing pilaster (fig. 19). Molding would have been continuous across the outer pedestals and the pilasters, as can be seen from the angle of the miters. Instead of projecting sideways to meet molding turning toward the back of the panel, the miter is reversed to meet a plane that projected forward at a 90-degree angle to the pedestal (note pedestal on panel C in fig. 17). This miter indicates that the missing pilasters were set square to the altarpiece and not on the diagonal. No remnants of adhesive or nail holes related to the pilasters are visible, suggesting that the battens were used as attachment points. It is known that horizontal bars could have protruded to the left and right of the three main panels: the grooves cut to hold the battens extend the full width of panels A and C (fig. 5). Pilasters could have been nailed to these extensions from the reverse.

At their most elaborate, pilasters formed buttresses that were anchored at floor level,[52] as is the case in the Rinuccini polyptych by Giovanni del Biondo (see fig. 1). They were a major means of support for the top-heavy constructions. For *Madonna Enthroned* they were probably less extensive, although it is likely that they had highly decorated surfaces of richly gilded *pastiglia*. The existing framework on *Madonna Enthroned* is embellished with gilded fruit and flower designs that closely follow the motif visible in photographic documentation of the altarpiece attributed to Agnolo Gaddi of the *Madonna and Child with Saints Lawrence and Philip* in the Oratorio di S. Caterina d'Alessandria, Antella, near Florence (fig. 20).[53]

The area above the capitals on *Madonna Enthroned* was covered by short frame sections. It is possible that these ornaments were similar in style to the rectangular blocks

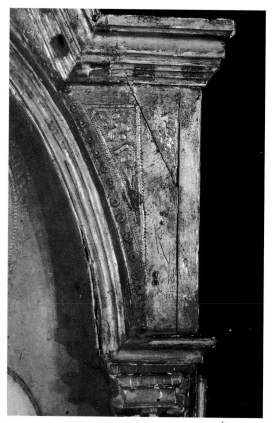

19. *Madonna Enthroned*, detail, frame of panel C (before treatment), showing an inset, which fills the space originally occupied by a pilaster. The diagonal join is original, but the space at the far left and right of the upper framework was infilled with rectangular lengths of wood during an earlier restoration

20. Photograph published in 1908 of Spinello Aretino (later attributed to Agnolo Gaddi), *Madonna and Child with Saints Lawrence and Philip*, n.d. Oratorio di S. Caterina d'Alessandria, Antella (before removal of the pilasters and part of the framework); photograph: Alinari/Art Resource, New York

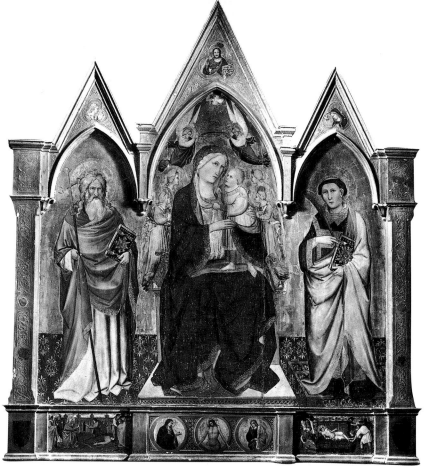

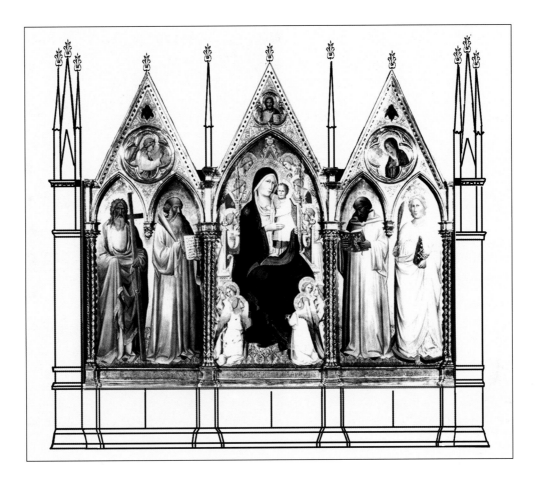

attached to Giovanni del Biondo's polyptych *Madonna and Child with Four Saints*, 1372, originally in the Capella Tosinghi e Spinelli, Santa Croce, Florence (fig. 1). On *Madonna Enthroned*, their purpose was to hide the gaps between the three panels and the pilasters and to continue the line of decoration established by the spiral columns. Clues of the original design of these elements may be gleaned from the dentil molding that runs around the perimeter of the main panels. It probably formed a continuous ribbon around these small additional frame elements. Each end of the dentil and ogee molding has been mitered indicating that at the junctions of the two frame sections the missing ornamentation had a rectangular profile. It is possible that the ornaments were not simple rectangles but were carved in more elaborate shapes. At each location is a series of incisions lying in the gesso similar to those made around the spiral columns on the panels below. The lines are slightly curved, indicating that miniature spiral columns may have been used. However, a precedent for

such ornamentation in this region has not been found in other altarpieces of the period.

In continuation of this theme, the pilaster-like forms may have extended upward to form finials beyond the boundary of the panels, as seen, for example, in Lippo Vanni's (fl. after 1341–d. 1375) fresco painting of a polyptych in the Convento di San Francesco, Siena, c. 1360, that has a forest of spires. The finials on *Madonna Enthroned* may have reached the same height as the decorative antefix attached to the apex of each panel (fig. 21). Within the tip of each panel there is a hole in which the ornaments were pegged: a dowel made of poplar was discovered in the hole in panel A. The dowel—which was roughly shaped into a point—was the means of attachment for a decorative ornament that probably resembled the acanthus bud depicted on the Madonna's painted throne (fig. 16). Evidence for the attachment of crockets was less clear because, although there are nail holes along the upper edges of each panel, these may relate to a later addition of fretwork. All the frame ornaments were nailed

onto the altarpiece after painting had been completed. The columns were fixed with large, long-tailed nails driven into the gap between the panels: wood at the edges is bruised in the shape of elongated triangular nail profiles (fig. 22). The artist made an attempt to disguise the presence of the fixings: when attaching the capitals to panels A and C, nails were hidden in the deepest hollows of the carving. Other paintings display the method of attachment in a more overt manner. On Lorenzo Monaco's *Madonna of Humility with Four Saints*, 1404 (Museo della Collegiata, Empoli), pilasters with a simple rectangular profile are secured with large-headed nails hammered through from the front, a technique also visible in Luca di Tommè's (documented 1356–1390) *Madonna and Child with Bishop and Saints John the Baptist, Gregory, and Francis*, c. 1366–1373 (Pinacoteca Nazionale, Siena).[54]

There is no technical evidence of the predella on *Madonna Enthroned*. At the scale of this altarpiece, the predella could have been formed out of an extension of the base panel, in a scheme similar to that seen in an early photograph of the center panel of Gaddi's polyptych *Madonna and Child with Angels and Saints Benedict and Peter, John the Baptist and Miniato*, 1375.[55] Or it may have been constructed separately as a box structure,[56] as, for example, in *The Vision of Saint Bernard with Saints Benedict, John the Evangelist, Quinto, and Galgano* by the Master of the Capella Rinuccini (fig. 23).[57] A similar format may also be seen in Bicci di Lorenzo's (1373–1452) *Madonna and Child with Saints*, Saint Ippolito polyptych, Bibbiena, Arrezo,[58] or in the spectacular polyptych by Lorenzo di Niccolò in San Domenico, Cortona.[59]

New Ornaments for the Redisplay of the Altarpiece

If, in the future, the missing predella is identified, it would provide more structural information about the original appearance of the altarpiece. For the present, to recapture the three-dimensional quality of the original appearance of the triptych, replacement frame ornaments were made as part of the recent restoration treatment. It became apparent during this investigation that the restoration should be restricted to items of known dimension and style and that the new frame sections

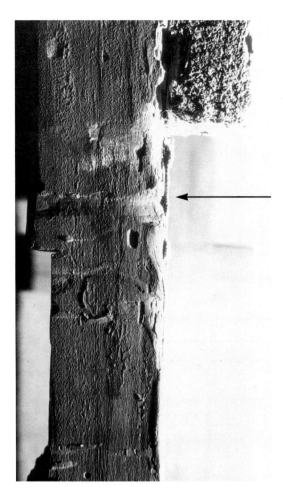

22. *Madonna Enthroned*, detail, edge of panel B, showing triangular indentation left by a nail that marks the point of attachment for the original triple capital. The nail sat in the gap between the panels

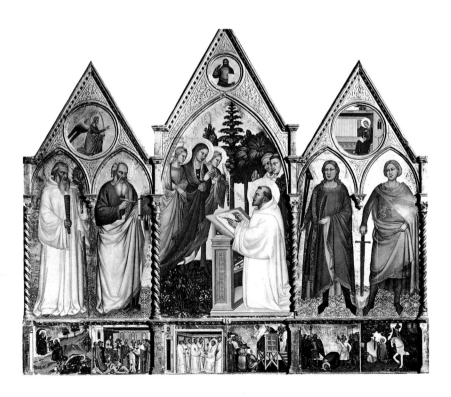

23. Master of the Capella Rinuccini, *Apparition of the Virgin to Saint Bernard (The Vision of Saint Bernard with Saints Benedict, John the Evangelist, Quinto, and Galgano)*, 1368, tempera on panel
Galleria dell'Accademia, Florence; photograph: Alinari/Art Resource, New York

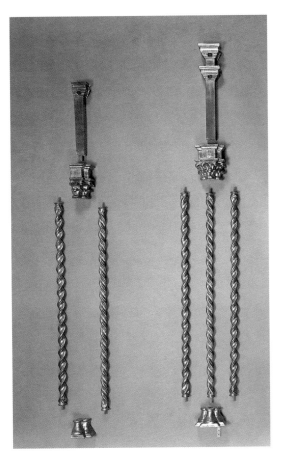

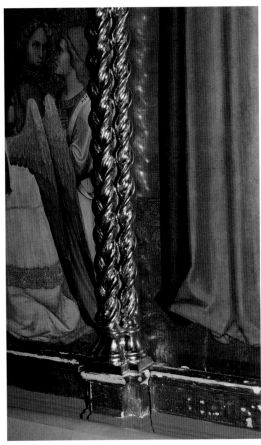

not hamper the interpretation of elements that once existed beyond the present boundary of the altarpiece. Only those sections that projected forward of the image and appeared to lie within the perimeter of the painting were re-created. Their size, proportion, and design were governed by the construction marks left on the painting by the carpenter and the artist, and by the differential aging of the surfaces. On panel A, the gilding on the left-hand side had a discolored, tarnished, undulating pattern related to the spiral column that had once existed in this area; the pattern was also detected under the arch. The explanation for this phenomenon is unclear, except that both areas would have been more shaded than the remainder of the gilding.

The frame elements that projected past the perimeter of the painting remain more hypothetical in shape, size, and decoration, especially the pilasters, which could have had highly ornate surfaces. The new frame elements were added to link the images and to suggest a continuity beyond the boundaries of the panels with the intention of emphasizing what remains of the framework without insisting that the image is complete.

New sections of the frame were carved and linked together with dowels (fig. 24) using the original capitals as prototypes.[60] To replicate the original surfaces, the ornaments were decorated with bole over gesso and then water gilded. Double thickness gold was required to obtain a match with the painting.[61] Originally, the gold in the painting and frame had a highly reflective surface resembling gold plate. When the spiral columns were attached (fig. 25)—and before the new gilding was toned to match the aged original— it was observed that the columns were reflected in the flat gold of the original, giving the impression of a continuation of spirals into the space occupied by the saints, a replica of the common architectural device of capitals and columns grouped around a pilaster.[62] This effect was muted by the natural aging of the gold surface.

When the replica columns were inserted, spatial characteristics within the composi-

26. Agnolo Gaddi, *Madonna Enthroned with Saints and Angels* (after conservation treatment)

tion became more apparent (fig. 26). A visual rhythm was created between the angels and spirals. The artist had alternated figure and twist to increase the illusion of depth within the pictorial space. The series commences with the three-dimensional columns of the framework and culminates with the pillars on the throne. By considering the altarpiece as a three-dimensional structure, an artist could blur the division between actual and invented space. Gaddi used architectural devices of the framework to enhance the illusion of space within his images.

The reintegration of frame ornaments on *Madonna Enthroned* was possible because the greater part of the original framework remained: molding profiles, nail holes, stepped bases, and inscription board, in addition to the guidelines left by the carpenter and artist. A minimum amount of new frame was added to recapture the space without overwhelming the original with conjecture.

NOTES

I am grateful to all those who gave time and support for this research. It was enriched by their expertise and by discussions of the issues. My thanks to members of the painting conservation department, National Gallery of Art, in particular David Bull and Sarah Fisher; to members of the scientific research department, Barbara H. Berrie, Suzanne Quillen Lomax, Michael Palmer, and especially Susana Halpine, former staff biochemist, for their analytical expertise; to Steve Wilcox, frame conservator, for decoration of the gilded ornamentation so splendidly carved by Silvano Vestri; and to Janice Gruver, conservation division editor, for her fine-tuning. Thanks also to Walter M. Brown, National Museum of Natural History, Smithsonian Institution, for scanning electron microscopy imaging, and to Peter Booth, Tate Gallery, for comments on the text.

My fellowship at the National Gallery of Art was funded by the Andrew W. Mellon Foundation and the Charles E. Culpeper Foundation. Their sponsorship made it possible for extensive research in Italy to be undertaken in support of the conservation treatment.

1. Martin Wackernagel, *The World of the Florentine Renaissance Artist: Projects and Patrons, Workshop, and Art Market* (1938), trans. Alison Luchs (Princeton, 1981), 131.

2. Henk W. van Os, *Sienese Altarpieces 1215–1460: Form, Content, Function*, vol. 2 (Groningen, 1990), 36, see also chap. 2, "Florentine Models," 65–85.

3. Agnolo Gaddi was born around 1350. In 1351 his father, Taddeo Gaddi (c. 1300–1366), was recorded as living in Via Santa Maria in the Quartiere San Giovanni, Florence. It is possible that Agnolo inherited his father's house since his widow is known to have been still living in this street in 1404. By 1381, Agnolo Gaddi was a member of the Arte dei Medici e Speziali. He is documented as working in Rome, Florence, and Prato. Like many artists of the period, Gaddi ran a workshop producing commissioned altarpieces, designs for sculpture and monuments, and domestic altarpieces for sale, in addition to executing frescoes, for which he was assisted by pupils. His most famous pupil is the author of *Il Libro dell'Arte*, Cennino Cennini. By the 1390s Gaddi was in financial trouble following a fine of 600 lire for attacking Miniato Tufi, a tax collector. In a document dated 20 December 1392, Agnolo Gaddi professed to be bankrupt and the fine was waived. During this period (1392–1395) he is documented as working principally on a cycle of frescoes in the Capella della Sacra Cintola, Duomo, Prato, and also intermittently (1391–1394) for the merchant Francesco di Marco Datini on the decoration of his palace in Prato. Gaddi's last documented altarpiece was an important commission for San Miniato al Monte, on the outskirts of Florence. He was buried in Santa Croce on 16 October 1396. Bruce Cole, *Agnolo Gaddi* (Oxford, 1977), 4–7, app. 1, 51–56; app. 3, 60–61, 66–67. See also Roberto Salvini, *L'arte di Agnolo Gaddi* (Florence, 1936), 180–182. For Taddeo Gaddi, see Andrew Thomas Ladis, *Taddeo Gaddi: Critical Reappraisal and Catalogue Raisonné* (Columbia, Mo., and London, 1982), 258.

4. *Madonna Enthroned with Saints and Angels* (1937.1.4a, b, c) entered the collection of the National Gallery of Art in 1937. Before then it was owned by Duveen's, New York, R. Langton Douglas, London, and descendants of the fifth earl of Ashburnham, Ashburnham Place, Battle, Sussex. For a full provenance, see Fern Rusk Shapley, *Catalogue of the Italian Paintings* (Washington, 1979), 192–194.

The saint on the far left is Saint Andrew, who was one of the twelve apostles. His feast day is 30 November. His presence suggests that the triptych was made for an altar of Saint Andrew, in a Cistercian foundation, signified by the presence of Saints Benedict (c. 480–c. 550) and Bernard of Clairvaux (c. 1090–1153) on the left and right of the Madonna and Child, respectively. David Hugh Farmer, *The Oxford Dictionary of Saints* (Oxford, 1979), 16–17, 35–36, 39–40. On the far right is Saint Catherine of Alexandria, whose feast day is 25 November. She is the patron saint of maidens, philosophers, preachers, and apologists, among others. Alan Butler, *Lives of the Saints*, ed. Herbert Thurston and Donald Attwater, vol. 4 (New York, 1956), 420–421.

5. The size of an altarpiece was determined by the width of its designated altar. This fixed the horizontal dimension and prescribed the height, which was in proportion to the width. Most altarpieces on this scale were commissioned for specific sites, and measurements are occasionally found in contracts. Jill Dunkerton, Susan Foister, Dillian Gordon, and Nicholas Penny, *Giotto to Dürer: Early Renaissance Painting in the National Gallery* (London, 1991), 129.

6. Mary Bustin reports on Agnolo Gaddi, *Madonna Enthroned with Saint and Angels*, 1988–1994. Conservation treatment commenced in 1988 and was completed in 1991. Technical examination included the use of the binocular microscope, x-radiography, infrared reflectography, and cross sections. Analysis of materials was undertaken by scientists in the scientific research department, National Gallery of Art, Washington, using energy dispersive x-ray diffraction, gas chromatography with mass spectrometry, high-performance liquid chromatography, x-ray diffraction, and thin-layer chromatography. Scanning electron microscopy imaging was carried out by Walter Brown, National Museum of Natural History, Smithsonian Institution, Washington.

7. The idea of treating the frame and panels as separate entities developed with the increasing complexity of the altarpiece format such as the polyptych. John White, "Carpentry and Design in Duccio's Workshop: The London and Boston Triptychs," *Journal of the Warburg and Courtauld Institutes* 36 (London, 1973), 93.

8. See, for example, Eve Borsook and Fiorella Superbi Gioffredi, eds., *Italian Altarpieces 1250–1550: Function and Design* (Oxford and New York, 1994); Jakob Burckhardt, *The Altarpiece in Renaissance Italy*, ed. and trans. Peter Humfrey (Oxford, 1988); Monica Cämmerer-George, *Die Rahmung der Toskanischen Altarbilder im Trecento* (Strasburg, 1966); Julian Gardner, "Fronts and Backs: Setting and Structure," in *La pittura nel XIV e XV secolo: Il contributo dell'analisi technica alla storia dell'arte*, ed. Henk W. van Os and J.R.J. van Asperen de Boer, *Atti del XXIV Congresso del Comitato Internazionale di Storia dell'arte*, vol. 3 (Bologna, 1979), 297–322; Christa Gardner von Teuffel, "The Buttressed Altarpiece: A Forgotten Aspect of Tuscan Fourteenth-Century Altarpiece Design," *Jahrbuch der Berliner Museen*, vol. 21 (1979), 21–65; Peter Humfrey and Martin Kemp, eds., *The Altarpiece in the Renaissance* (Cambridge, 1990); Jacqueline Marette, *La connaissance des primitifs par l'étude du bois: Du XIIᵉ au XVIᵉ siècle* (Paris, 1961); and van Os 1990.

For detailed photographs of altarpiece components, see Anna Maria Maetzke and Nicola Fruscoloni, eds., *Il polittico di Lorenzo di Niccolò della Chiesa di San Domenico in Cortona: Dopo il restauro* [exh. cat., Palazzo Casali-Salone Mediceo] (Cortona, 1986), 1–23 and unnumbered plates that follow. For technical investigation of the manufacture of Italian altarpieces before 1400 with a comprehensive bibliography, see David Bomford, Jill Dunkerton, Dillian Gordon, and Ashok Roy, *Art in the Making: Italian Painting before 1400* (London, 1989); and Dunkerton et al. 1991. For an overview of the development of the frame in the Renaissance and for a glossary of terms, see Timothy J. Newbery, George Bisacca, and Laurence B. Kanter, *The Italian Renaissance Frames* [exh. cat., Metropolitan Museum of Art] (New York, 1990).

9. Cennini provides insight into the purpose of the cloth: When preparing to paint, he instructs, "set

your ancona up in front of you; and mind you always keep it covered with a sheet, for the sake of the gold and the gessos, so that they may not be injured by dust, and that your jobs may quit your hands very clean." Cennino d'Andrea Cennini, *The Craftsman's Handbook, "Il Libro dell'Arte"* (c. 1390), ed. and trans. Daniel V. Thompson Jr. (New York, 1960), 92.

10. Creighton E. Gilbert, "Peintures et menuisiers au début de la Renaissance en Italie," *Revue de l'Art* 37 (1977), 9–28.

11. Letter of 7 September 1342(?) in G. Pini and Gaetano Milanesi, eds., *La scrittura di artisti italiani*, secs. 14–17, vol. 1 (Rome, 1876), reprinted in Ladis 1982, 255, doc. 16.

12. Gilbert 1977, 10.

13. Bomford et al. 1989, app. 3, 197–198; surviving accounts for the San Pier Maggiore altarpiece, 1370, Florence, are in the Archivio di Stato, San Pier Maggiore, vol. 50, fol. 6ᵛ.

14. Cole 1977, app. 3, doc. 13, 62.

15. Michael Baxandall, *Painting and Experience in Fifteenth-Century Italy*, 2d ed. (Oxford and New York, 1988), 4.

16. Poplar was identified in samples taken from the base panel of panel C (right panel), *pastiglia*-bearing section, molding, inscription board, base, and dowel. Linden (lime) was identified in samples taken from the ogee molding and the capital. The plank on which the altarpiece is supported, a later addition, was identified as spruce (*Picea* sp.). Michael Palmer, conservation scientist, scientific research department, National Gallery of Art, Washington, "Analysis Report: Wood Identification, The Gaddi Altarpiece," 22 November 1990. *Pastiglia* is a raised pattern made from gesso.

17. The use of poplar has been reported in many investigations of panel painting technique. For further information, see Marette 1961, 65–67.

18. Robert Harvey Farmer, *Handbook of Hardwoods*, 2d ed. (London, 1972), 169–170.

19. Gardner von Teuffel 1979, 22; Norman E. Muller, "Reflections on Ugolino di Nerio's Santa Croce Polyptych," *Zeitschrift für Kunstgeschichte* 57 (1994), 54–55.

20. Barbara H. Berrie, senior conservation scientist, scientific research department, National Gallery of Art, Washington, "Analysis Report," 23 August 1989. Casein was identified by amino acid analysis and immunological methods. An additional unknown component was thought to be either clay or calcium carbonate: calcite was identified through x-ray diffraction; lime was expected owing to Cennino Cennini's description of the glue made from cheese and quicklime used by woodworkers (Cennini 1960, 68). Lime casein, which is highly water-resistant, has a working time of 10–45 minutes, depending upon ambient temperature. See Rutherford J. Gettens and George L. Stout, *Painting Materials* (New York, 1942), 8.

21. Cennini 1960, 69.

22. Muller 1994, 54–55.

23. Bomford et al. 1989, 112–113. They also describe the San Pier Maggiore altarpiece by Jacopo di Cione (page 160), a large construction that was assembled after painting by securing the panels onto battens used as an armature. The battens were nailed on from the reverse.

See also plates (unnumbered) in Maetzke and Fruscoloni 1986, in which mortise and tenon pegged links on battens behind the upper register of Lorenzo di Niccolò's *Coronation of the Virgin* are illustrated.

24. Francesco di Marco Datini and Domenico da Cambio of Florence to Francesco di Marco and Manno d'Albizo of Pisa, 9 July 1392, in Enrico Bensa, *Francesco di Marco da Prato: Notizie e documenti sulla mercatura italiana del secolo XIV* (Milan, 1928), 92:

Al nome di Dio Amen. Fattaadi VIIII di luglio 1392.

A di VIII di questo vi mandammo II forzieri di mercio le quale iscrivemme che pello primo buono passaggio le mandaste in Provenza a nostri. Se sia giunta a tempo rispondrete come n'arete eseguito.

Questo di vi mercie grossa e II casse, in che ha una lavola d'altare: preghiamovi la facciate iscaricare pianamente, e cimile quando la fate cancare in nave la mettano di sopra accio non abbio troppo carico addosso e tutto mandate as nostri di Vignone.

Darete al vetturale per sua vettura della balla delle mercie mezzo f. e delle due casse f. due e mezzo, sicche in tutto gli date f. tre coi passaggi e noi avvisate di tutto. Iddio vi guardi.

25. Ladis 1982, 160–161; see also 255–258.

26. Disruption of the face has been exacerbated by past attempts to even out the surface by sanding down uplifted paint; paint along the cracks is heavily abraded.

27. Incised lines are also visible on the San Pier Maggiore altarpiece. These include two parallel horizontal lines that mark the base line from which a compass marked the arches. Bomford et al. 1989, 175.

28. The standard Florentine measurements of the time were: 1 *braccio a panno* = 20 *soldi* = 58.36 cm; 1 *braccio a panno* = 12 *crazie*; 1 *crazia* = 4.86 cm. Bomford et al. 1989, 205.

29. For related construction techniques, see Cämmerer-George 1966, sketches 2–5.

30. Joel Brink, "From Carpentry Analysis to the Discovery of Symmetry in Trecento Paintings," *Art Bulletin* 67, no. 1 (March 1985), 345; Matthäus Roriczer (Roritzer) published the masons' secret in a small booklet, *Puechlen der fialen* (Regensburg, 1486), 78 pages. See Paul Frankl, "The Secret of the Mediaeval Masons," *Art Bulletin* 27, no. 1 (March 1945), 58; and John White, *Duccio: Tuscan Art and the Medieval Workshop* (London, 1979), 191.

31. Mary Bustin, "Lorenzo Monaco, A Closer Look: Style and Technique of a Florentine Painter" (thesis, Courtauld Institute, London, 1986), 7–8.

32. Scalloped tracery was never installed around the arches on the *Madonna Enthroned*. Bole and gesso in

the groove have not been abraded. The act of inserting a wooden tracery would have scratched the surfaces.

33. Galleria dell'Accademia, Florence, inv. no. 1890 n458. The frame has been restored, incorporating replica frame elements to complete the central force of the image. The painting in its pretreatment state is visible in an undated photograph: Alinari P. 2, no. 797.

34. Nails for the attachment of columns and foliate ornaments are listed in the accounts for the San Pier Maggiore altarpiece: "per bollette e chiovi per chiavare i colonelli e folgle, s.V." This entry follows the entry for the varnishing (dated 19 September 1371) of the main panel and the predella. The purchase of nails is contemporaneous with provision of the curtain colors and rings, the block and tackle, and battens for assembling the altarpiece in the church. Thus the attachment was among the last tasks of installation. Bomford et al. 1989, 197–198, citing doc. 1371, Archivio di Stato, Florence, San Pier Maggiore, vol. 50, fols. 8v, 9.

See also Giusi Testa and Raffaele Davanzo, *Dalla Raccolta alla Musealizzazione: Per una relettura del museo dell'opera del Duomo di Orvieto* [exh. cat., Palazzo Papale] (Orvieto, 1984), 55, which illustrates two spiral columns, capitals, and leaf decorations that had been temporarily removed from a domestic altarpiece for conservation treatment. The nails are headless.

35. Gilbert 1977, 14, cites this document, published in Gaetano Milanesi, *Documenti per la storia dell'arte senese* 2 (1854), 241–242.

36. Cennini 1960, 69.

37. The fibers were measured on the x-radiograph. The length has been distorted, however, by the combination of the imaging process and the curvature of the panel, making fibers at the edges of the panels appear longer than those at the center.

38. The planar disruption caused by natural movement of the wood around the knot has been exacerbated by a later attempt to dismantle the altarpiece. Scars on the wood show that a metal bar was inserted between framework and base panel in the upper right of the center panel. It was used as a lever to force the two layers apart. Unfortunately the weak point around the knot splintered and the distortion of the front ensued. It is probable that attempts to dismantle the altarpiece ceased at this juncture.

39. Cennini (1960, 70) described the attachment of the strips of fabric: they were dipped into "best size" and smoothed over the flats with the palm of the hand, then left to dry for two days.

40. The strength of the cloth may be explained by the protection afforded by the overlying ground. Layers of gesso isolated the cloth from the air, thus slowing down oxidation, and, as calcium sulfate, they acted as an alkaline reserve buffering the linen against the internal acidic byproducts of aging.

41. A comprehensive description of the manufacture of gesso and the methods of application is given in Bomford et al. 1989, 17–19. See also Beate Federspiel, "Questions about Medieval Gesso Grounds," in *Historical Painting Techniques, Materials, and Studio Practice* (Leiden, 1995), 58–64.

42. On the far right area of the altarpiece at the foot of panel C the trails are approximately 3 millimeters wide.

43. The color could be seen where the gilding is worn and also throughout the depth of the *pastiglia* in a section on the shoulders of panel B that had been shaved down in the nineteenth century to allow the attachment of extra frame pieces.

44. Cennini 1960, 6, 84, 86.

45. Giovanni Poggi, "La capella del Sacro Cingolo nel Duomo di Prato e gli affreschi di Agnolo Gaddi," *Rivista d'Arte* 14 (1932), 355–376, discusses documents from 1385–1396 from the account books of the Duomo. All expenses for the preparation of the wall, erection of scaffolding, and provision of a trestle were met by the Duomo, Prato.

46. Tin and blue pigments were also bought in Florence, from Donato di Bonifazio. "Donato di Bonifazio da Firenze, speziale . . . per ib 1 e mezo d'azuro olra-marino finiss(im)o per l. 8ib., l.120 e per 2 mila pezi d'oro l.65 s.2, e per 1 peso di stagno s. 18." Poggi 1932, 363, doc. 38, accounts for 3 September 1392–20 November 1393.

47. Maffio, *battiloro*, features regularly as a source of gold for Agnolo Gaddi's work in the Cappella della Sacra Cintola. Poggi 1932, doc. 58, accounts for 21 July 1394–24 April 1395, of the Capella della Sacro Cintola, Duomo, Prato, 367–368.

Jo Kirby, app. 4, in Bomford et al. 1989, 201, 204, noted a discrepancy in the prices of gold bought at this time and speculated that the gold might have been bought from several suppliers over a period of a few months. Gold leaf for the Capella della Sacro Cintola was purchased by the parish for Gaddi's use: on 26 August 1394, 1,100 *pezzi* (gold leaves) were purchased for 33 *libra* (lira), 11 *solidi* (soldi), and later in November, 500 *pezzi* were acquired for 16 *libra*.

48. Cennini 1960, 84–85.

49. Galleria dell'Accademia, Florence, inv. 1890 n8464; Uffizi, Florence, inv. 1890 n887.

50. See Maetzke and Fruscoloni 1986, 5–8, and plates that follow.

51. Galleria dell'Accademia, Florence, inv. 1890 n8468. The altarpiece was formerly in Santa Felicità, Florence.

52. Gardner von Teuffel 1979, 22–25.

53. The photograph appears in Joseph Archer Crowe and Giovanni Battista Cavalcaselle, *A New History of Painting in Italy: From the II to the XVI Century*, ed. Edward Hutton, vol. 1 (London and New York, 1908), 390–398.

54. Illustrated in Sherwood A. Fehm Jr., *Luca di Tommè: A Sienese Fourteenth-Century Painter* (Carbondale and Edwardsville, Ill., 1986), 119, cat. 32.

55. The polyptych is in the Contini Bonacossi Collection, Palazzo Pitti, Florence. The photograph, which is undated, is from the *fototeca* at Villa I Tatti. The predella has since been removed from the polyptych.

56. For a description of predella boxes, see Muller 1994, 56–59.

57. The polyptych is now in the Galleria dell'Accademia, Florence, inv. no. 1890, n8463.

58. This altarpiece is illustrated in Gennaro Tampone, ed., *Legno e Restauro: Recherche e restauri su architetture e manufatti lignei* (Florence, 1989), 147.

59. Maetzke and Fruscoloni 1986 illustrate a complete predella box (unnumbered plates).

60. Capitals, columns, and feet were carved by Silvano Vestri, of C. and S. Martelli, Florence.

61. Gessoing, gilding, and toning of the new ornaments were carried out by Steve Wilcox assisted by Richard Ford, frame conservators, department of exhibitions and loans, National Gallery of Art, Washington.

62. One Sienese example is illustrated in van Os 1982, fig. 17, 129.

APPENDIX

Gaddi's Application of Paint and the Surface Coating on *Madonna Enthroned*

Although the focus of this essay has been primarily on the construction process and frame elements, certain aspects of Gaddi's application of paint, the media he used, and the painting's surface coating are noteworthy.

The Application of Paint

Agnolo Gaddi taught Cennino Cennini for twelve years; therefore, it might be expected that the master's techniques would be described in the pupil's book.[1] While a full comparison between the altarpiece and treatise is not within the scope of this essay,[2] a few anomalies noted during conservation treatment of *Madonna Enthroned* are of interest, particularly the artist's handling of paint coupled with manipulation of undercolors. And while the punchwork and tooling of the gilded surfaces are not covered here, it is also of interest that two punches used by Taddeo Gaddi on his *Madonna and Child* of 1334 (Gemäldegalerie, Berlin) were used fifty years later by his son, Agnolo, on *Madonna Enthroned*.[3]

Agnolo Gaddi had a fast, confident manner of painting that captured subtle depths in the normally opaque egg tempera paint. He paid considerable attention to the color and absorbancy of the surface underlying his final image. When starting to paint, he delineated his figures and geometric shapes by

1. *Madonna Enthroned*, detail, panel B (during treatment), showing angel in lower right photographed in raking light. The surface of the gesso was heavily scarred by the knife when excess gold was removed prior to painting

incising the basic forms into the gesso before painting. After gilding, all the gold that trailed over this line was removed, occasionally scarring the gesso in the process (fig. 1). Superfluous gold leaf does not appear to have been removed as a measure to ensure a good bond between subsequent paint layers and the substrate. Elsewhere adhesion has not proved problematic. The paint adheres well to the gold leaf in the brocades regardless of whether the artist used vermilion bound with glue size, as in the brocade carpet, or lead white bound with egg, as in Saint Catherine's dress.[4] It is more likely that the irregular squares of leaf were removed due to the artist's predilection for transparent paint coupled with a grasp of the influence of underlying substrates and colors on final hues. Any variations in the underlayer would be visible in the final image. Paint laid over the highly reflective surface of gold leaf has an appearance different from that laid over matte white gesso. It appears darker and more transparent and will tend to sit on the surface of the gold, unlike paint applied over gesso, which is absorbed. By scraping the

2. *Madonna Enthroned*, detail, panel B, showing drips of green paint decorating the throne. Glimpses of the red undercolor are visible

3. *Madonna Enthroned*, detail, panel C (after cleaning), showing shoulder area of Saint Bernard. Large brushstrokes are visible. The thickness of the paint varies across the area, creating a lively but intense appearance

4. *Madonna Enthroned*, detail, panel A (after cleaning), showing folds of Saint Benedict's habit. The dark base colors have been overlaid by tight, short strokes of egg tempera in the highlights. The deep shadows have not been worked up

gold away, the artist could paint directly on the white gesso. Elsewhere Gaddi manipulated underlayers to enhance the range of hues in his palette and to retain the depth of color without loss of freshness: the green border of the throne is tempered with an underlayer of vermilion, while the intensity of ultramarine in the Madonna's cloak is cre-

ated by a double underlayer of dark gray followed by azurite.

Methods of paint application vary according to the substrate. Where paint was applied directly to bare gesso, the marks have an immediacy resulting from the use of large brushes and fast, almost notational strokes. The absorbent ground soaked up the paint, thus capturing the nuances of each brushstroke, while avoiding the drips and pools of paint created when a well-loaded brush passed over a previously coated area as it did, for example, in the green paint applied over vermilion on the throne (fig. 2). The fine, hatched strokes commonly ascribed to egg tempera exist only where paint was applied in layers over an undercolor. A smaller brush was necessary for fine modeling over the low-absorbing substrate, for example for the flesh, modeled over a typical green earth undercolor on which the features were drawn in *verdaccio*, or in the clothing of Saint Andrew, which is painted in a necessarily gritty mixture of lead-tin yellow and azurite.

The fast marks created by a well-loaded, large brush represent the start of the painting process. The artist worked from dark to

light in the manner described by Cennini.[5] What Cennini did not mention was that it was not necessary to cover all the gesso. In *Madonna Enthroned*, the paint application is so thin in places that it forms the barest minimum of skin over the surface but left a lively appearance that did not need further modification (fig. 3). Where possible, Gaddi left the natural variations in brushstrokes visible, not seeking to control them with an overlay of the small, fine strokes typical of the medium. Only when working over a layer of egg tempera did he resort to small, short strokes, as, for example, to introduce highlights on the gray habits (fig. 4).

It was important that the design be visible whether the artist painted thinly or in multiple layers. In the sleeves of Saints Benedict and Bernard, for example, underdrawing can be seen under infrared examination. The lines are notational. They resemble the fast strokes of paint laid directly onto the gesso with a pointed brush.[6] Where dense paint would hide the underdrawing, the design was reinforced with incised lines to ensure that the major folds of the drapery, for example, could be followed later in the painting process. Incised guidelines were used to mark folds of clothing in the green cloak of Saint Andrew and to establish geometric shapes of furniture or objects, for example in the throne, book, and Saint Andrew's cross. It is apparent that where the underdrawing could be perceived while the folds were being painted, there was no need to strengthen the drawing.

The blue cloaks of the Madonna and the Virgin Annunciate are elaborate constructions. Both are badly damaged, but the sequence of painting can be determined from cross sections (fig. 5) and from examination of the surface by microscopy. The artist used a double underlayer to enhance the richness of the appearance of natural ultramarine. This thrifty act, cognizant of the expense of ultramarine, was in keeping with the tight control of the amount of gold leaf employed.[7] An initial dark gray layer was covered with a thick coat of azurite, over which the robe was modeled in ultramarine with red lake in the deepest shadows. To prevent the underlayers from being disturbed by the top coats, media were alternated. The dark gray and the ultramarine paint are sensitive to moisture,[8] suggesting that they were bound in size.[9] The

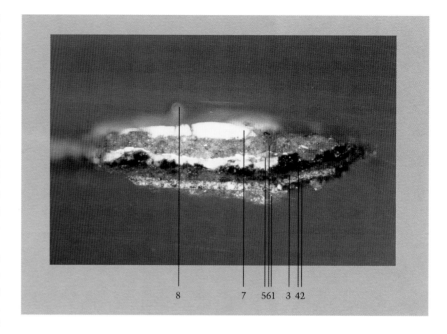

azurite layer was not water soluble and contained the air bubbles characteristic of an emulsion. It is likely, therefore, that the azurite was carried in an egg tempera. Because the azurite layer had been severely abraded, it was possible to see that the color had been applied with a large brush and worked vigorously over the area without regard for form. Brushstrokes traverse the lap of the Madonna in cross hatching to form a flat color field. The resulting rich blue formed the basis for washes of ultramarine over the light areas and thick impasto for the shadows, although little of the ultramarine pigment remains. The shadows now resemble black encrustations due to infiltration of aged surface coatings—principally an oleoresinous varnish—and dirt particles into the granular paint. In cross sections, a few particles of red lake were found intermingled with the ultramarine. The disruption of the paint meant that it could not be established whether these red particles represented an additional wash of red lake on top of the blue or an admixture with ultramarine to enhance the hue.[10] Using the ultramarine over a double base coat meant that its prized purplish blue hue could be attained at the lowest cost. Originally the effect may have been of a deep blue drapery moving from a translucent greenish blue in the highlights to an encrusted purplish color in the shadows.[11]

Little time was allowed for the paint to dry before the artist moved to the next stage

5. Cross section of paint from the Madonna's blue robe (after cleaning), *Madonna Enthroned*, panel B:

1. gesso
2. dark gray of first underlayer
3. azurite underlayer
4. thin incomplete glaze of ultramarine
5. oil mordant
6. gold leaf
7. discolored layer in non-drying oil
8. white drip of foreign matter

6. *Madonna Enthroned*, detail, panel B (after cleaning) showing angel's face. A fine, pale gray layer covers the paint

7. *Madonna Enthroned*, detail, panel A (after cleaning), showing Saint Andrew's robe. A brown speckled layer is visible on top of the green robe

8. Glair exhibiting cracks and bubbles. Egg white was beaten into a foam, then left overnight to settle. The resulting liquid was painted out onto glass and allowed to dry naturally. It cracked on drying. Photographed at 50x

of painting. The paint was still wet when the design of hemlines of the angels in pink drapery in the foreground were decorated with mordant gilding; guidelines were scored into wet paint with a stylus to define the hemlines. The buff-colored oil mordant roughly follows these guidelines.[12]

Surface Coating

The altarpiece has a problematic gray-speckled coating present over the whole of the painted and gilded surface (fig. 6). Over the paint, it resembles a thin veil of soft gray that mutes the colors and reduces the tonal range. A matte layer is visible on the gold as a thin, blanched spotted material, while on Saint Andrew's robe the layer appears brown and speckled (fig. 7). Gray layers similar to this coating on *Madonna Enthroned* have been reported as the aged remains of a glair varnish,[13] although initial aging tests have shown that egg white yellows on aging.[14] Analysis was carried out to determine the identity of the layer on *Madonna Enthroned*.

There were practical problems in sampling the coating. It was so thin that it was not possible, even under magnification, to be certain that the sample material came from the top layer alone and did not contain the egg tempera from the paint below. All the paint analyzed had been found to be either egg tempera or size interlayered with egg; for example, in the brocade carpet, vermilion in animal glue was glazed with red lake bound in egg tempera.[15] The gray coating was imperceptible in cross sections. Samples of the gray layer were analyzed using high-performance liquid chromatography and gas chromatography–mass spectrometry, but results were inconclusive. All the samples analyzed were shown to contain whole egg, a finding suggesting that either the sample had been contaminated by the underlying paint or that the gray layer was not bound by a medium to form a discrete coating on top

of the paint. Rather, indications from the amino acid analysis support a theory that the gray appearance is due to ingrained dirt in the upper surface of the paint.[16]

To see if the upper layer of the painting could be characterized by examination under high magnification, samples from the painting were viewed using the scanning electron microscope and compared to test panels that had been prepared using a sequence and composition similar to the original painting. The glair recipe followed Cennino Cennini's instructions.[17] Egg white was beaten into a foam and left to settle overnight. The resulting liquid was used as the varnish (fig. 8). While the glair on the test panels could be seen as a highly crazed discrete layer, no comparable layer could be perceived on top of the original paint.[18] Thus there was insufficient evidence to provide a precise identification of the gray surface layer. As it was insoluble, it was not removed from the surface of the painting.

NOTES TO APPENDIX

1. Cennino d'Andrea Cennini, *The Craftsman's Handbook*, *"Il Libro dell'Arte"* (c. 1390), ed. and trans. Daniel V. Thompson Jr. (New York, 1960), 2. Cennini stated that he was taught by Agnolo Gaddi for twelve years and established his pedigree by tracing his artistic lineage back through Taddeo Gaddi to Giotto, who was Taddeo's godfather. Further, Cennini wrote that he would "make note" of what he was taught by his master, Agnolo Gaddi, and what he had tried out himself. The date of the treatise is c. 1390.

2. The techniques and materials of trecento painting are extensively covered in David Bomford, Jill Dunkerton, Dillian Gordon, and Ashok Roy, *Art in the Making: Italian Painting before 1400* (London, 1989).

3. Erling S. Skaug, *Punch Marks from Giotto to Fra Anjelico: Attribution, Chronology, and Workshop Relations in Tuscan Panel Painting, with Particular Consideration to Florence, c. 1330–1430*, vols. 1–2 (Oslo, 1994). Skaug records six punch shapes. The punches inherited from Taddeo Gaddo are numbers 234 and 734; see vol. 2, secs. 5.2, 8.2, and 2:91–98. For information on Agnolo Gaddi's punches, see 1:260–264.

4. Susana M. Halpine, "An Investigation of Artists' Materials Using Amino Acid Analysis: Introduction of the One-Hour Extraction Method," *Conservation Research 1995*, National Gallery of Art, Studies in the History of Art, 51, Monograph Series II (Washington, 1995), 41–43.

5. Cennini 1960, 91–92.

6. Catherine Metzger, associate paintings conservator, personal communication, National Gallery of Art, Washington. The gray habit of Saint Bernard was examined with a Kodak 310-21X thermal imager configured to operate in the 1.5 to 2.0 micron spectral region.

7. The ultramarine used in the fresco cycle by Agnolo Gaddi in the Capella della Sacro Cintola, Duomo, Prato, was bought from Donato di Bonifazio, *speziale*, of Florence between 1392 and 1394. On 27 October 1394 different qualities of ultramarine were purchased simultaneously. Later, on 20 April 1395, one purchase of *azzurro fino* matched the price of ultramarine bought the previous year, while *azzurro* was about a third of the price. Bomford et al. 1989, app. 4 (Poggi 1932, docs. 37 and 58, 363, 367, 368), 202.

8. The blue cloaks of both the Madonna and the Virgin Annunciate are the most damaged areas of the painting. The upper layer of ultramarine is moisture sensitive and has been severely depleted, probably as a result of a selective washing. The entire painting is covered with minute drips of white oil paint, which are particularly apparent in the dark areas. It is possible that the blue was cleaned in an attempt to remove these blemishes. Certainly, copious amounts of moisture have displaced the ultramarine, which was found to have dribbled across the brocade carpet, displacing the vermilion (which is also bound in size) in its path. During a later restoration, the blue trails were partially removed, leaving ultramarine particles in the hollows of the punchmarks. A few of the white drips were removed mechanically, and underneath them ultramarine glazes were found to be intact. It is notable that other water-soluble areas of vermilion are undisturbed. If the whole painting had been washed so liberally, more damage would have occurred.

To reintegrate the cloak with the remainder of the painting, it was determined by curatorial and conservation staff members that the area would be repainted on top of the damaged areas of the original. See painting conservation department treatment reports 1988–1994. Complete photographic records were kept.

Analysis of the white drips was undertaken and reported by Suzanne Quillen Lomax, organic chemist, scientific research department, see "Analysis Report," 22 August 1990.

9. Cennini (1960, 68) recommended a size made from the scrapings of goat or sheep parchment for tempering (binding) dark blues.

10. In Cennini's (1960, 55) description of painting a "Mantle for Our Lady" in secco, he wrote, "If you wish to shade the folds, take a little fine lac, and a little black, tempered with yolk of egg; and shade it as delicately and neatly as you can, first with a little wash then with the point; and make as few folds as possible because ultramarine wants little association with any other mixture."

11. For further details on the modeling of blue robes, see Norman E. Muller, "Three Methods of Modeling the Virgin's Mantle in Early Italian Painting," *Journal of the American Institute for Conservation* 17, no. 2 (1978), 10–18.

12. Fatty acid analysis using gas liquid chromatography identified a drying oil. Lomax, "Analysis Report," 22 August 1990.

13. A painting by Jacopo del Casentino, *Madonna and Child*, 1300, in Saint Stefano, Pozzolatico (a small church near Impruneta), has a gray layer. See Alfio del Serra, "A Conversation on Painting Techniques," *Burlington Magazine* 127 (1985), 4.

14. In tests carried out at the Hamilton Kerr Institute, egg white varnish samples had become slightly yellow after eighteen months of aging. Renate Woudhuysen-Keller and Paul Woudhuysen-Keller, *The History of Eggwhite Varnishes*, ed. Ann Massing, *Hamilton Kerr Institute Bulletin* 2 (1994), 95.

15. Amino acid analysis by Susana M. Halpine, scientific research department, National Gallery of Art, Washington, "Report on Gaddi, *Madonna Enthroned with Saints and Angels*," 23 January 1990.

16. Two samples were analyzed from Saint Andrew's robe. Egg material (yolk/white/whole) was found in both. "There is a higher than usual amount of the amino acid glycine, which may indicate contamination from dust or finger prints." Susana M. Halpine, biochemist, "Amino Acid Analysis Report," 5 March 1991. A fatty acid analysis using gas chromatography–mass spectrometry identified the presence of a non-drying oil. Lomax 1990.

17. Cennini 1960, 99–100.

18. Walter Brown, National Museum of Natural History, Smithsonian Institution, Washington, provided scanning electron microscopy imaging of samples of azurite and lead-tin yellow egg tempera painted-out over a gesso ground and then varnished with glair. The test panels were allowed to dry naturally and then were sampled in the same manner as areas of the painting.

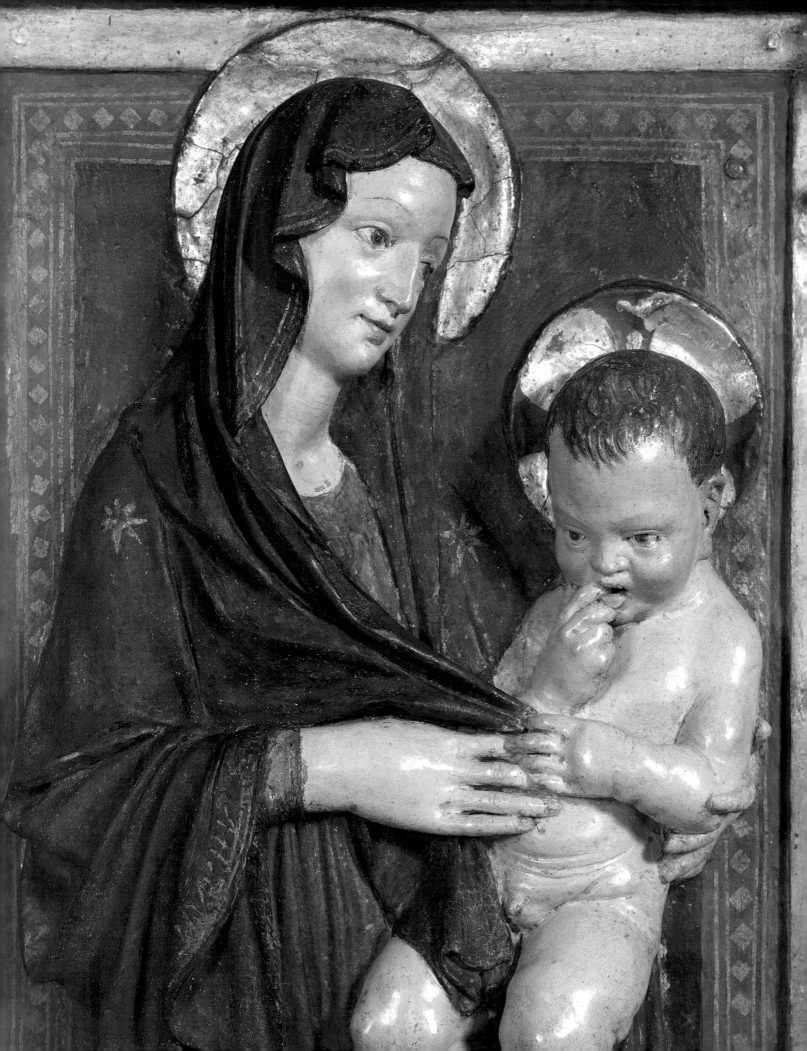

PENELOPE EDMONDS

A Technical Examination, Investigation, and Treatment of a Fifteenth-Century Sienese Polychrome Terra-Cotta Relief

Despite the many Madonna and Child devotional reliefs surviving from fifteenth-century Italy, few are modeled directly in terra cotta and still fewer possess remnants of their original polychromy. The National Gallery of Art, Washington, has in its collection a polychrome and gilt terra-cotta relief *Madonna and Child* that has been attributed to the circle of Giovanni di Turino. It is mounted in a gilded wooden tabernacle frame that displays the painted dove of the Holy Ghost in the roundel of the pediment. Thermoluminescence tests corroborate in general terms the date assigned to the relief based on art-historical and stylistic evidence.[1]

The relief was acquired in its current frame in 1952 by the Samuel H. Kress Foundation and was restored by Joseph Ternbach in 1956 (fig. 1).[2] It had never been examined out of its frame, however, and apart from thermoluminescence conducted in 1971, it had received little curatorial or conservation investigation. In 1991 the *Madonna and Child* was taken off display, providing the opportunity for a full technical and scientific examination of the materials and method of manufacture. Comparison of the *Madonna and Child* to other Italian devotional reliefs of the same period permitted a better understanding of the object's art-historical context. Following investigation into that context, technical examination of its method of manufacture, and analysis of the paint layers, an ethical approach was devised for its treatment.

Emergence of Fifteenth-Century Madonna and Child Devotional Reliefs

The production of the half-length Madonna and Child relief as a popular devotional object is known to have been a manifestation of the prevailing climate of Mariolatry, that is, worship of the Virgin, in Italy during the fifteenth century. Ulrich Middeldorf commented, "What is so puzzling is the sudden outbreak of this fashion, its almost total disappearance after the lapse of a few generations, and its local circumscription." He added, "A phenomenon that should interest the economic historian is the prodigious production of Madonna reliefs of a handy size during the fifteenth century in Florence. The appearance of these reliefs is virtually limited to Florence; in Siena there were some; elsewhere none except occasional pieces."[3]

Such devotional representations of the Virgin made of materials such as stucco, gesso, carta pesta, or terra cotta were often prescribed for use by women and children.[4] Compared to materials such as marble or bronze, terra cotta allowed for fast, inexpensive, and relatively easy production of Madonna and Child compositions. These relief compositions were created either by direct modeling or by use of simple molding techniques.[5]

Technical examination of the National Gallery *Madonna and Child* relief indicates that various techniques were used in its fabrication, probably the separate molding of

67

some parts, such as faces and hands, with modeling to create the mantle, robe, and additional decorative incised details. The relief was then fired, painted, and gilded.

Despite the many terra-cotta Madonna and Child reliefs extant today in private collections, churches, and museums, there are few original sources describing how they were created.

Stylistic Influences

There are many questions about the stylistic origin of the National Gallery *Madonna and Child*. Earliest documentation of the relief's provenance shows that it was displayed in the Brogi Pesciolini Palace in San Gimignano about 1921.[6] Before the object was acquired by the National Gallery of Art it had been attributed to Jacopo della Quercia (c. 1374/1375–1438), later to Vecchietta (Lorenzo di Pietro, 1412–1480), and then to Giovanni di Turino (1385–c. 1455), a Sienese goldsmith and bronze caster. In 1987 the attribution was changed to circle of Giovanni di Turino, c. 1430. Stylistic comparisons of the National Gallery *Madonna and Child* with other works by Giovanni di Turino reveal some similarities but also present striking differences.[7]

The Madonna is composed with her face and body slightly turned to her left, away from the viewer, and has a melancholic and unfocused stare. The sympathetic address in the wistfully inclined head has been described by Millard Meiss as characteristic of thirteenth-century Sienese Madonnas.[8]

The characteristics of the Sienese Madonna type are exemplified by the stiffness of the figure and the strong rhythmic curvilinear folds of her drapery. Similarly, Sienese prototypes may be reflected in the headdress of the Virgin, although by the fifteenth century this style was already widely copied by Florentine sculptors and painters.[9] She holds the Christ Child in her left hand while her right hand rests horizontally at his waist; this position creates a strong, almost severe, horizontal line by the meeting of her right forearm with his left arm.

An important stylistic point of departure for Sienese painters and sculptors from 1350 to 1425 was the *Maestà* altarpiece, 1308–1311, by Sienese artist Duccio di Buoninsegna (c. 1260–c. 1319).[10] The Madonna depicted in the central panel of the *Maestà* (fig. 2) and

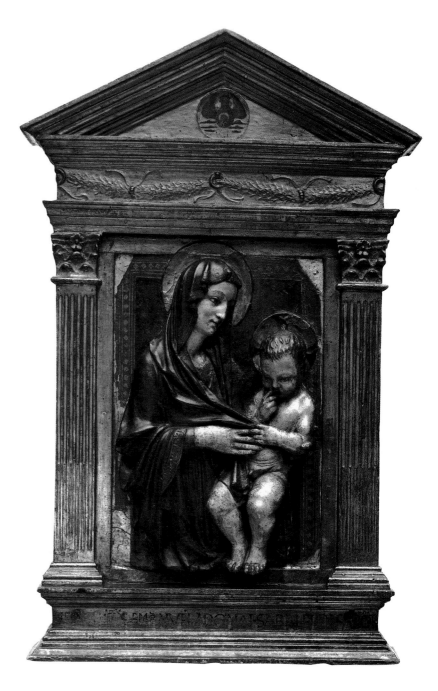

the National Gallery relief are similar in pose and proportion. The inclined head of the Madonna, the frontality of the Child, and the spatial relationship between the two figures are common features of this composition and of Sienese paintings of the trecento. The same strong horizontal position of the Madonna's proper right hand in the National Gallery relief appears in the proper right forearm of the Madonna in Duccio's *Maestà*, although the Child does not reach to meet her and is entirely different in style.

Another painted panel, the National Gallery

1. Circle of Giovanni di Turino, *Madonna and Child*, Sienese, c. 1430, polychrome terra-cotta relief, in frame (after conservation treatment in 1956 and before treatment by the author in 1993)

Madonna and Child with Donor (fig. 3) by the Sienese painter Lippo Memmi (active 1317–1347), exhibits the same stiffness of drapery and inclined head as the *Madonna and Child* relief. Other visual similarities, such as the meeting of the Madonna's hand with the

Christ Child's hand and his tugging of the drapery can also be observed. What differs, though, is the style in which the Child is rendered compared to the Sienese-type Madonna. The Child in the *Madonna and Child* relief is not only large and robust but also nude; his eyes are downcast, his right index finger is in his mouth, and his left hand touches the Madonna's fingers and tugs the fabric of her mantle. These naturalistic aspects, such as sucking a finger, pulling the Madonna's drapery, and fat, rounded limbs are more comparable to many reliefs from Donatello's (c. 1385–1466) circle.[11] Therefore, although in some respects the Child embodies some characteristics that are more mid-fifteenth-century Florentine than Sienese, "the illogical placement of the child, without clear support from his mother's arm or body, does

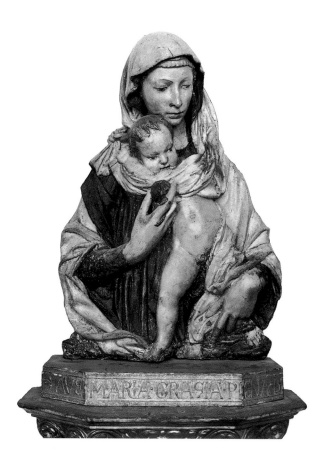

Technical Examination

A succession of early restorations of the National Gallery *Madonna and Child* obscured both the remaining original and first overpaint layers of polychrome as well as the finer incised details in the terra cotta. Nevertheless, visual examination and x-radiography confirmed that the terra-cotta substrate was in good condition and that the figures had been created in high relief with attention to detail. In addition, analytical identification indicated that the remaining original polychromy had been painted using traditional Italian tempera techniques.

4. Donatello, *Madonna and Child*, mid-fifteenth century, polychrome terracotta relief
Museo Bardini, Florence

5. *Putto seduto*, Tuscan, mid-fifteenth century, stucco
Museo Bardini, Florence

not suit Florentine tastes for rational, clearly understood structure."[12]

The Christ Child in the *Madonna and Child* attributed to Donatello (fig. 4) shows similarities to the National Gallery Christ Child in the forward movement of the hair, large forehead, flattened nose, and lowered brow, but the animation of the Madonna and the naturalism of the folds in the drapery are lacking in the National Gallery relief.[13]

The National Gallery Child also compares to a putto (fig. 5) described as Tuscan, fifteenth century, of painted stucco.[14] This Child is equally robust but is unattached to any composition. While the two have similarities such as the proper right index finger in the mouth, the similar position of the first two fingers of the proper left hand, the robust anatomy, rounded, lined stomach, the attitude of the head, and the analogous position of the legs, there is a difference in the circular direction of the hair of the putto compared to the forward-moving hair of the Child in the National Gallery relief. Thus, the National Gallery relief exhibits a transitional style with both Sienese and Florentine characteristics.

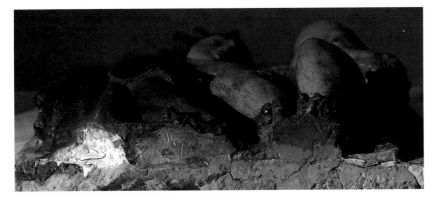

6. Profile of *Madonna and Child* (during treatment): (a) top view, and (b) bottom view

7. X-radiograph of *Madonna and Child*. The dark region in the Child's head indicates a hollow area

Construction and Modeling Process

The techniques used to construct the terra-cotta *Madonna and Child* can be compared with those for *Madonna and Child*, c. 1460 (not illustrated), attributed to the school of Verrocchio (1435–1488) and discussed by

Stephen Rees-Jones,[15] and also compared to the *Madonna and Child* attributed to Donatello (see fig. 4) and described by Anna-Maria Giusti and Angelo Venticonti.[16]

The National Gallery relief is rectangular and measures 66.7 centimeters in length and 45.7 centimeters in breadth. The background is a maximum of 3.8 centimeters in thickness. At its point of highest relief, from the top of the Child's head to the reverse, the relief measures 14 centimeters (fig. 6).

The edges, varying in thickness between 3 and 3.8 centimeters, are flat and squared, suggesting that a support may have been constructed, such as a flat, boxlike container or modeling frame for its preparation. Wooden boards were often used as supports for the construction and modeling of terra-cotta reliefs.[17] In some instances the wooden, boxlike support was lined with sheets of paper to separate it from the clay for ease of removal; however, no evidence of this practice is present on the reverse of the National Gallery *Madonna and Child*. At the edges are several stepped uneven marks made by wire used to cut the wet or leather-hard clay[18] to separate the terra cotta from the frame. The marks are present at the lower side of the proper left edge, at the midpoint of the top edge, and at the proper right edge. Three holes are also present around the edges, one at the top and two on the proper left edge. They were created before the clay was fired.

X-radiography revealed more details regarding the method of the relief's construction, illuminating the combination of molding and modeling techniques used by the artist and highlighting later changes in the remounting of the relief. The base layer of the relief was gradually built up with handfuls of clay smoothed out over the wooden, boxlike support. Individual pieces of clay approximately 5 centimeters in width, used to build up the relief, are distinguishable in x-radiographs. The general shapes of the two figures were then built up, concurrent with preliminary shaping of the heads. An ovular void, approximately 8.8 by 5 by 4.5 centimeters maximum, visible in the x-radiograph (fig. 7), indicates that the head of the Child is hollow.[19]

Rees-Jones observed that during the modeling of the *Madonna and Child* attributed to the school of Verrocchio, the clay had been scooped from the front down to the base in

the head and body areas to make them hollow during the actual modeling process. However, the reverse of the National Gallery relief (fig. 8) reveals hollowed-out areas that were scraped from behind in a vertical direction after the relief's construction. The clay was scraped out with tools at the leather-hard stage to reduce the weight and thickness of the piece and to minimize the possibility of cracking during shrinkage of the clay body on drying and firing.

The faces of the Madonna and Child appear to have been produced separately in molds, like masks, and then attached to the relief. The molded face of the Child was attached over the premodeled and hollowed head. Lines of closure are present, visible as a diagonal line that runs down the side of the Child's proper right cheek close to the right ear. The right ear is only partly formed due to its proximity to the background. The crown of the Child's head is slightly flattened and irregular and may have been the point of closure.

Five indentations are present where the top of the Child's head, just behind the crown, meets the halo. These small, regularly placed apertures (the remains of which can be seen in x-radiographs), which open to the void inside the head, were commonly added to allow for the escape of gases during firing.

The three-dimensionality of the Child's arms and legs and the Madonna's proper right hand suggests that they may have been fabricated in piece molds. The Child's legs are fully formed and stand in high relief, although their underside appears rough and unfinished. X-radiography also revealed join lines at the Child's proper right wrist and at the Madonna's proper right forearm, indicating that the hands may have been separately molded and then joined to the relief. Finger impressions of the artist can be seen in the terra cotta: a broad shallow groove is present under the Madonna's proper right wrist, and another is visible on an exposed area of terra cotta on the Madonna's proper right index finger.

It is evident that the drapery was added as a separate component to the form of the Madonna. The clay appears to have been rolled out in flat sheets and then arranged in folds and joined over her form.

Many impressions made by modeling tools used to delineate decorative motifs in

8. *Madonna and Child,* reverse (during treatment)

the garments are present, seen as impressed lines between the fingers and the Child's hair and toes. They are also most apparent at the band of the Madonna's sleeve, along the top edge of the mantle surrounding her face, and at the edge of the mantle resting on the Child's thigh, where a series of Kufic characters (derived from Islamic formal decorative inscriptions and later adapted by European artisans)[20] have been incised. It is likely that such incised designs were created at the leather-hard stage, when the clay was firm and partially air-dried but still impressionable. As modeling in the Madonna's eyes is very subtle, it is likely that a tool was used to delineate the iris and eyelid. The tool used for such incised decorations may have been a wooden modeling stick with a rounded wedged end.[21]

The Structural Condition of the Remounted *Madonna and Child*

The relief was roughly removed from its original mount at some time early in its history, resulting in irregular breakage and loss of all four corners, with the greatest loss of terra cotta occurring at the lower proper right corner. The upper portion of the Madonna's

halo was broken tangentially across the top where it had extended above the edge of the relief. The high position of the Madonna's head in the composition caused the upper section of the halo to exceed the top edge of the relief. It is probable that an original upper section of the halo, supported by the adjacent surface of the original mount, was damaged, and it was replaced when the relief was moved into its current frame. The halos we see now are a composite of at least two restorations. They were built up in gesso and then gilded after the relief was placed into its present frame. There is no evidence to suggest that the relief has been reduced in size

to account for the missing top portion of halo. In fact, the original fire-skin[22] is still present on all four edges on the terra cotta, excluding the damaged corners.

Condition of the Tabernacle Frame

The current tabernacle frame (fig. 9) with an inscription along the base[23] has been described as "Florentine in vocabulary and later in style than the relief."[24] Burn marks at evenly spaced intervals along the base of the frame and soot and wax residues on the toes of the Christ Child indicate that candles were probably placed at the base of the piece, evidence that the relief was used for devotional purposes in its present frame.

It is believed that the frame was constructed to hold the relief since scribe marks on the inside of the backing board correspond to the dimensions of the terra cotta and the liner.[25] The relief was installed into the front of the frame, and, to cradle the terra cotta, recesses were cut into the inner side of the backing panels in the frame. Wooden shims were placed into the gaps between the terra cotta and the liner and adhered with animal glue and gesso to secure the relief in the frame. A variety of materials were used to compensate for the missing corners. These materials included roughly triangular wedges of wood secured with an animal glue and handmade nails driven in from the front; a carved piece of cork was also found in the lower proper right corner (used as a fill material because of its light weight and suitability for carving). The corners were then filled with gesso to match the level of the terra-cotta surface. The upper arc of the Madonna's halo, presumed to have been lost during the removal from the original mount, and damaged areas of the proper right corner including the cork fill, were recreated with a "compo-like" material that contained a large amount of natural resin.[26]

Over the years numerous cracks had developed in the fill materials around the relief due to the tendency of the relief to shift in the frame. Movement of the relief had also caused a large diagonal crack to develop at the proper right lower replacement corner. A large horizontal crack was present at the Madonna's halo between the replaced top section and the edge of the relief.

9. X-radiograph of tabernacle frame, *Madonna and Child*

Condition of the Polychromy

Overall the painted surface suffered from extensive haphazard restoration. Four major campaigns of intervention, or overpaintings, were detected. These campaigns, including partial cleaning and instances of localized repainting and regilding, competed with one another and resulted in a complex surface in poor condition. Trace amounts of original polychromy from the flesh tones, robe, and mantle were obscured by the successive restoration treatments.

The flesh tones of both figures had an uneven, damaged surface. Grime and an intractable discolored varnish over the flesh tones created a dark appearance, reduced the sculptural depth of the object, and obscured delicate areas of modeling in the terra cotta.

During the third restoration the Madonna's mantle had been disfigured with a thick, dark brown overpaint that not only obscured the remaining evidence of the traditional blue color of the mantle but also obscured the sculptural form by completely covering incised decorations on the band on the Madonna's sleeve and edges of the mantle. This water-soluble brown overpaint tended to flatten the tonality of the modeled contours in the drapery. In some areas, such as the Madonna's proper right shoulder, the thick brown overpaint was applied directly onto exposed surfaces of terra cotta, acting as both a fill material and as a paint. This extensive overpaint also disguised remnants of gilding from earlier restorations, such as stars on both of the Madonna's shoulders, a double line of gilding that borders the edge of the mantle, and embellishments on the sleeve.

During the third restoration the upper edges of the folds on the Madonna's red robe had also been poorly overpainted with a thick layer of water-soluble red overpaint, or restorer's mix. This layer obscured a superior first overpaint layer of gesso painted with vermilion and glazed with red lake. Flaking and cupping paint were present throughout the red robe and the background. Almost all polychromy was lost on the cuff at the Madonna's wrist. Decorative incised lines at the band at the neck of the robe had been obscured by red overpaint.

In 1956, during the fourth campaign, the restorer used a strong alkaline solution in an attempt to clean the flesh tones. This solu-tion caused the paint in the areas of highest relief on the figures—such as the Madonna's face and the Child's chest and proper left forearm—to be severely overcleaned. Any glazes that may have been present on the surface were probably damaged by the caustic solution, resulting in a raw, blanched appearance in the paint. Conversely, it appears that many areas of dark, discolored varnish were deliberately left on the underside of the contours of the figures to imitate shadow; such areas include the underside of the Child's legs, proper left arm and jaw, and between the toes and fingers. In actuality, however, these false shadows served instead to belie and confuse the real sculptural form of the figures. In heavily cleaned areas the paint was brittle and had a propensity to flake, leaving small areas of exposed terra cotta. There were large losses of paint and gesso on the Madonna's proper left fingers and proper right knuckles and on the Child's toes. Discolored varnish in the eyes of both figures not only obscured the delicacy of the modeling in these areas but left them with disconcerting, vacant stares.

There was little definition between the mantle and the background behind the figures. Evidently as the compounded results of several restorations, the background consisted of layers of red and green paint under the brown overpaint, remnants of stars, a layer of discolored oil-resin varnish, and shellac. The entire paint surface was uneven, with cracking and some cleavage of the paint.

The gilded corners, which were not original, tended to distract the viewer from the main composition. The gilded border pattern in the background was degraded and fragile.

Examination and Analysis of Paint Layers

A full examination and analysis of the paint layers was undertaken to distinguish the campaigns of restoration, determine the presence of any original paint, and design a suitable treatment for the polychromy. Paint cross sections were made to reveal the succession of interventions (described in the appendix).[27]

Determining Prior Interventions

Determining the succession of layers in the polychromy was a formidable task due to the history of partial cleaning and local overpaints and regilding. Each intervention is described

based on information obtained from cross sections and microscopic examination of the object.

Examination of paint cross sections showed some remnants of original polychromy to be present, painted with tempera techniques traditionally used in the fifteenth century. The first overpaint layers were also painted using tempera techniques, although they were not applied with the care or superior technique found in the original remnants. The first overpaint, which coincided with the placement of the relief in its present frame, had flesh tones in good condition, and a substantial amount of this first overpaint was also detected in the robe and mantle.

In general, the quality of the materials and techniques decreased with each subsequent intervention. For example, the original layers were painted on a finely prepared gesso using a range of pigments commonly found in tempera painting during the first half of the fifteenth century. Covering remnants of the original layers were the first overpaint layers consisting of a gesso that appears to be overly rich in medium (that is, containing much animal glue) and painted with admixtures of pigments that resulted in darker colors, instead of the pure brilliant colors found in samples of the original paint. The gold leaf in original layers was replaced by a thick, tin-gold laminate that was haphazardly applied.

Original Layers

The original paint layers were distinguished from overpaints based on gesso and pigment types, particle sizes, medium used, and location directly on the terra-cotta substrate and by comparison with contemporaneous practices as documented in the literature. The original paint layers of the flesh tones, robe, and mantle are characterized by techniques commonly found in Italian tempera paintings executed in the fifteenth century. A range of pigments such as ochers, vermilion, green earth, azurite, lead white, and carbon black was found painted on a very fine, white calcium sulfate (gesso) ground.

A technique for underpainting often found in Italian tempera painting and described by Cennino Cennini in his fourteenth-century treatise Il Libro dell'Arte[28] as verdaccio was used for shadows in the flesh tones (see cross section A, two views). Green earth pigment created this cool undertone for the warm flesh tones. Visual examination also revealed the remnants of original flesh tone layers with traces of verdaccio at the edges of the faces of the figures, beneath the Madonna's proper right hand, and between the Child's toes.

The robe (see cross section B) was painted with a red lake, which was possibly the original glaze (the intermediate paint layer could not be detected in the sample) over a fine white gesso ground. Although traditionally the glaze would be painted over an opaque layer such as vermilion, this layer is not present since the sample was taken from an intersection of two areas of color.

A sample of original paint from the mantle (see cross section F) was azurite, which appeared to be very compact with few visible impurities. The inner side of the Madonna's mantle was originally painted with synthetic malachite over the fine white gesso (see cross sections B and J). The pigment was identified using EDX as malachite (see cross section B), but the globular particle form suggests artificial preparation by precipitation, that is, a synthetic malachite. At the National Gallery, London, in several fifteenth-century Italian panel paintings a green globular pigment was detected with an x-ray diffraction (XRD) pattern identical to that of natural malachite but morphologically consistent with the precipitated origin.[29]

Traditionally, the areas such as the Kufic border pattern in the robe at the Madonna's neck, and the border pattern along the mantle over her head and at her sleeve, were likely to have been gilded, following the incised lines in the terra cotta. However, no gilded layers remain in these areas as evidence of such original embellishments.

The appearance of the original background is not known since no physical evidence of it remains. It may have been entirely gilded, in keeping with the Sienese origins of the relief. The composition of the Child's original halo is seen in cross section D. Remnants of an original halo, identical in construction to that shown in cross section D, can also be seen beneath the halo that is currently visible on the Madonna.

Dotted lines in the diagram in figure 10 show the locations of the remnants of extant original paint. Figure 11a is a diagram of an approximation of the original appearance of the Madonna and Child.

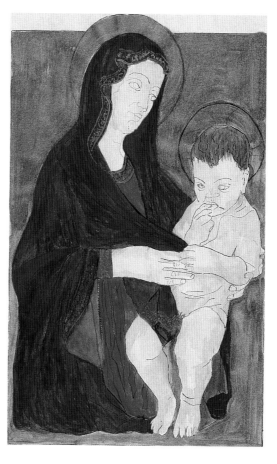

10. Schematic drawing of *Madonna and Child*, showing location of the remnants of original paint

11. Schematic rendering of successive overpaints of *Madonna and Child*: (a) approximation of the original appearance, (b) approximation of the appearance of the relief after the first overpaint, and (c) approximation after the second overpaint

The loss of the original background, most of the flesh tones, and almost all of the mantle and robe can be attributed to natural degradation over time and harsh cleaning methods. In the past, it was not unusual for flaking or damaged polychromy to be routinely scraped off and "refreshed."[30]

First Overpaint Layers

As mentioned, the first overpaint of the polychromy was concurrent with the placement of the relief in the frame in which it is presently mounted. This intervention involved major structural work, since the terra cotta, its four corners missing after a clumsy (or violent) removal from its original mount, was secured in the frame with wooden shims, large amounts of animal glue, nails, and gesso. The gilding on the frame appears to correspond with the polychrome and gilding of the first overpaint on the terra cotta, confirming that the current frame was designed to hold the relief concurrent with the first overpaint. With a few exceptions, almost all of the original paint on the Madonna's mantle, robe, and flesh tones of the figures was lost or scraped off by the time the reframing occurred. Therefore, in the first overpaint the mantle, robe, and flesh tones were completely repainted. Replacement corners were added, the background was gilded, and halos of the Madonna and Child were regilded.

Areas that reveal the first overpaint layers were characterized by a glue layer, applied to exposed areas of terra cotta and over the original halos, probably as an isolating layer for the repainting. A medium-rich gesso composed of coarse particles was applied over the glue layer. Cross section C shows the area sampled from the Madonna's red robe; E shows the area sampled from the Child's halo; and J shows the area sampled from the Madonna's mantle.

A thick, nonpigmented isolating layer composed of egg white located directly over the medium-rich gesso was the common feature found in samples of the first overpaint from the Madonna's robe (see cross section

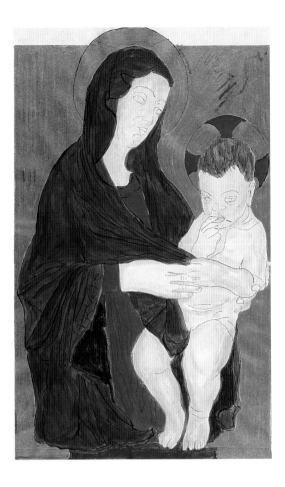 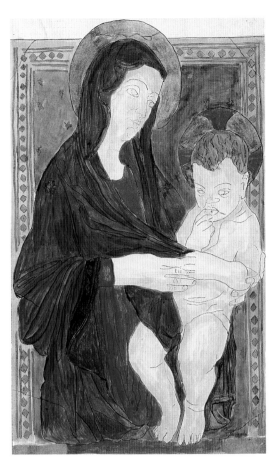

B) and her blue mantle (see cross section G). The paint layers over the egg white isolating layer, which are vermilion and azurite, respectively, were bound in a medium identified as egg yolk.[31]

The use of egg white as an isolating layer or sealant for the gesso on the terra-cotta relief could have derived from Renaissance Italian techniques used on wood, stone, and painted caskets. Sealing gesso or plaster grounds before painting in oil was a common technique mentioned by Cennini.[32] Giorgio Vasari also described how an artist should spread four or five coats of the smoothest size over the gesso with a sponge.[33] However, Cennini also mentioned the use of egg white as an isolating varnish over a gesso ground for "carved wood and stone," possibly to seal the absorbent gesso ground before painting. Further, in his discussion on the application of tin leaf decorations and gesso to caskets he recommended that once they are stuck on with size, they should be varnished: "when it [the varnish] is dry take a beaten egg white and rub over the varnished part with a sponge moistened in this white; and then, with the other colors, hatch and embellish the ground."[34]

Since the presence of egg white is rarely analyzed, it is not possible to say whether the use of an egg white isolating layer on the first overpaint polychrome for this relief is typical of fifteenth-century techniques. It is of equal interest that the vermilion and azurite paint layers above the egg white layers (see cross sections B and G) are bound in egg yolk.

As in the original polychrome layers, the pigments of the first intervention were typical of fifteenth-century techniques. Traditional technique was employed, for example, in a red lake glaze over a body of vermilion (see cross section B and C), used to create brilliance and depth in the painted surface of the Madonna's red robe. However, the vermilion and glaze were applied directly over the band of the Madonna's neck with little regard for the incised designs in the terra cotta, thus obscuring their detail. The flesh tones of the first overpaint did not have the green underlayer found in the original flesh tones.

The mantle lining was painted with ocher suspended in a dark brown resinous matrix, followed by green earth pigment, giving an olive green appearance.

The background, its original layers lost or scraped off, was gilded during the first overpaint campaign. Cross section I shows the gilding on the wooden replacement at the proper right corner of the relief from the first overpaint. Visual examination has shown that this gilding extended throughout the background. The Madonna and Child's original halos were also regilded, and their construction can be seen in cross section E.

Figure 11b shows an approximation of the appearance of the relief after the first overpaint.

Second Overpaint Layers

During the second overpaint the flesh tones and the lining of the Madonna's mantle from the first overpaint were coated with a thick oil-resin varnish that subsequently became severely discolored.[35]

The mantle was repainted with a double layer of azurite, and on it the stars, composed of a laminate of tin and gold, were applied with a mordant (see cross section H). The vermilion robe from the first overpaint was not repainted.

Again, the background was either degraded or had been scraped off by the time of the second overpaint application. Cross section K shows the background from the second overpaint consisting of first and second overpaint gesso followed by a layer of vermilion, green earth pigment, and another layer of green earth mixed with verdigris. The green background was decorated with a geometrical border pattern, currently visible, that was composed of the same tin and gold laminate present in the stars. Additional stars were placed throughout the background, and the incised band on the Madonna's sleeve and the edges of her mantle were also decorated with the tin and gold laminate. Figure 11c shows a diagram of an approximation of the appearance of the relief after the second overpaint.

Third Overpaint Layers

By the time of the third overpaint it is probable that the oil-resin varnish was sufficiently discolored to give the flesh tones a mislead-

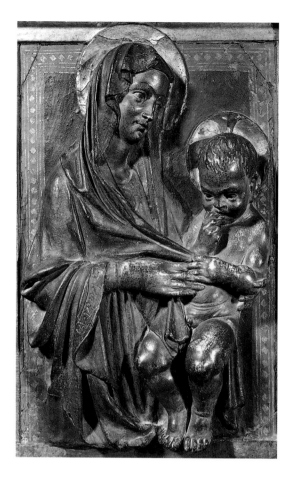

12. *Madonna and Child*, photographed in 1956, when it was acquired by the Kress Foundation, National Gallery of Art

ing dark, monochrome appearance. A thick brown "restorer's mix," composed of ochers (red and yellow iron oxides) and carbon black, was applied to the Madonna's mantle (see cross section H) and the background to match the monochromatic appearance of the flesh tones. This brown overpaint obscured exposed areas of terra cotta, earlier layers of paint, and remnants of stars in the background and on the mantle. The overpaint was so thick on the mantle that it filled delicate incised marks that delineate the band on the Madonna's sleeve and the girdle that hangs from the proper right side of her waist. The restorer's mix, applied carelessly over the Madonna's red robe (see cross section C), was composed of red and yellow ocher and carbon black. When the relief was acquired by the Kress Foundation, the restorer's mix and discolored varnish still covered the surface (fig. 12).

Fourth Overpaint Layers

The *Madonna and Child* received conservation treatment in 1956[36] following the Kress Foundation acquisition.

13. *Madonna and Child* (during treatment, 1993)

To reduce the dark appearance of the relief, the restorer attempted to remove the nearly intractable oil-resin varnish with a strong alkaline solution, resulting in some abrasion of the upper layer of the flesh tones and blanching of the paint. The cleaning was unsuccessful, and great amounts of uneven varnish residue on the surface left the flesh tones with a very dirty, mottled appearance.

After the partial and unsuccessful cleaning, losses in the mantle were disguised by applying Prussian blue pigment mixed with a black pigment (see cross section G). A large area of the upper surface of the Child's halo was removed to reveal part of the original gilding of the halo; however, the complete removal was never finished.

The replacement corners were cleaned to reveal the gilding from the first overpaint on their surfaces. It is possible that the restorer revealed the gilding in an attempt to create a visual differentiation between the original terra-cotta relief and the replacement corners. A layer of shellac, possibly from the 1956 restoration, was found on the background and over the entire mantle. Figure 1 shows the condition of the relief after treatment in 1956.

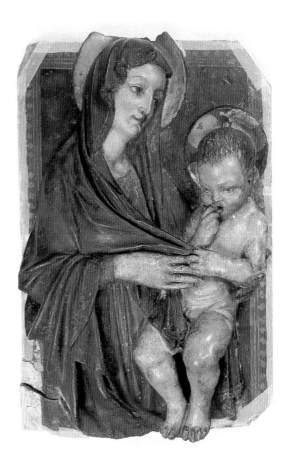

Conservation Treatment, 1993–1994

Following art-historical research and analytical investigation, conservation treatment on the *Madonna and Child* was begun in September 1993 and was completed in May 1994. The aim of the treatment was to return the polychrome relief to a legible and harmonious state. Developing a treatment approach for the polychromy was difficult because localized areas of cleaning and repainting in the past—such as the complete removal of the original and first overpaint backgrounds—meant that not one intact, congruent overpaint remained on the relief. The multiple layers of paint on the relief were the result of four campaigns of restoration, and the few remnants of original overpaint that still existed in protected areas did not provide a reading of the polychromy legible enough to justify the removal of all the superseding paint layers.

The first overpaint was determined to be the most comprehensive, since the second, third, and fourth overpaint layers were partial interventions consisting of varnishing, localized gilding and regilding, and some retouching. After test cleaning was conducted on small areas of the polychromy to determine the condition and extent of the remaining paint layers, and in conjunction with examination of paint cross sections, it was decided that the obscuring brown and red pigment mixtures from the third overpaint and the remnants of disfiguring oil-resin varnish should be removed to reveal the polychromy from the first overpaint.

Before removing the relief from its frame, flaking paint in the background of the relief and in areas of the red robe were consolidated using a 7 percent solution of gelatin in water. The entire surface was lightly cleaned to remove superficial dirt. The terra-cotta relief was removed from the frame (fig. 13).

Areas of retouching on the mantle and in the background made by the 1956 restorer were removed. The brown overpaint was removed from the mantle to reveal areas of azurite from the first overpaint. Gold embellishments on the band of the sleeve and two stars, one on the Madonna's right shoulder and one on her left shoulder, were further

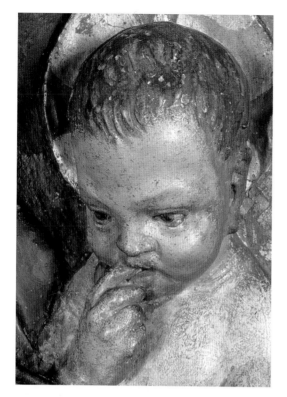

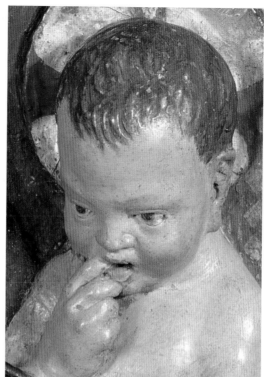

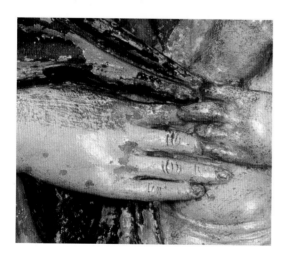

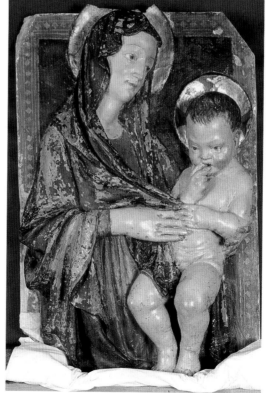

revealed. The thick red restorer's mix on the robe was also removed to reveal a significant amount of the vibrant red of the first over-paint on the robe.

The discolored and uneven oil-resin varnish on the flesh tones and in the eyes of both figures was cleaned, using finest grade scalpels, under a microscope with a 180-degree tilting head to negotiate the contours in the sculpture. The removal of the varnish was one of the most time-consuming aspects of the treatment, owing to the damaged and

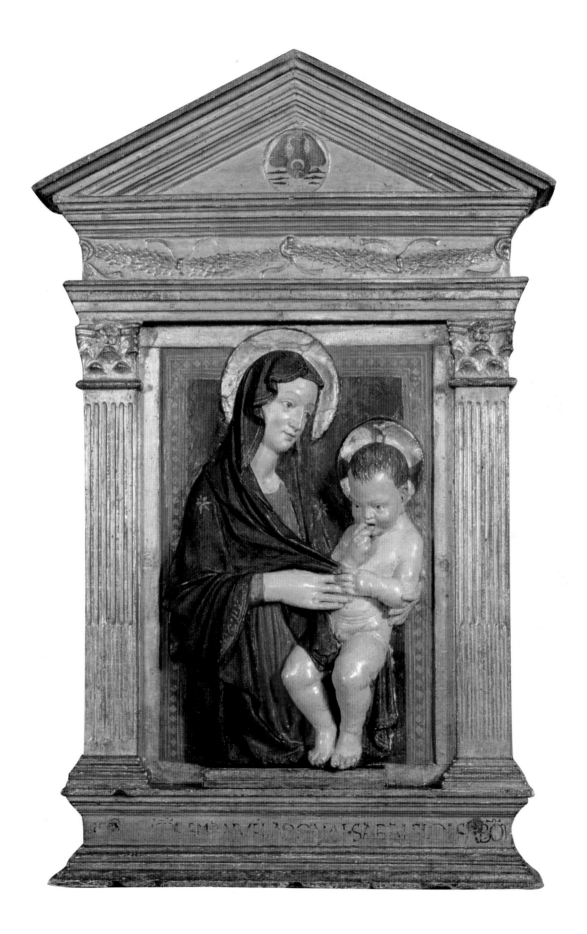

18. Circle of Giovanni
di Turino, *Madonna
and Child* (framed, after
conservation treatment,
1994)

fragile paint underneath the varnish. Details of the Child's face before and after cleaning are shown in figures 14 and 15. Figure 16 shows a detail of the hands of the Madonna and Child during cleaning. Areas of thick varnish in undercut portions of the toes and back of the legs were first treated with a wax paste containing ammonium hydroxide.[37] This paste softened the built-up areas of varnish sufficiently to allow for their safe removal with a scalpel.

As there was almost nothing behind the colored background of the second overpaint to indicate its previous appearance, this overpaint was considered part of the object's history and, as a compromise, left intact.

Exposed areas of terra cotta on the mantle, robe, and small losses in the background were first isolated with a thin layer of Acryloid B72 resin and filled with Polyfilla tinted with ground pigments. Figure 17 shows the relief during treatment. The fill material was burnished in selected areas to create a compact fill and again isolated with a fine layer of Acryloid B72. The robe and mantle were then retouched using pigments bound in Mowilith resin.[38] Large, visually distracting losses in the flesh tones of both subjects were filled with Polyfilla and retouched with pigments in Mowilith to unite the surface.

The gilding on the halos was lightly cleaned to remove built-up grime, then varnished with slightly tinted blond shellac.

Top and lower proper left corners of the relief were reconstructed using separately cast corners composed of phenolic Microballoons[39] mixed in epoxy resin. This technique was chosen because the corners needed to be strong, lightweight, easy to carve, pose

no threat of abrasion or damage to the adjacent terra-cotta surfaces, and be detachable should it be necessary for the relief to be removed from the frame in the future. The relief was placed back into the frame, and the three replacement corners were each held in place with a screw into the liner and joined with gesso to the interior liner of the frame. Gaps at each corner were filled and retouched to match the adjacent background surface. The gilded border pattern was completed with ocher pigments bound in Mowilith.

In addition to developing a more secure mounting system, a plinth was designed and installed, following curatorial request, in the space between the base of the frame and the base of the relief to support the *Madonna and Child* and to correct the "floating" appearance of the figures caused by this space. Areas of flaking gesso on the frame were consolidated, and the frame was cleaned to remove built-up grime and excessively dark areas of discolored varnish.[40]

In summary, the removal of the discolored varnish, the obscuring overpaints, and the completion of missing areas in the background make it possible for the sculptural form of the figures in the relief, especially the Child, to again be seen and appreciated. The tonal depth and modeled details in the mantle were restored, and the traditional color scheme of the first overpaint campaign has been reinstated. Removal of the obscuring brown paint and dark varnish has returned the National Gallery *Madonna and Child* (fig. 18) to a more harmonious state and allows the viewer to once again observe the gentle contemplative expressions that belong to a fifteenth-century Italian devotional relief.

NOTES

The author wishes to thank Shelley Sturman, head of object conservation, National Gallery of Art, Washington, who supervised and encouraged this project, and Daphne Barbour, Kelly McHugh, Judy Ozone, and Sheila Payaqui.

I am grateful to the following National Gallery of Art staff: Alison Luchs, curator of early European sculpture; Catherine Metzger, associate paintings conservator, and Carl Villis, former Getty intern, painting conservation department, who provided advice and encouragement; and Philip Charles, imaging and visual services, who photographed the relief at all treatment stages.

Finally, I am indebted to the Andrew W. Mellon Advanced Fellowship in Object Conservation, National Gallery of Art, for making this research project possible.

1. Thermoluminescence testing in 1971 showed that the terra-cotta relief was fired between 1266 and 1426. A second thermoluminescence testing carried out in 1992 showed that the terra-cotta relief was fired between 1392 and 1592. The naturalistic gestures of the Child, however, suggest that the relief may have been produced closer to 1460.

2. Condition and restoration record, curatorial file, National Gallery of Art, Washington.

3. Ulrich Middeldorf, "Some Florentine Painted Madonna Reliefs," in *Collaboration in Italian Renaissance Art*, ed. W. S. Sheard and J. T. Paoletti (New Haven and London, 1978), 79.

4. Deborah Strom, "Desiderio and the Madonna Relief in Quattrocento Florence," *Pantheon* 40 (Spring 1982), 130; Giancarlo Gentilini, "Nella Rinascita delle Antichità," in *La Civilità del Cotto: Arte della terracotta nell'area Fiorentina dal XV al XX secolo* (Florence, 1980), 71. These devotional pieces were usually mounted on walls or inserted into the niches of *sportelli* (small doors), with the base decorated with the coat of arms. Fra Giovanni Dominici encouraged the use of sculpture and paintings in the home for private contemplation and promulgated their use as aids in stimulating devotion and religious fervor. Thus the gentle and domestic depiction of the Madonna and the Christ Child, such as the Child holding a pomegranate or a small bird, encouraged piety and was a typical theme for terracotta reliefs of the Renaissance.

5. For a discussion on methods of fifteenth-century mold production, see Strom 1982, 131; F. Negri Arnoldi, "Tecnica e scienza," *Storia dell'arte italiana* (Turin, 1980), 163–178; and Gentilini 1980, 71.

6. Earliest documentation shows that the relief was owned by Leopoldo Nomi. See Leone Chellini, *San Gimignano e Dintorni*, 2d ed. (Modena, 1921), 101. It then passed to Teresa Nomi Pesciolini, San Gimignano. Thereafter its movement can be traced to Florence, where it was sold to Luigi Grassi in 1923; it then passed to Achille Clemente, Florence, then to Alfredo Barsanti, Rome, 1928. Provenance records are from Mario Barsanti, curatorial file, National Gallery of Art.

7. Leslie Mohr, curatorial file, National Gallery of Art, 1987.

8. Millard Meiss, *Painting in Florence and Siena after the Black Death* (Princeton, 1951), 146.

9. Anna Jolly, Cambridge University, personal communication, 7 August 1993.

10. Keith Christiansen, *Painting in Renaissance Siena* [exh. cat., Metropolitan Museum of Art] (New York, 1990), 4.

11. Jolly 1993.

12. Mohr 1987. The Child's characteristics resembling the depictions of the Christ Child attributed to Donatello are not surprising since sculpture in fifteenth-century Siena was largely influenced by Donatello's baptistery relief, bronze door, and statue of Saint John the Baptist in the Duomo. However, Jolly 1993, maintains that "on the whole I have found relatively little evidence for an influence of Donatello's Madonnas from the 1420s and 1430s on comparative Sienese works. Donatello's later stay in Siena, around 1460, seems to have had greater impact on the [stylistic] development of Sienese Madonnas."

13. Anna-Maria Giusti and Angelo Venticonti, "Madonna col Bambino," *OPD Restauro: Quaderni dell'Operificio della Pietre Dure e laboratori di restauro di Firenze* (Florence, 1986), 87–90; Christine de Benedictus, *Il Museo Bardini: Sculpture* (Milan, 1984). In a statement of provenance prepared 29 November 1951 by Enzo Carli, then director of the Picture Gallery of Siena, that was directed to the owner at the time, Mario Barsanti, Rome, Carli wrote of the converging influences in the relief: it "is not, in my opinion, the work of Jacopo [della Quercia] but by a Sienese sculptor nearly contemporary with Quercia, and partly influenced by him but still more strongly under the influence of Ghiberti and—also partly—under that of Donatello." Carli also suggested, "This interesting personality can, with a certain assurance [pending a close examination of the original, which I know only from the photograph you sent me], be identified with the Sienese Giovanni di Turino . . . , a rare and exquisite sculptor and goldsmith, a collaborator of Jacopo della Quercia, of Ghiberti and of Donatello in the statue and reliefs of the celebrated baptismal font at San Giovanni in Siena." Curatorial file, National Gallery of Art.

Giovanni di Turino and his father, Turino di Sano (generally considered active second half of the quattrocento, but perhaps earlier), produced two relief panels for the Siena Baptistery font, joining in the collaborative effort with Jacopo della Quercia, Donatello, and Lorenzo Ghiberti (1378–1455) from 1423 to 1427, who were also commissioned to prepare works for the baptismal font completed during the years 1416 to 1434. See John T. Paoletti, *The Siena Baptistery Font* (New York and London, 1979), 73. Giovanni di Turino's bronze reliefs, *The Birth of the Baptist* and *The Preaching of the Baptist*, commissioned for this font, are strikingly similar in composition to scenes from Ghiberti's bronze doors of the Baptistery in Florence. It is documented that Giovanni di Turino went to Florence on at least four occasions, and,

according to Paoletti (page 73), "at the time of the two earlier trips Ghiberti was just finishing the model for the panel of the North doors, which Giovanni obviously saw, since a majority of the figures in the Turini reliefs for Siena derive directly from them." It is this relationship between Giovanni di Turino and Ghiberti that may have prompted Enzo Carli in 1951 to suggest that the National Gallery *Madonna and Child* may have been by Giovanni di Turino.

The naturalistic characteristics of the Child by Donatello enable us to understand Carli's attribution. Carli is most likely accurate in the first part of his statement that the artist was influenced by Donatello in the modeling of the Child, but it is unlikely that the artist was Giovanni di Turino, who, according to Ulrich Alexander Middeldorf, *Sculptures from the Samuel H. Kress Collections: European Schools, Fourteenth to Nineteenth Century* (London, 1976), 16, "was primarily a goldsmith and bronze caster and only comparatively rarely did marble sculpture [and unlikely] to have been engaged in the production of such commercial devotional objects as terra cotta or stucco Madonnas."

14. Museo Bardini, Florence, inv. no. 1089.

15. Stephen G. Rees-Jones, "A Fifteenth-Century Terra-cotta Relief: Technology, Conservation, Interpretation," *Studies in Conservation* 23, no. 3 (1978), 95–113, see especially 97–106.

16. Giusti and Venticonti 1986, 87–90.

17. Rees-Jones 1978, 99, discussed terra-cotta models (*bozzetti*) around which a wooden ledge would be placed as a working frame.

18. Clay is described as "leather-hard" when it is dried to the critical point so that individual clay particles touch and the body is rigid but retains sufficient moisture to be carved or joined. See Prudence M. Rice, *Pottery Analysis: A Source Book* (Chicago, 1987), 478.

19. Rees-Jones 1978, 102, found the head and upper body of the Child in the relief *Madonna and Child* (school of Verrocchio) to be hollow and described the process by which clay was scraped out down to the base from the front at these thick areas in high relief. The sides of the hollowed areas would have been built up and closed over.

20. Phillipa Lewis and Gillian Darley, *Dictionary of Ornament* (New York, 1986), 181.

21. Rees-Jones 1978, 104. According to Giusti and Venticonti 1986, 88, traditionally, once a terra-cotta relief was fired, its surface was filed with fine rasps to provide tooth for the application of a layer of gesso. The gesso was used to smooth out uneven areas in the fired surface and provide a ground for the paint. The object would then have been painted with "mineral pigments in an egg binder in one single application and enriched with glazes in the flesh tones."

22. A "fire-skin" is a fine surface film that forms on terra-cotta sculpture. See John Larson, "The Conservation of Terracotta Sculpture," *Conservator* (United Kingdom Institute for Conservation), no. 4 (1980), 40: "It would seem to originate in the plastic stage, when the clay is being constantly wetted. A slip is formed on the surface and becomes permanent when the clay is fired. The fire-skin is usually paler than the rest of the terra cotta body."

23. On the frame, at the bottom, the inscription reads: IESVS·XRS·EMANVEL·ADONAI·SABAI·ELOI·SABOT. *Sculpture: An Illustrated Catalogue* [National Gallery of Art] (Washington, 1994), 102.

24. Mohr 1987.

25. Nancie Ravenel, frame conservator, conservation division, frame examination report, 8 March–27 April 1994. The markings suggest that the liner was constructed as part of the frame to accommodate the relief. These observations were made for the first time in 1994 while the relief was removed from the frame by Ravenel and Stephan Wilcox, frame conservator, conservation division, and the backing board detached.

26. There is no single formula for "compo" or "composite plastic materials," although they may include animal glues, drying oils, lead compounds, resins, starch pastes, eggs, and inert fillers. See Jonathan Thornton, "'Compo': The History and Technology of 'Plastic' Compositions," *AIC Preprints*, 13th Annual Meeting of the American Institute for Conservation (Washington, May 1985), 113–126.

27. The polychromy was examined at 40x magnification using a stereo microscope. Preparation, photography, and examination of cross sections were conducted by Michael Palmer, conservation scientist, scientific research department, National Gallery of Art, with assistance from the author. Thirty paint cross sections were taken from the polychromy on the relief and from the gilding on the frame. These samples were taken throughout the relief in protected, undercut areas to obtain undamaged paint layers that best reflected the series of interventions that had occurred. Eleven cross sections (A–K) were selected that best describe the history of interventions on the relief and the frame. See the appendix for a description of these cross sections.

After polishing, cross sections were examined and photographed using a Leitz Orthoplan compound light microscope in both normal reflected light and under visible fluorescence. Pigments were identified using light microscopy and energy dispersive x-ray analysis (EDX). Energy dispersive x-ray analysis was carried out by Melanie Feather, conservation scientist, Conservation Analytical Laboratory, Smithsonian Institution, Washington, 14 August 1992.

Binding media of selected samples were determined using ultraviolet fluorescence microscopic staining techniques to establish general media categories. High-performance liquid chromatography (HPLC) for analysis of amino acids was also used to identify binding media in selected samples. High-performance liquid chromatography was carried out by Susana Halpine, biochemist, scientific research department, National Gallery of Art, "Amino Acid Analysis Report, Circle of Giovanni di Turino, *Madonna and Child*, 1961.9.103," 5 August 1993.

28. Cennino d'Andrea Cennini, *The Craftsman's Handbook, "Il Libro dell'Arte"* (c. 1390), ed. and

trans. Daniel V. Thompson Jr. (New York, 1960), 73, 99–100, 110.

29. Rutherford J. Gettens and Elisabeth West FitzHugh, "Malachite and Green Verditer," in *Artists' Pigments: A Handbook of Their History and Characteristics*, ed. Ashok Roy, vol. 2 (Washington, 1993), 194–197. Malachite of a spherulitic particle form, probably artificial, was found, for example, on a panel from an altarpiece (National Gallery, London), *The Whim of the Young Saint Francis to Become a Soldier*, c. 1437–1444, by the Sienese artist Stefano di Giovanni, known as Sassetta (c. 1400, perhaps 1392–1450).

30. Giusti and Venticonti 1986, 87.

31. Halpine 1993.

32. Ceninni 1960, 73.

33. Giorgio Vasari, *Vasari on Technique* (1550), trans. Louisa S. Maclehose (New York, 1960), 230.

34. Cennini 1960, 99–100, 110.

35. Gas chromatographic analysis (21 August 1992) by Suzanne Quillen Lomax, organic chemist, scientific research department, National Gallery of Art, showed that the varnish was composed of a drying oil mixed with a small amount of diterpene resin (such as pine resin or copal).

36. According to Joseph Ternbach, February 1956, curatorial file, National Gallery of Art, the relief was "cleaned and restored."

37. An ammonia wax paste was prepared since the wax, acting as a carrier, allows for increased control and application to small areas of thick varnish in the undercut areas. There are some claims that the wax also reduces diffusion of the ammonia into the paint surface, although this effect has not been proven. See Aviva Burnstock and Tom Lerner, "Changes in the Surface Characteristics of Artificially Aged Mastic Varnishes after Cleaning Using Alkaline Reagents," *Studies in Conservation* (1992), 37, 165–184.

The following is a recipe for ammonia wax paste: 50 g of bleached beeswax, 150 ml of turpentine, 15 ml of 0.880 ammonia solution diluted with 30 ml distilled water. The beeswax is dissolved in the warmed turpentine. When almost cold, add the diluted ammonia solution, stirring until a smooth paste is obtained; pH=9.

38. Mowilith resin is composed of AYAA and AYAC polyvinyl acetate resins and is distributed by Conservation Materials Ltd.

39. Phenolic Microballoons, manufactured by Union Carbide Corp., were used as a fill material to extend and reduce the weight of the epoxy resin.

40. Conservation work on the frame and construction of the plinth were carried out by Nancie Ravenel.

APPENDIX

Cross sections A through K showing layers of overpaint. Layers where overpaint history is uncertain are noted by a question mark.

Photomicrograph of cross section A, view 1: sample of flesh tones from the Child's proper left ear (**110x**)

original layers }
1. glue
2. gesso
3. *verdaccio*: green earth and small amount of lead white
4. flesh color layer: lead white, small amount of vermilion and red lake
5. varnish layer

layers of first overpaint }
6. medium-rich gesso
7. flesh color layer: lead white, vermilion, and red lake
8. flesh color layer: lead white, vermilion
9. discolored varnish

Photomicrograph of cross section A, view 2: sample in cross section A, stained with amido black 3 (**110x**)
Areas stained blue indicate the presence of protein

Photomicrograph of cross section B: sample from the lower portion of the Madonna's red robe where it intersects with the green interior of the mantle (**220x**)

original layers }
1. gesso
2. red lake
3. synthetic malachite

layers of first overpaint }
4. medium-rich gesso
5. nonpigmented layer (shown to be egg white using HPLC analysis)
6. vermilion mixed with a small amount of red lake
7. red lake glaze

Photomicrograph of cross section F: sample of Madonna's original blue mantle located in a protected undercut area beneath the proper right wrist (**160x**)

original layers }
1. terra-cotta substrate
2. gesso
3. azurite bound in animal glue

Photomicrograph of cross section G: sample from the proper right edge of the Madonna's mantle (**220x**)

layers of first overpaint }
1. medium-rich gesso
2. thick, nonpigmented layer shown to be egg white
3. thin layer of resin or glue
4. layer of azurite, large particles with some inclusions

(?) }
5. grayish layer, dirt or debris

layer of fourth overpaint }
6. fine layer of Prussian blue pigment

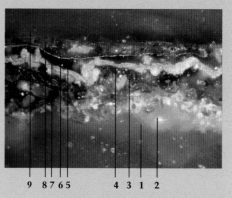

Photomicrograph of cross section H: sample from star on Madonna's proper right shoulder (**160x**)

1. glue
2. gesso
3. azurite layer: lower part is composed of finely ground particles, upper part is composed of coarse azurite particles and small amount of cuprite

layers of second overpaint }
4. mordant containing iron oxide particles

tin-gold laminate }
5. tin oxide (formerly a layer of tin foil, now mineralized)
6. resin layer
7. gold layer

layer of third overpaint }
8. restorer's mix: iron oxides and carbon black

layer of fourth overpaint }
9. shellac

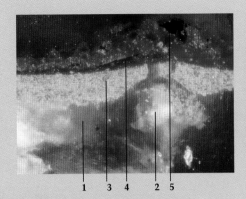

Photomicrograph of cross section C: sample from the lower portion of the Madonna's red robe (**220x**)

layers of first overpaint }
{
1. glue (directly on the terra-cotta substrate)
2. medium-rich gesso
3. vermilion mixed with a small amount of red lake
4. red lake glaze
}

layer of second overpaint }
{
5. restorer's mix: red and yellow iron oxides, vermilion, some carbon black
}

Photomicrograph of cross section D: sample from the original gilded layer of Child's halo (**220x**)

original }
{
1. gesso
2. red earth bole
3. gold leaf
}

Photomicrograph of cross section E: sample from the upper gilded layer of Child's halo (**220x**)

layers of first overpaint }
{
1. glue
2. medium-rich gesso
3. red earth bole
4. gold leaf
5. translucent remnants of a surface coating
}

Photomicrograph of cross section I: sample from the lower proper right replacement corner of the relief (**110x**)

layers of first overpaint }
{
1. medium-rich gesso
2. red earth bole
3. lead white and red lake particles
4. gold leaf
}

(?) }
{
5. blue layer: azurite, lead white, yellow iron oxide, traces of vermilion and small blue, spherical unidentified particles
6. layer of azurite
}

layer of third overpaint }
{
7. restorer's mix
}

Photomicrograph of cross section J: inner side of Madonna's mantle, behind the Child's proper left thigh (**110x**)

original layers }
{
1. terra-cotta substrate
2. gesso (partially yellowed)
3. synthetic malachite
}

layers of first overpaint }
{
4. glue layer
5. medium-rich gesso
6. red and yellow iron oxides
7. green layer containing green earth
}

(?) }
{
8. thin resinous layer
}

Photomicrograph of cross section K: sample from the background near the lower right side of the Madonna's halo (**110x**)

1. gesso from first overpaint (gilding lost or degraded)

layers of second overpaint }
{
2. gesso from second overpaint
3. vermilion layer
4. green earth layer
5. green earth and verdigris
}

(?) }
{
6. dark resinous layer
}

Analysis of Polychrome Layers, Circle of Giovanni di Turino, *Madonna and Child*

The following analyses lead the reader through the cross sections that best represent the successive interventions in the polychromy. The sections are discussed according to their location on the relief and, where possible, show the order of intervention.

Cross Section A

Sample from the flesh tones of the Child's proper left ear (views 1 and 2)

Binder analysis was limited to microchemical staining of cross section A because of the small amount of extant original flesh paint and its fragile nature. The sample was stained with amido black 3 (AB3) to detect the presence of protein.

Beginning at the bottom, the layers are: (1) a semitransparent layer, present directly on the terra cotta. When stained, it showed the presence of protein and appears to be a glue layer. The original ground layer (2) is comprised of very white gesso, followed by a fine layer (3) of green earth mixed with a small amount of lead white, commonly used in tempera painting as a *verdaccio* for the flesh color. The original flesh color layer (4) is a mixture of lead white with a small amount of vermilion and red lake. Above the original flesh color layer is a thin layer (5) that fluoresces and appears to be a varnish. Another layer of gesso (6) marks the beginning of the first overpaint. It is characterized by coarse particles and contains a greater amount of medium compared to the original gesso shown by the strong blue reaction when stained with AB3 and compared to the original gesso. There are two flesh color layers. The first (7) is composed of lead white and vermilion, while the layer above it (8) contains particles of red lake to create warmer tones for the flesh color. On top of these layers is a discolored varnish (9). Analysis of the varnish showed it to be composed of a drying oil mixed with a small amount of diterpene resin (such as pine resin or copal), findings that suggest an oil-resin varnish.[1]

Cross Section B

Sample from the lower portion of the Madonna's red robe where it intersects with the green interior of the mantle

Beginning at the bottom, the layers are: (1) a very fine, white original gesso composed of calcium sulfate, confirmed by energy dispersive x-ray analysis (EDX) (fig. 1);[2] this gesso, the same as the original gesso seen in cross

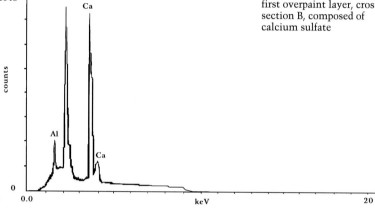

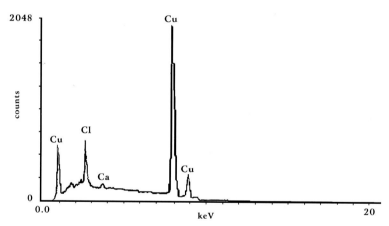

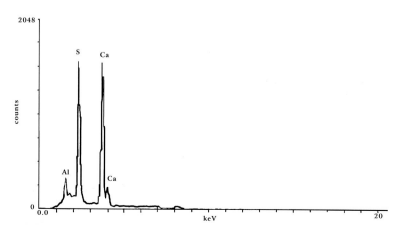

1. *Madonna and Child*, energy-dispersive x-radiograph (EDX) of sample in cross section B, original ground composed of calcium sulfate

2. *Madonna and Child*, EDX of green layer in cross section B, composed of copper carbonate pigment

3. *Madonna and Child*, EDX of ground layer in first overpaint layer, cross section B, composed of calcium sulfate

4. *Madonna and Child,* high-performance liquid chromatogram (HPLC) showing the presence in cross section C sample of egg yolk and animal glue in the vermilion and gesso layers, respectively: (a) supernatant, and (b) precipitate

section A, has been applied directly on the terra-cotta surface, followed by (2) a layer of a red lake. A layer (3) of green pigment from the interior of the Madonna's mantle is a copper carbonate pigment (fig. 2), probably synthetic malachite, also known as green verditer.

The first overpaint layers begin with a ground layer (4) composed of calcium sulfate or gesso (fig. 3) followed by a thick nonpigmented layer (5) with a thickness range of between 9 to 30 microns. This layer may have been used as a sealant for the gesso or as an isolating layer from the red layer above it (6), which is composed of vermilion mixed with a small amount of red lake. The nonpigmented layer stained positively with amido black 2 (not shown), indicating the

presence of egg. The red vermilion body (6) is glazed with a red lake (7), which has become abraded over time.

Cross Section C

Sample from the lower portion of the Madonna's red robe

Beginning at the bottom, the first two overpaint layers are: glue directly on the terra cotta (1), a medium-rich gesso (2), a body of vermilion mixed with a small amount of red lake (3), followed by a red lake glaze (4). A sample of the vermilion layer with a portion of gesso from the first overpaint analyzed using high-performance liquid chromatography (fig. 4) indicated that the binding medium was egg yolk, with some animal glue that can be attributed to the presence of the gesso layer.[3] The second overpaint layer, which is a restorer's mix (5), is a thick layer composed of red and yellow iron oxides, vermilion, and some particles of carbon black. It is water soluble and contains little or no binding medium.

Cross Section D

Sample from the original gilded layer of the Child's halo

Beginning at the bottom, the layers are: gesso (1), red earth bole (2), and gold leaf (3).

Cross Section E

Sample from the upper gilded layer of the Child's halo

Beginning at the bottom, the layers are: glue (1), medium-rich gesso (2), red earth bole (3), gold leaf (4), and translucent remnants of a surface coating (5).

Cross Section F

Sample from the Madonna's original blue mantle located in a protected undercut area beneath the proper right wrist

Beginning at the bottom, the layers are: terra cotta (1), followed by a fine white gesso ground (2) with the same composition as the gesso layer found in samples from the original flesh colors and robe (see cross sections A and B). The pigment layer (3) was identified as azurite bound in animal glue and is very compact with few visible impurities.

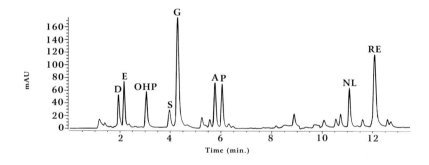

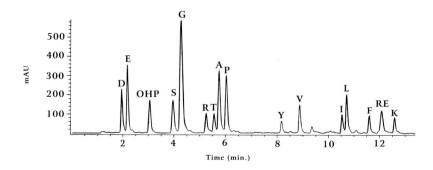

Cross Section G

Sample from the proper right edge of the Madonna's mantle

Beginning at the bottom, the first layer of overpaint includes a medium-rich gesso (1) followed by a thick (15 microns) nonpigmented layer (2) that appears to match the characteristics of the thick nonpigmented layer described in cross section B from the Madonna's robe. This nonpigmented layer is of an unusually great thickness, possesses a slight fluorescence, and is curiously located directly over the gesso of the first overpaint, in the manner of a sealant for the gesso or an isolating layer in preparation for the next intervention. High-performance liquid chromatography (fig. 5) showed this layer to be composed of egg white (water-soluble egg).[4] A very thin layer of resin or glue that fluoresces (3), present over the nonpigmented layer, is possibly a binding medium from the pigment layer above, which is a layer of azurite (4), followed by an unidentified grayish layer that may be dirt or debris (5), and a thin layer (6) of fine, dark particles of Prussian blue. Prussian blue pigment was used in the 1956 restoration[5] and is part of the fourth overpainting.

Cross Section H

Sample from star on the Madonna's proper right shoulder

This sample is from part of the second overpainting, and the layers of this cross section were complete down to the terra cotta but possessed no original layers, as they had been lost.[6] The isolating glue layer on the surface of the terra cotta signifies, as with other cross sections, that a new intervention had begun. Beginning at the bottom on the surface of the terra cotta, the layers are: glue (1), followed by a gesso (2). Above the gesso is a layer of azurite (3) with a small amount of cuprite particles; the lower part of the layer is finely ground and the upper part of the layer contains larger particles. A transparent layer (4) containing iron oxide particles was applied over the azurite and is probably a mordant for the layer above (5), which was identified as tin (fig. 6). Undulating and cracked, this grayish white layer, now fully mineralized or corroded, was once a layer of tin leaf or tin foil.

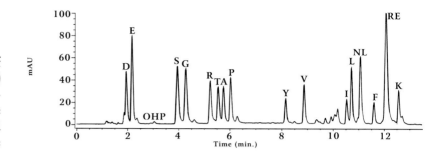

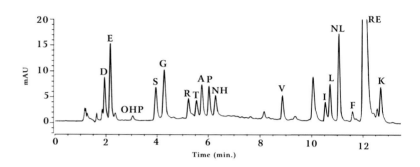

5. *Madonna and Child*, HPLC showing the nonpigmented layer in cross section G, composed of egg white: (a) supernatant, and (b) precipitate

Above this mineralized tin layer is a resin layer (6), and a layer of gold leaf (7) follows. The tin-resin-gold layers appear to be a metallic laminate, used for the stars and other decorative elements in the second overpaint. Above the gold leaf is the brown restorer's mix (8) from the third overpaint that is composed of ochers (iron oxide) and carbon black pigment. Above this mix is a thin layer (9) that appears to be shellac.

Cross Section I

Sample from the lower proper right replacement corner of the relief

Beginning at the bottom, the gesso layer (1) corresponds to the medium-rich gesso of the first overpainting, also present in cross sections A, B, E, and G, confirming that the first overpainting was concurrent with the movement of the relief into the present frame. A red earth bole (2) is followed by a very light pink layer of lead white and red lake particles (3) and a disrupted layer of gold leaf (4). The gold leaf is followed by a densely compacted light blue layer (5) consisting of azurite, lead white, yellow iron oxide, traces of vermilion, and numerous unidentified blue particles that are small (less than 1 micron) and spherical in outline. A medium-rich

6. *Madonna and Child*, EDX of second overpaint layer, cross section H, showing the presence of tin

(4) appears to be green earth, and the second layer (5) appears to be green earth combined with a small amount of verdigris. Above them is a dark resinous layer (6).

dark layer of azurite (6) is followed by remnants of a restorer's mix (7). The gilded portion of this cross section represented by layers 1 through 4 is part of the gilded background executed in the first overpainting.

Cross Section J

Sample from the inner side of the Madonna's mantle, behind the Child's proper left thigh

Beginning at the bottom, this sample includes the terra-cotta substrate (1) that begins the original layers, a fine gesso layer that has become partially yellowed (2), followed by a green layer (3) that appears to be synthetic malachite and is also present in cross section B. A thin, fluorescing glue layer (4) is followed by a medium-rich ground layer (5). A glue layer and a medium-rich ground layer, as previously noted, are common features indicating the beginning of a first overpainting. A layer of red and yellow iron oxides embedded in a dark brown nonfluorescing matrix (6) is followed by a green mix (7) that appears to contain green earth and a thin resinous layer (8).

Cross Section K

Sample from the background near the lower right side of the Madonna's halo

Beginning at the bottom, the layers are: (1) ground (gesso) present from the first overpaint, followed by another ground (gesso) layer (2) from the second overpaint, and (3) a red layer comprised of vermilion, followed by two green layers of which the first layer

NOTES TO APPENDIX

1. Gas chromatographic analysis was conducted by Suzanne Quillen Lomax, organic chemist, scientific research department, National Gallery of Art, Washington, 21 August 1992.

2. Energy-dispersive x-ray analysis was carried out by Melanie Feather, conservation scientist, Conservation Analytical Laboratory, Smithsonian Institution, Washington, 14 August 1992.

3. High-performance liquid chromatography was carried out by Susana Halpine, biochemist, scientific research department, National Gallery of Art. "Amino Acid Analysis Report, Circle of Giovanni di Turino, *Madonna and Child*, 1961.9.103," 5 August 1992.

4. Halpine 1992.

5. Joseph Ternbach, curatorial file, February 1956.

6. The layers viewed directly on the terra cotta match other samples of second overpaint, not original or first overpaints. Also, the glue layer on the terra cotta means a new restoration was begun, as seen in other cross sections from the *Madonna and Child*.

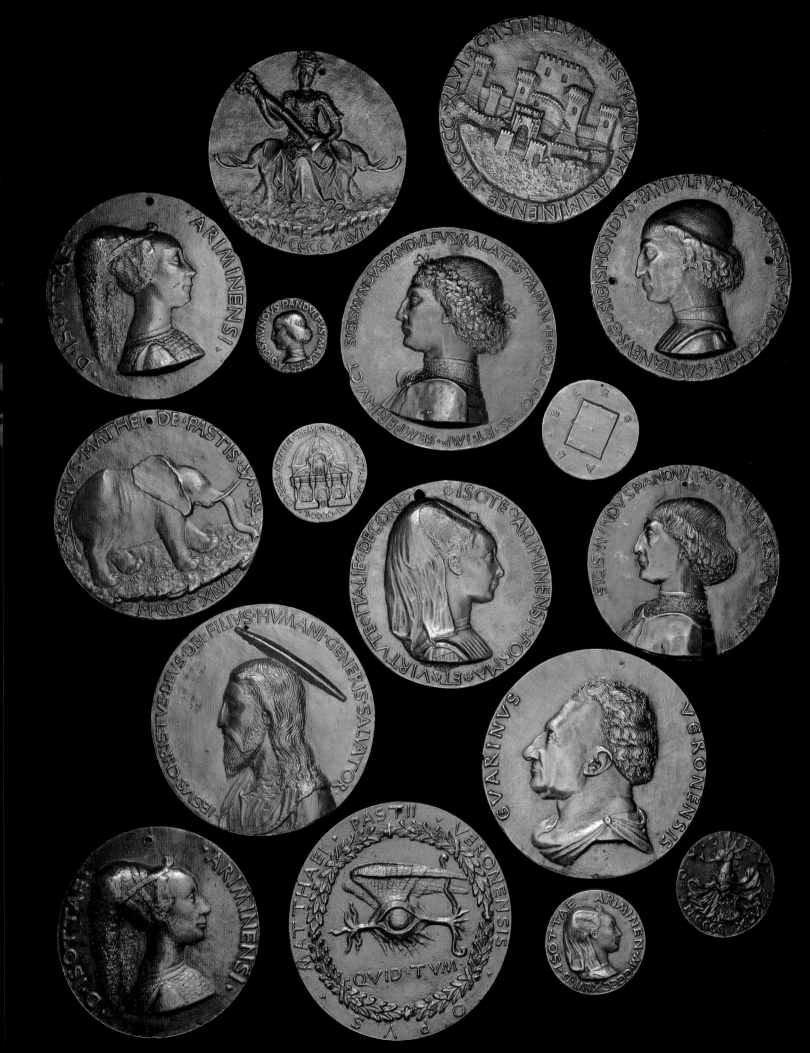

LISHA DEMING GLINSMAN

Renaissance Portrait Medals by Matteo de' Pasti: A Study of Their Casting Materials

A survey of Renaissance portrait medals in the collections of the National Gallery of Art, Washington, served as the impetus for this study. Encompassing well over seven hundred medals, this collection is one of the largest and finest groups of Renaissance portrait medals ever assembled.[1] The survey culminated in the development of a statistical model for separating the medals into distinct alloy groups.[2] Eight principal groups were identified from a core selection of 202 cast Italian Renaissance portrait medals comprised of copper-based alloys that are considered authentic. The most notable group of medals are leaded bronzes containing 10–60 percent more antimony and arsenic than is generally present in Renaissance portrait medals. More than half the medals in this group are attributed or assigned to Matteo de' Pasti (c. 1420–1467/1468). This group of medals by Matteo or his workshop (fig. 1) is the only group to exhibit such distinctive characteristics. The possibility that a particular artist may have chosen to use a specific alloy composition led to an in-depth study of these medals.

Historical Background

The portrait medal, born in the humanist climate of early fifteenth-century Italy, developed as a means of promoting personal recognition. Its invention in 1438 (possibly following suggestions by Leone Battista Alberti) is generally credited to Antonio di Puccio, known as Pisanello (c. 1395–1455). Pisanello incorporated the Renaissance ideal of the focus on man and his unique identity into an intimate and portable object. Usually, portrait medals are circular. The obverse is a relief portrayal of an individual, and the reverse depicts a mythological or symbolic image or a significant event identified with the sitter. Occasionally double portrait medals were made with both obverse and reverse portraits. Unlike coins, medals had no currency value; they were valued instead as commemorative objects. They were durable and easily portable, and therefore popular for exchange as tokens of patronage, power, or friendship. Because medals were relatively affordable—compared to sculpture or painted portraits—they represented not only heads of state (including their family members) but private citizens as well. As medals are made of long-lasting materials, they imparted immortal qualities to their sitters.[3]

As production of portrait medals became widespread in Italy, groups or schools of medalists emerged in all the principal city-states. Medalists frequently traveled from city to city; thus it is difficult, if not impossible, to associate a medalist with a school or location.[4] Matteo's work as a medalist is no exception, and many unanswered questions cloud our knowledge about his career. The period of his activity as a medalist (1441–1467/1468) coincides with the period

during which the portrait medal itself gained popularity in northern Italy.[5] Matteo spent most of his career working at the Malatesta court in Rimini, which, under the rule of Sigismondo Pandolfo Malatesta (1417–1468), briefly evolved into a center of learning comparable to other northern Italian courts.[6] Like other humanist settings, the Malatesta court in Rimini employed an array of artists: among the most noted were Leone Battista Alberti (c. 1404–1472), Piero della Francesca (1410/1420–1492), Agostino di Duccio (1418–1481?), and Matteo de' Pasti.[7]

Matteo de' Pasti, born into a prominent family in Verona, was the son of a physician and the grandson of a member of the Florentine Bardi family.[8] He is recorded in a Venetian painting commission of 1441, presumably as an illuminator for Piero de' Medici for illustrations to a "Triumph of Fame" manuscript of Petrarch. In 1444, Matteo was again employed as an illuminator, in Verona, for Leonello d' Este. It is believed that he moved to Rimini in 1446, where he supervised for Sigismondo Malatesta the work of reconstruction and decoration at the church of San Francesco (called the Tempio Malatestiano).[9] Following his marriage to Lisa Baldegara of Rimini sometime between 1446 and 1449, Matteo sold his property in Verona and became an important member of the court circle in Rimini as well as a close companion of Sigismondo Malatesta.

Matteo produced and signed portrait medals of seven individuals, principally his patron Sigismondo and Sigismondo's mistress (and later third wife), Isotta degli Atti (1432/1433–1474). In addition, another group of eighteen unsigned variants of these medals may have been produced in Matteo's workshop.[10]

Sigismondo authorized many medals to be placed in the foundations of the buildings that he commissioned. Their purposes are complex, but one of them was to ensure his fame, even after his death. A considerable number of these foundation medals (either by or after Matteo de' Pasti) were discovered when the buildings were bombed during World War II. These medals have served as the basis for Pier Giorgio Pasini's reevaluation of Matteo de' Pasti's medals, shedding new light on their sometimes problematic chronology and style.[11]

Seventeen portrait medals by Matteo in the collection of the National Gallery of Art, along with comparative information from a medal in a private collection, were analyzed for this study. George Hill's corpus for Renaissance portrait medals, written in 1930, has been established as the standard for cataloguing these medals.[12] Of these medals, eight are portraits of Sigismondo Malatesta, six are of Isotta degli Atti, and there is one each of Guarino da Verona (1374–1460), Jesus Christ, and Leone Battista Alberti. Each medal was examined under low magnification using a binocular microscope to study its fabrication. In addition, the medals were analyzed using secondary emission energy dispersive x-ray fluorescence spectrometry (XRF) to determine their surface alloy composition.

Method of Manufacture

All the medals examined in this study were cast. A granular quality of their surfaces observed under magnification suggests that a sand or other granular material was present in the mold (fig. 2).[13] This granular surface appearance is consistent with the generally accepted notion that the majority of Renaissance medals were not cast using the lost-wax process but were, as suggested by George Hill, cast in two-part dry sand molds.[14]

Many contemporary treatises describe the art of sand casting, including accounts by Cennino Cennini, Benvenuto Cellini, Alessio

2. Photomicrograph, fig. 9, obverse, showing granular characteristics consistent with sand casting. View shown is upper left area

Piemontese, and Vannoccio Biringuccio.[15] Biringuccio's *Pirotechnia*, published in Venice in 1540, is the first book to encompass the complete field of metallurgy. His chapters on the "small art of casting" enumerate the benefits of sand casting on small objects as being quick and easy:

But in order to avoid work and expense there are shorter and easier ways to be used, both because the things can be handled more easily and because it is not necessary to have so much regard for the forces of small materials. Therefore, wishing to make a distinction for you, I shall call this the small art of casting. Before speaking of this, I shall tell you of several methods of making powders [sand] for moulding. Then I shall also tell you of the methods of moulding in boxes and in frames, and how the said powders are to be prepared for casting either dry or green. Then I shall tell you some methods that are held secret by the masters for handling the metals in melting and making them flow readily, so that you may easily fill the cavities of your moulds.

Biringuccio states further that sand casting is the preferred method when creating multiple reproductions:

But if one has to make a large quantity of works of one kind, he should for the sake of convenience use the method with powder because it is short and requires less time and expense.

To produce a medal, the medalist would first make a model from a pliable material such as wax or clay, which Biringuccio described:

It is also customary to make a plaster capable of being worked easily by hand in making medallion portraits, leafwork, or scenes in bas-relief so that they can be moulded for making them in bronze if you wish. To do this, take two parts of very pure white wax, one of white lead, and a little goat's tallow, and mix them all together.[16]

The model was then pressed into a soft material that could be a compound consisting of gesso, pumice, water, or even a fine sand bound with glue.[17] While still soft or damp, the mold was often completed using punches to impress any letters or design elements to form the inscription. The letters could also be formed of wax as part of the model. Both obverse and reverse halves of the mold were then dried prior to being joined (sometimes in a flange). Openings were created to provide access for the molten metal to enter the mold as well as to allow gases formed in the process to escape. Molten metal was then poured into the mold. When cool, the mold was carefully opened to ensure that the cast was not damaged and to preserve the mold for another cast. Care was taken during the mold making and casting process to produce a clean cast to avoid the need for chasing or retouching the finished medal, which could destroy its satiny finish. Finally, medals made from copper alloys were usually given a lacquer or a chemical patina to color their surface.[18]

The medals in this study are multiples: more than one example exists of each. Hill described the production of multiples in terms of a secondary mold made from extant originals.[19] Patricia Tuttle noted that Renaissance authors record casting specific medals precisely to serve as models for additional molds.[20] In either case, following the recipe for mold making described by the Renaissance authors cited above, two or more medals from a single mold could often be poured. As Biringuccio explained: "It also served me very well in that one, two, three, or four casts were made without having to mould it again."[21]

XRF Analysis of Surface Alloy Composition

Secondary emission energy dispersive x-ray fluorescence spectrometry,[22] which is a non-destructive technique for determining elemental surface composition, was used to ascertain the nature of the alloys in each medal. XRF is a well-established analytical technique and, because of its nondestructive capabilities, has proven to be invaluable in the study of art objects.[23] It provides rapid, simultaneous multielement analyses and has the added benefit of being a quantitative technique when analyses are compared with the appropriate standards. Although XRF is a surface technique, and slight difficulties may arise from the analysis of unprepared surfaces,[24] the kind of quantitative information obtained from the analysis is valid for the aims of this study. The results using this methodology do not produce a fully quantitative analysis, such as achieved in an inductivity couples plasma (ICP) study, which quantitates down to the low parts per million. However, the

Table 1
Alloy Composition of Medals Attributed to, or after, Matteo de' Pasti Using XRF Analysis of Surface

Figure No.	Obverse	Reverse	Diameter	National Gallery of Art No.
Bronze				
4	Sigismondo Malatesta	Fortitude	8.2 cm	1957.14.653
5	Isotta degli Atti	closed book	4.2 cm	1957.14.657
6	Leone Battista Alberti[a]	winged eye	9.3 cm	1957.14.648
7	Jesus Christ[a]	tomb	9.3 cm	1957.14.649
Leaded bronze				
8	Sigismondo Malatesta[b]	San Francesco	4.0 cm	1957.14.658
9	Sigismondo Malatesta	castle of Rimini	8.5 cm	1942.9.167
10	Isotta degli Atti	Malatesta elephant	8.5 cm	1957.14.651
11	Isotta degli Atti	closed book	4.0 cm	1957.14.656
12	Sigismondo Malatesta	shield	4.3 cm	1957.14.650
13	Sigismondo Malatesta	emblem of authority	3.1 cm	1992.55.3
14	Sigismondo Malatesta	castle of Rimini	8.1 cm	1957.14.654
	Sigismondo Malatesta[c]	castle of Rimini	—	—
Medium-zinc brass				
15	Guarino da Verona	fountain	9.4 cm	1957.14.647
Low-zinc brass				
3	Sigismondo Malatesta	castle of Rimini	8.3 cm	1957.14.652
16	Isotta degli Atti	Malatesta elephant	8.4 cm	1942.9.166
17	Isotta degli Atti	Malatesta elephant	8.4 cm	1942.9.165
18	Isotta degli Atti[d]	Malatesta elephant	8.3 cm	1957.14.655
Copper and lead				
19	Sigismondo Malatesta[e]	no design	9.1 cm	1957.14.659

Hill nos. are from George Francis Hill, *A Corpus of Italian Medals of the Renaissance before Cellini*, 2 vols. (London, 1930), 1:37–43, 319; 2:pls. 29–35
bdl=below detection limits (approximately 500 ppm)

a. These medals are believed to be contemporaneous. George F. Hill and Graham Pollard, *Renaissance Medals from the Samuel H. Kress Collection at the National Gallery of Art* (London, 1967)
b. After Matteo de' Pasti. Hill and Pollard 1967, 17; J. Graham Pollard, "Medals," in The Collections of the National Gallery of Art, Systematic Catalogue, Washington, forthcoming. In Pollard, Pasini suggests the medal is by de' Pasti
c. Not illustrated, private collection
d. This medal is believed to have been made in an unknown Riminese workshop, which reproduced de' Pasti original medals. Pollard (forthcoming)
e. After Matteo de' Pasti. Probably a later work. Hill and Pollard 1967, 17

results are used to place the medals into a number of different categories that can then serve as a basis for further discussion.

The obverse and reverse of each medal were examined by XRF.[25] Calculations were made for the amount of copper, tin, zinc, and lead, as well as impurities such as iron, nickel, silver, antimony, and arsenic.

The term "bronze" is widely accepted as a generic, nontechnical term for art objects composed of any copper alloy; furthermore, it is art-historical practice to refer to any copper-based alloy used in the Renaissance as a bronze. However, to categorize these medals into distinct alloy groupings, a more accurate definition is necessary. Technically, bronze is understood to be an alloy of copper and tin, sometimes with other elements in smaller quantities present. Brass is an alloy of primarily copper and zinc, sometimes with other elements in smaller quantities also present. This more precise terminology will be used when classifying these medals by alloy composition.

Of the seventeen medals examined (table 1), eleven are bronzes (figs. 4–14); of these, most are leaded (containing 5 percent or more lead) (see figs. 8–14). Five medals are brass (fig. 3 and figs. 15–18), and one is an alloy containing primarily copper and lead (fig. 19).

In contrast, of the 202 cast Renaissance portrait medals of copper-based alloys analyzed as part of the National Gallery's systematic catalogue study (fig. 20), the majority

Table 1 (continued)

Hill No.	Elements (in percentages)								
	Copper	Tin	Zinc	Lead	Iron	Nickel	Silver	Antimony	Arsenic
178	77.2	14.7	0.6	1.8	0.3	0.8	0.2	3.4	1.0
189	83.1	10.9	2.5	0.7	0.2	0.4	0.2	1.2	0.9
161	79.9	9.0	1.1	3.6	0.2	0.5	0.2	3.5	2.0
162e	86.4	8.1	0.4	3.0	0.2	0.3	0.1	1.5	bdl
183	75.7	12.4	2.2	6.8	0.3	0.9	0.2	1.5	1.0
177	80.1	7.3	0.6	6.1	0.4	0.5	0.1	3.8	1.1
167	80.8	7.2	0.6	5.8	0.1	0.5	0.1	3.8	1.1
188	79.5	6.9	0.5	10.1	0.4	0.4	0.2	2.1	bdl
165	76.2	5.9	0.3	11.3	0.2	0.6	0.2	4.5	0.9
182	79.6	5.4	0.5	9.5	0.1	0.5	0.2	4.2	0.9
186	78.3	5.0	0.4	8.8	0.3	0.5	0.2	6.0	0.5
186	74.2	14.3	0.3	8.1	0.2	1.0	0.1	1.9	0.3
158	85.2	2.4	11.2	0.2	0.4	0.3	0.3	bdl	bdl
174	89.3	1.4	6.8	0.4	0.3	0.3	0.2	0.2	1.0
187	88.6	2.9	7.0	0.2	0.4	0.2	0.2	0.0	0.5
167	88.9	2.1	6.3	0.8	0.6	0.3	0.2	0.2	0.7
187	89.7	2.1	5.9	0.2	0.3	0.5	0.2	0.0	1.0
190c	86.8	0.6	0.8	6.9	0.2	0.4	0.2	3.4	0.8

(65 percent) are brasses. Fourteen percent are tin bronzes and only 7 percent are leaded bronzes, for a total of 21 percent of bronzes of both types. One percent is unalloyed copper, and the remaining 13 percent are quaternary bronzes (also known as leaded gun metals). Of the 202 Renaissance portrait medals examined, only nineteen contain antimony in greater than trace amounts (above 1 percent). In addition, most of these high-antimony medals contain significant quantities of arsenic. Of the group of nineteen medals containing high antimony, nine are attributed to Matteo de' Pasti. The remaining ten medals have been attributed to eight different fifteenth-century medalists from all over Italy.[26]

The Significance of Alloy Composition and Impurity Levels

During the Renaissance, copper ore was mined and crushed under water-driven stamps and washed to concentrate the ore. The concentrated ore was smelted using blast furnaces to extract crude copper cakes from the ore. These crude copper cakes were then refined also using blast furnaces to purify the metal, generally resulting in thin cakes of rosetta copper. This now "refined" copper metal was turned over to the coppersmith, armorer, or foundry worker to be finished by hand. The metallic copper produced had varying degrees of purity depending on a variety of factors: the original composition of the ore, the extent

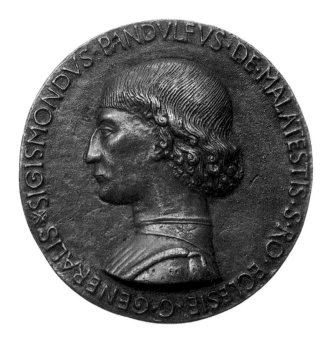 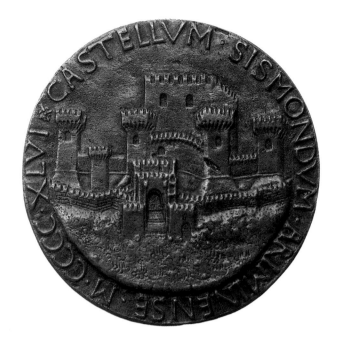

of smelting and refining the workman deemed necessary, as well as the order in which the copper was extracted from the melt (the first few cakes of rosetta copper produced are generally higher in impurities).

The bronze medals by Matteo—leaded or not—as well as the one copper and lead medal, contain unusually high antimony impurities (greater than 1 percent, see table 1). All but two of these high antimony medals also contain arsenic. This variation in impurities suggests that Matteo used metal refined from two separate types of antimony-containing copper ores for casting his portrait medals. One copper ore used, often referred to in mining terms as gray copper, is a complex mixed copper ore body of the tetrahedrite fahlerz type that are copper-arsenic-antimony sulfides such as $(CuFe)_{12}(AsSb)_4S_{13}$. This gray copper ore is indigenous to Freiberg in Saxony (Germany), Kremnitz in Hungary (today Kremnica in Slovakia), and mines near Saint Austell, Cornwall (as well as mines of North Carolina, whose ores were unavailable during the Renaissance).[27] Two medals—the portrait of Jesus Christ (fig. 7) and the portrait of Isotta with the closed book reverse (fig. 11)—contain high amounts of antimony but no arsenic; most likely these medals were made from metal refined from an antimonial copper ore composed of $Cu_2S+Sb_2S_3$, which occurs in the Harz mountain range

(Germany).[28] Furthermore, although in Cornwall mining for tin had existed from Roman times onward, it was not until the seventeenth century that Cornish tin miners began to seriously excavate the more valuable cupreous deposits nearby. Therefore, it is unlikely that the copper originated from Cornwall.[29] This fact narrows the origin of gray copper to the mines of Saxony and Hungary and the antimonial copper to the mines of the Harz region. All three of these mining districts were active during the Italian Renaissance (fig. 21).[30]

Antimony expands on cooling; this unique characteristic allows the finest details of the mold to be preserved. It also imparts hardness and a smooth finish to soft metal alloys, making it a valuable addition to alloys containing large amounts of lead.[31] Arsenic in the alloy also adds hardness to the lead in a leaded bronze. Lead in amounts over 2 percent is insoluble in copper and has an increased tendency to pool, thus creating a potential source of weakness. Of the five brass medals examined, all are low in lead (less than 1 percent), and none contained high levels of antimony. Therefore, considering the elemental composition of these medals, it seems likely that Matteo was aware of the special casting properties of alloys made from metals obtained from these complex mixed copper ores from Saxony and Hungary. He exploited

3. Matteo de' Pasti, obverse: *Sigismondo Pandolfo Malatesta, Lord of Rimini*; reverse: *The Castle of Rimini*, 1446, low-zinc brass
National Gallery of Art, Washington, Samuel H. Kress Collection

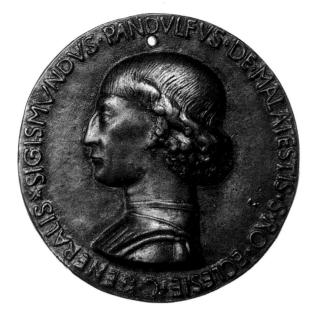

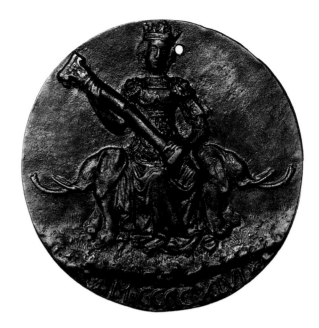

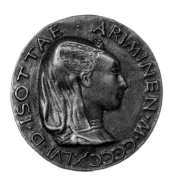

4. Matteo de' Pasti, obverse: *Sigismondo Pandolfo Malatesta, Lord of Rimini*; reverse: *Fortitude Holding Broken Column*, 1449–1450, bronze
National Gallery of Art, Washington, Samuel H. Kress Collection

5. Matteo de' Pasti, obverse: *Isotta degli Atti of Rimini*; reverse: *A Closed Book*, 1454–1460, bronze
National Gallery of Art, Washington, Samuel H. Kress Collection

these properties, using his knowledge of the characteristics of the metals refined from these ores to his advantage, at least with many of the medals cast toward the end of his career in Rimini.

Grouping the Medals by Their Properties

Pasini believes that all the motifs for Matteo's medals had been created by 1454; thereafter they were continually being reworked to achieve a more simplified design that resulted in an increase in empty spaces and a gradual shrinking of the inscription. For example, the stops in the form of the heraldic four-petaled Malatesta roses (fig. 10) are no longer prominent, and the little round points of inspacing have been replaced with a more classical motif of triangular points (fig. 16).[32] This continual reworking of the medal designs makes correlating alloy composition

with style virtually impossible. In addition, because the medals are commemorative, little correlation can be established between images that depict the sitter in various stages of maturity. Several broad generalizations, however, can be drawn by comparing the XRF analyses data.

Leaded Bronze

As mentioned, of the seventeen medals examined that are attributed to Matteo (fig. 22), the largest proportion (eleven) are bronzes, and of these, seven are leaded bronze. The Sigismondo medal with the castle of Rimini reverse, Hill 177 (fig. 9) is almost identical in elemental composition to the signed Isotta medal with the Malatesta elephant reverse, Hill 167 (fig. 10). These two medals are leaded bronzes with closely similar impurities; their composition suggests that they were cast at the same time and supports Pasini's premise that Matteo conceived these two medals to form a pair.[33] These medals are also comparable in alloy composition to four others: the Sigismondo medal with a castle of Rimini reverse, Hill 186 (fig. 14), Sigismondo with a [heraldic] shield reverse, Hill 165 (fig. 12), a Sigismondo with an emblem of authority reverse, Hill 182 (fig. 13), and the Isotta medal with a closed book reverse, Hill 188 (fig. 11). The Sigismondo medal with the San Francesco reverse, Hill 183 (fig. 8), also belongs in this group; even though it is currently cata-

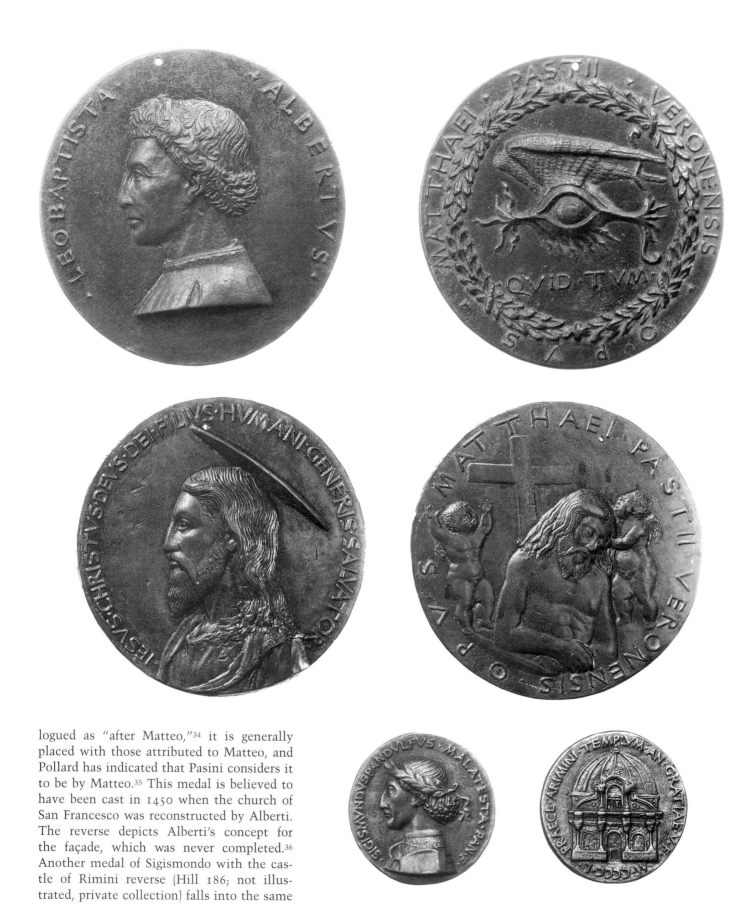

logued as "after Matteo,"[34] it is generally placed with those attributed to Matteo, and Pollard has indicated that Pasini considers it to be by Matteo.[35] This medal is believed to have been cast in 1450 when the church of San Francesco was reconstructed by Alberti. The reverse depicts Alberti's concept for the façade, which was never completed.[36] Another medal of Sigismondo with the castle of Rimini reverse (Hill 186; not illustrated, private collection) falls into the same

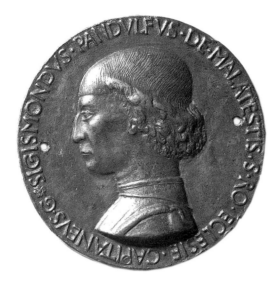

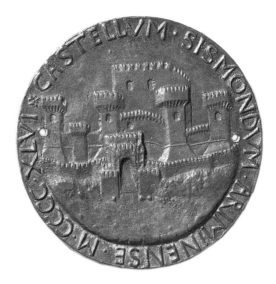

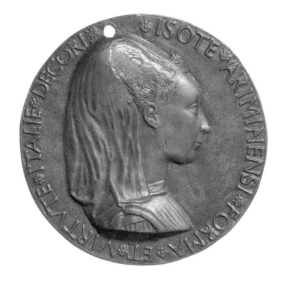

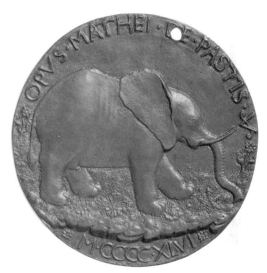

compositional group as the National Gallery leaded bronze medals.

Bronze

Three medals are bronzes with closely similar alloys and impurities: the Sigismondo medal with the Fortitude reverse, Hill 178 (fig. 4), the Isotta medal with the closed book reverse, Hill 189 (fig. 5), and the signed Leone Battista Alberti medal, Hill 161 (fig. 6). The signed Jesus Christ medal, Hill 162e (fig. 7), is a bronze similar in alloy composition to the three medals shown in figures 4, 5, and 6 except that arsenic has not been detected, and, if it is present, it is below the detection limits of the instrument. The Jesus Christ medal is believed to be contemporaneous with the Alberti medal, which has been conventionally dated between 1446 and 1450, when Alberti was in Rimini to oversee the reconstruction of the church of San Francesco.[37]

Copper and Lead

The Sigismondo medal without a reverse design, Hill 190c (fig. 19), is unique compared to the other Matteo medals, as it is neither a bronze nor a brass but is composed primarily of copper and lead. Nevertheless, its high antimony content range is similar to many of the other medals examined; this medal has been placed as "after Matteo" and is most likely a later work.[38]

Brass

The three other Isotta medals with the Malatesta elephant[39] reverse, Hill 187, 167, and 187 (figs. 16–18), as well as the Sigismondo medal with the castle of Rimini reverse, Hill 174 (fig. 3), are all low-zinc brasses with similar impurities. The portrait medal of Guarino da Verona, Hill 158 (fig. 15), who was a scholar and professor of the classics at the University in Ferrara from 1430 until his death,[40] is a medium-zinc brass; if antimony and arsenic are present, these elements are in levels below detection limits. This medal differs significantly in alloy composition, and its method of fabrication—with such fine details as wrinkles around the sitter's eye and neck, striated texturing of the face, and delicate chase marks—makes it the most refined of all the National Gallery medals in this group. The design of the medal also differs from other Matteo medals, and the inscription contains several types of lettering unlike other Matteo medals in the National Gallery collection. The G in GVARINVS and the first E in VERONENSIS appear in Gothic majuscules, as well as the E in MATTHEUS on the reverse. This medal, therefore, can be presumed to represent the product of a foundry different from those that produced the other medals analyzed for this study. Also, its distinctly different alloy composition, including impurities, and differing design support its dating as an early work by Matteo while he was active in Ferrara,[41] and not the more recent dating assigned to the medal.[42]

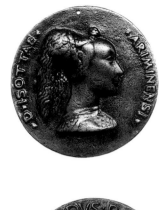
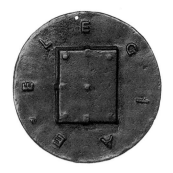
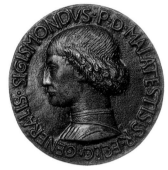
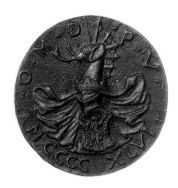
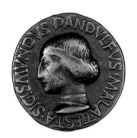
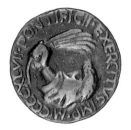

11. Matteo de' Pasti, obverse: *Isotta degli Atti of Rimini*; reverse: *A Closed Book*, 1446, leaded bronze
National Gallery of Art, Washington, Samuel H. Kress Collection

12. Matteo de' Pasti, obverse: *Sigismondo Pandolfo Malatesta, Lord of Rimini*; reverse: *Shield, Helmet, Elephant-crest, and Mantling*, 1450–1451, leaded bronze
National Gallery of Art, Washington, Samuel H. Kress Collection

13. Matteo de' Pasti, obverse: *Sigismondo Pandolfo Malatesta, Lord of Rimini*; reverse: *Emblem of Authority*, 1447, leaded bronze
National Gallery of Art, Washington, Gift of Lisa and Leonard Baskin

14. Matteo de' Pasti, obverse: *Sigismondo Pandolfo Malatesta, Lord of Rimini*; reverse: *The Castle of Rimini*, 1446, leaded bronze
National Gallery of Art, Washington, Samuel H. Kress Collection

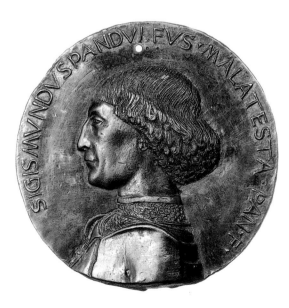
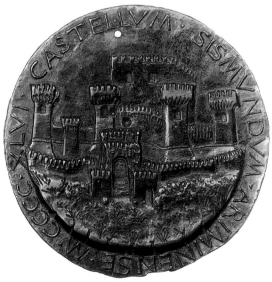

15. Matteo de' Pasti, obverse: *Guarino da Verona*; reverse: *Fountain Surmounted by a Nude Male Figure*, c. 1454–1455/1456, medium-zinc brass
National Gallery of Art, Washington, Samuel H. Kress Collection

16. Matteo de' Pasti, obverse: *Isotta degli Atti of Rimini*; reverse: *The Malatesta Elephant*, 1446, low-zinc brass
National Gallery of Art, Washington, Widener Collection

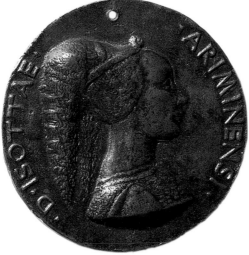

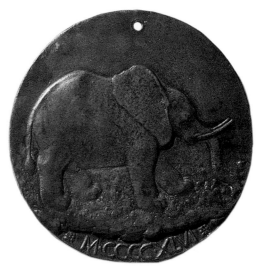

17. Matteo de' Pasti, obverse: *Isotta degli Atti of Rimini*; reverse: *The Malatesta Elephant in a Meadow*, c. 1453, low-zinc brass
National Gallery of Art, Washington, Widener Collection

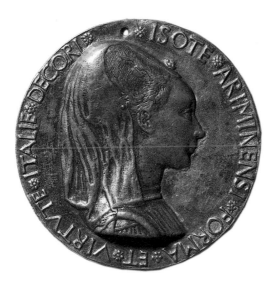

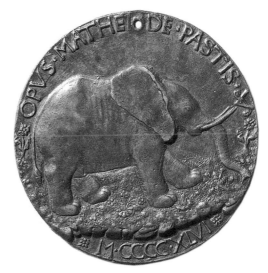

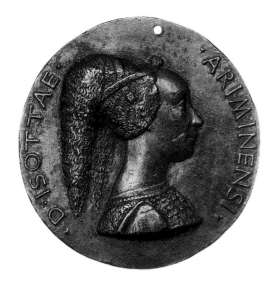

18. Matteo de' Pasti, obverse: *Isotta degli Atti of Rimini*; reverse: *The Malatesta Elephant*, 1446, low-zinc brass
National Gallery of Art, Washington, Samuel H. Kress Collection

Conclusion

This study was initiated to learn more about the unusual compositional nature of a series of portrait medals by Matteo de' Pasti. Microscopic examination revealed that all the medals were probably sand cast. There is little evidence of cold working on the medals,[43] which may be an indication of the attention to perfecting the mold so that few flaws occurred in casting. The medals classified as bronze produced by Matteo in Rimini, with or without lead, contain unusually high antimony impurities. All but two of these bronze, high antimony medals also contain arsenic. The one copper and lead medal examined (considered "after Matteo") contains significantly high levels of antimony and arsenic. This grouping by variation in impurities suggests that Matteo used metal refined from two separate types of antimony-containing copper ores for casting his portrait medals: gray copper, originating from the mines of Saxony and Hungary, and antimonial copper from the mines of the Harz region. This study has strengthened the belief that Matteo had an extensive knowledge of practical metallurgy, was well aware of the special casting properties of the alloys produced from these complex mixed copper ores, and used the metal obtained from these ores advantageously during the latter half of his career while he was connected with the Malatesta court in Rimini. The analysis of the medals, using XRF techniques, has brought us a step closer toward considering what trade routes

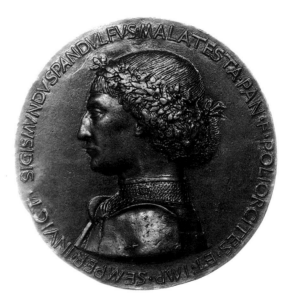

19. After Matteo de' Pasti, obverse: *Sigismondo Pandolfo Malatesta, Lord of Rimini*, probably 1456(?), copper and lead
National Gallery of Art, Washington, Samuel H. Kress Collection

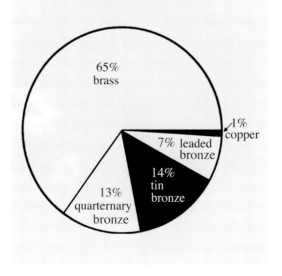

65% brass

1% copper

7% leaded bronze

14% tin bronze

13% quaternary bronze

20. Alloy composition of 202 cast National Gallery of Art Italian Renaissance portrait medals examined by XRF

21. Renaissance mining towns at the time of Agricola

From Bern Dibner, *Agricola on Medals* (Norwalk, Conn., 1958), Burndy Library, Dibner Institute for the History of Science and Technology, Massachusetts Institute of Technology, Cambridge, Massachusetts

22. Alloy composition of seventeen National Gallery of Art portrait medals by or attributed to Matteo de' Pasti examined by XRF

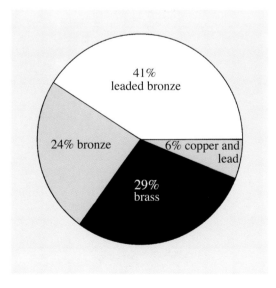

may have been used during the period Matteo worked. It also has enabled us to speculate about mine locations and ore preferences that may have been cultivated by individual Renaissance artists, based on the unique working properties of alloys prepared from specific sources.

NOTES

I especially thank Daphne Barbour, associate object conservator, National Gallery of Art, Washington, for her examination of the Matteo de' Pasti medals. The insights she offered on Renaissance casting practices of these medals were invaluable. Thanks are also due to other National Gallery staff, including Lorene Emerson, photographer for several of the images; E. René de la Rie, head of the scientific research department; Shelley Sturman, head of object conservation; Alison Luchs, curator of early European sculpture; and Douglas Lewis, curator of sculpture and decorative arts, for their encouragement and support throughout this endeavor. Last, I am indebted to Janice Gruver, editor for the conservation division, for her patience and diligence in reviewing this manuscript.

1. More than a decade ago, technical examinations began as part of the systematic catalogue survey of the National Gallery of Art's collections of portrait medals. This project has been an ambitious undertaking, for the catalogue includes technical and compositional information on each medal along with the art-historical interpretation. Insight into the metal composition and fabrication methods of these medals can assist in their attribution and provide valuable information on the metallurgical techniques the artists employed. The presence or absence of certain elements, even in trace amounts, can often provide clues about the fabrication date or establish statistical patterns that will lead to determining possible ore sources or even what trade routes may have been followed. J. Graham Pollard, "Medals," in The Collections of the National Gallery of Art, Systematic Catalogue, Washington, forthcoming.

2. Lisha Glinsman and Lee-Ann Hayek, "A Multivariate Analysis of Renaissance Portrait Medals: An Expanded Nomenclature for Defining Alloy Composition," Archaeometry 35 (1993), 49–67.

3. Stephen K. Scher, introduction to The Currency of Fame: Portrait Medals of the Renaissance [exh. cat., National Gallery of Art, Washington, and Frick Collection] (New York, 1994), 15.

4. See Mark Jones, The Art of the Medal (London, 1979).

5. Alison Luchs, "Matteo di Maestro Andrea de' Pasti," in Scher 1994, 59.

6. Scher 1994, 18.

7. Pier Giorgio Pasini, "Matteo de' Pasti: Problems of Style and Chronology," in Italian Medals, ed. J. Graham Pollard, National Gallery of Art, Studies in the History of Art, 21 (Washington, 1987), 143.

8. Ulrich Middeldorf, "On the Dilettante Sculptor," Apollo 107, no. 104 (1978), 310.

9. Luchs 1994, 59.

10. Pasini 1987, 143–159.

11. Pasini 1987, 143. For further information on the foundation medals, see Carla Tomasini Pietramellara and Angelo Turchini, Le Signorie dei Malatesti Storia Societa Cultura Castel Sismondo e Sigismondo Pandolfo Malatesta (Rimini, 1985), 131–145; and Pier Giorgio Pasini, "Note su Matteo de' Pasti e la Medaglistica Malatestiana," in La Medaglia d'Arte, atti del primo convegno internazionale di studio Udine 10–12 ottobre 1970 (Udine, 1973), 41–75. Unfortunately, alloy compositions of these foundation medals were unavailable for comparison.

12. George Francis Hill, A Corpus of Italian Medals of the Renaissance before Cellini, 2 vols. (London, 1930), 1:37–43, 319; 2:pls. 29–35. See table 1 for concordance of Hill number with National Gallery of Art accession number.

13. The medals under discussion were examined microscopically by Daphne Barbour, associate object conservator, National Gallery of Art, Washington.

14. George Francis Hill, Medals of the Renaissance, rev. ed.; ed. Graham Pollard (London, 1978), 25–27.

15. Cennino d'Andrea Cennini, The Craftsman's Handbook, "Il Libro dell'Arte" (c. 1390), ed. and trans. Daniel V. Thompson Jr. (New York, 1960), 130–131; Benvenuto Cellini, The Treatises of Benvenuto Cellini on Goldsmithing and Sculpture (1558–1562), trans. C. R. Ashbee (London, 1898; reprint, New York, 1967), 62; Alessio Piemontese, De Secreti del reverendo Donno Alessio Piemontese (Venice, 1555), 206–217; Vannoccio Biringuccio, De la Pirotechnia (1540), trans. Cyril Stanley Smith and Martha Teach Gnudi (New York, 1959), 323–332.

16. Biringuccio 1959, 323, 326, 331.

17. Scher 1994, 14.

18. For recent discussions on medal making, see Scher 1994, 13–14; and Patricia Tuttle, "An Investigation of Renaissance Casting Techniques of Incuse-Reverse and Double-Sided Medals," in Pollard 1987, 205–212.

19. Hill 1978, 28.

20. Tuttle 1987, 206.

21. Biringuccio 1959, 325.

22. XRF uses x-rays for sample excitation. X-ray photons that are directed at a sample, such as a portrait medal, interact with atoms in the sample. As an x-ray travels through a sample, it may be absorbed, giving up its energy to a sample electron that escapes from its orbital, leaving a vacancy. The atom is then in an unstable (excited) state. To regain stability, an electron from an outer shell drops into the inner shell vacancy, emitting x-rays as it does so. The atom is said to be in the stable (ground) state. Each x-ray emitted has a specific energy described by the energy difference between the excited and ground states of an atom or ion. These are called transitions. Each element has many possible series of transitions occurring simultaneously. These result in the generation of the K, L, and M (among others) transition lines that are observed as peaks on the x-ray spectra. The energies of the electron transitions are characteristic of the elements present in a sample and are detected and recorded as a series of peaks in a spectrum by the XRF instrument. Because the number of x-rays produced is proportional to the number of atoms present in a sample, quantitative elemental concentrations can be determined from the intensities of the energy peaks.

23. See also Daphne Barbour and Lisha Deming Glinsman, "An Investigation of Renaissance Casting Practices as a Means for Identifying Forgeries," in *Conservation Research*, National Gallery of Art, Studies in the History of Art, 41, Monograph Series II (Washington, 1993), 15–29.

24. C. F. Carter, "Preparations of Ancient Coins for Accurate XRF Analyses," *Archaeometry* 7 (1964), 106–113. As XRF analyzes approximately 10 to 20 microns depth of a copper alloy, factors such as inhomogeneity of the surface, surface enrichment or depletion, and certain patinations need to be considered when interpreting the results. Carter suggests that one way to avoid such results is by polishing or removing surface patination by acid treatment; this has not been done in the National Gallery of Art study, however, because removal of material from the medals was not permitted and also would diminish their artistic and monetary value. In addition, Carter's recommendation of abrading or acid treatment of the metal surface can destroy evidence of manufacturing techniques important to the study of these medals. Unlike the Roman coins Carter discussed, the portrait medals analyzed are not ancient burial objects and are in excellent condition, relatively clean, and free from corrosion. Therefore, it was decided that XRF analyses using calibrations with known standards of similar composition would be acceptable.

25. The XRF analyses were performed using a Kevex 0750A spectrometer. The x-ray tube and detector are mounted on a steel column that allows for vertical and horizontal movement of the spectrometer. The portrait medal is placed on an easel in front of the XRF where a laser and incandescent lamp are used to focus on the desired sample area. The spectrometer was equipped with a barium chloride secondary target, 6 mm collimators with an anode voltage and current of 60 kV and 0.4 mA, respectively. Live accumulation time was 200 seconds. Secondary targets provide nearly monochromatic x-rays to excite the sample and enhance the spectral lines of the elements analyzed. Because the Kevex spectrometer is an air-path instrument and is not equipped with a light-element detector, elements lighter than sulfur were not detected and are not included in these analyses. The results were quantified using the EXACT software program provided by Kevex that calculates elemental weight percentages and were compared with National Bureau of Standards (now the National Institute of Standards and Technology) UE 52-2 and UPB 83, as well as Tymetal standards BA 8-11. The results were normalized to 100 percent (each element was divided by the total and multiplied by 100) and an average value was determined.

The accuracy of each element is influenced by matrix effects as well as concentration level, the total number of counts acquired, and sample geometry. Under the best of conditions, quantities of major elements detected in the medals are valid to a range of approximately 5 percent (2.5 percent above or 2.5 percent below a reading), the minor elements with less than 1 percent concentration are accurate to a range of approximately 30 to 40 percent (15–20 percent above or below), while elements less than 0.1 percent are considered trace amounts and cannot be accurately quantified. The detection limits for trace elements are approximately 0.05 percent.

26. Glinsman and Hayek 1993, 54–55.

27. Robert H. Lamborn, *A Rudimentary Treatise on the Metallurgy of Copper*, vol. 1, suppl. ser. (London, 1860), 32–33.

28. Lamborn 1860, 35.

29. Lamborn 1860, 7–8.

30. Bern Dibner, *Agricola on Metals* (Norwalk, Conn., 1958), 8; William Barclay Parsons, *Engineers and Engineering in the Renaissance* (Cambridge, Mass., 1976), 179.

31. George S. Brady and Henry R. Clauser, *The Materials Handbook* (New York, 1979), 57–58.

32. Pasini 1987, 143–159. See George F. Hill and Graham Pollard, *Renaissance Medals from the Samuel H. Kress Collection at the National Gallery of Art* (London, 1967); Pasini 1987; and Scher 1994, for a discussion on the significance to the sitter of images on the reverse of the medals.

33. Pasini 1987, 146–147.

34. Hill and Pollard 1967, 17.

35. Pollard (forthcoming).

36. Hill 1978, 46.

37. Hill and Pollard 1967, 16.

38. Hill and Pollard 1967, 17.

39. Pollard (forthcoming) believes the Isotta/Malatesta elephant portrait medal (fig. 18; 1957.14.655a, b) is a late copy (aftercast) from an unknown Rimini workshop using Matteo's original medals.

40. Luchs 1994, 60.

41. Hill and Pollard 1967, 15–16.

42. Although Pollard (forthcoming) has recently redated this medal as a late work, my analysis supports an earlier date and foundry.

43. An exception is the Guarino da Verona medal, which is believed by Hill and Pollard (1967) to be an early work produced in Ferrara.

ANN HOENIGSWALD

Kazimir Malevich's Paintings: Surface and Intended Appearance

A
lthough he was a prolific writer on the philosophy of art, Kazimir Malevich (1878–1935) wrote relatively little about his painting technique, and virtually nothing is known about his specific choice of materials. Yet a close examination of his paintings reveals a remarkably sophisticated approach to materials and the painting process. In an April 1933 photograph (fig. 1), Malevich is shown seated before his *Girl with a Red Staff* of 1932–1933. When compared to the painting today, the photograph clearly suggests that the artist continued to work and rework his canvas.

From his earliest works to those of his final years, Malevich was keenly aware of the expressive and formal potential of his materials, and with skill, subtlety, and invention, he exploited the properties of these materials in a variety of ways. He wrote, "Color and texture in painting are ends in themselves, the very essence of painting."[1]

To present color and texture in their purest form, Malevich realized it was essential to focus on the surface of a painting. Many artists deal with the final surface by applying an overall varnish or by choosing to leave their pictures unvarnished. Malevich, in contrast, controlled the subtlety of his paint surfaces at every stage of their creation. Because of his unique handling of each stage of his compositions, the paintings in the 1990–1991 exhibition *Kazimir Malevich, 1878–1935* afforded both art historians and painting conservators an opportunity to learn more about

his focus on materials.[2] It became evident that Malevich's manipulation of materials to alter and contrast the surface appearance was of great importance to him. The choice of pigments and selective handling of materials as well as the decision whether or not to use surface coatings affected the appearance of his paintings. This concern is not unique to Malevich, but it was easily studied because of his known pronounced focus on the importance of surface characteristics and the well-preserved state of so many of the paintings examined. My observations about Malevich's paintings are the result of simple visual examination and the use of ultraviolet light, infrared reflectography, x-radiography, and x-ray fluorescence spectroscopy. Discussion will follow in the manner in which I examined the paintings, beginning with the support and followed by the ground, paint, and varnish or coating layers. Table 1 lists all the works examined, by date (see page 125).

The Support

Although Malevich also painted on cardboard and wood supports, I have focused primarily on the variety of fabric supports. Of the works in the exhibition, to which my examination was almost exclusively limited, at least ten to fifteen types of fabric can be identified. For purposes of general identification, they will be referred to as "canvas." However, the supports ranged from commercially prepared

canvas, seemingly identical to what was generally used by European painters at the beginning of the twentieth century, to canvas that was very coarse and rough, which Malevich used at the end of his career. One could legitimately question whether this coarse canvas was even intended for artists' use. While Malevich used a wide range of support materials, it seems he did not do so in a consistent pattern. What remains unresolved is whether this variety of supports was the result of choice or of necessity.

The availability of artists' materials in Russia before and after the revolution remains unclear. Contemporaneous photographs show ample fabric was available for the enormous revolutionary banners that virtually covered façades of buildings. On the other hand, we know that by the early 1920s the most basic materials were in short supply for the average citizen.[3] Yet if fabric was readily available to glorify the revolution, it is not known whether Malevich would have been in a position to purchase it; conversely, if basic goods were difficult to obtain, Malevich may or may not have had some access to them. An indication of fabric availability for Malevich is revealed by the fact that the 1990–1991 exhibition included only one canvas that was painted on both sides, *The Woodcutter*, 1912, and *Peasant Women at Church*, 1911 (fig. 3). If artists' canvas was scarce in the years preceding the revolution, it seems likely that reuse of a canvas would have occurred more frequently; therefore, it is more likely that Malevich employed a range of materials by choice rather than necessity.

The Ground (Priming)

Malevich used both primed and unprimed canvases. Although it can be assumed that availability occasionally dictated his choices, his techniques show he was adept in utilizing the properties of both types of canvas. Moreover, it is likely he realized that unprimed absorbent fabric could produce the appearance he sought to achieve on the paint surface. He also made use of unprimed canvas as a compositional device. This aspect is particularly pronounced where the unprimed canvas itself reads as a distinct tonal and textural area that serves to separate colors, as it does in *Suprematist Painting*, 1917–1918 (cat. no. 58),[4] where the unprimed fabric sep-

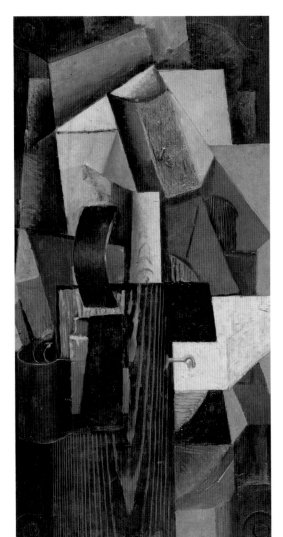

1. Kazimir Malevich seated in front of *Girl with a Red Staff*, 3 April 1933, Saint Petersburg
Photograph: Nikolai Suetin

2. Kazimir Malevich, *Vanity Case*, 1913, oil on wood
State Tretiakov Gallery, Moscow

3. Kazimir Malevich,
Peasant Women at Church,
1911, oil on canvas
Stedelijk Museum, Amsterdam

4. Detail, fig. 3, showing
unprimed canvas

arates the white background from the yellow
wedge. Malevich fully exploited the nature
of an unprimed support in *Vanity Case*, 1913
(fig. 2), exaggerating the natural grain of the
wood panel with paint and incorporating its

texture into the overall design.

Malevich's most conspicuous use of un-
primed canvas can be found in *Peasant
Women at Church* (fig. 3). Significant sec-
tions of the image are delineated by the
exposed fabric (fig. 4). This technique paral-
lels Malevich's execution of large gouaches
in the same year in which the exposed paper
support similarly plays a critical visual role
in the image as a whole.

Although Malevich used unprimed canvas,
presumably to draw attention to the rustic
nature of the subjects through the simplicity
and roughness of the fabric, the majority of
his paintings were executed on primed sup-
ports. While it appears he was interested in
exploiting the absorbent qualities of unprimed
fabric, which would leach the medium from
his paints, he also used primed canvas to
achieve greater control over his materials
and the final visual appearance of his paint-
ings. It is much easier to manipulate the
range of absorption on a primed surface than
on one that is unprimed. Some of Malevich's
canvases appear to have been commercially
prepared; yet, even then, it can be observed
that he occasionally rubbed through the pro-
prietary priming or added subsequent layers
of his own. There are also instances in which
he seems to have done the priming on large
expanses of fabric before stretching them.

As with the choice of fabric, the type of
ground used was directly related to Malevich's
concern for the quality of the surface of the
painting. The more absorbent the ground
material, the more matte in appearance the
oil paint layer becomes. In contrast, the denser
(and less absorbent) the ground, the richer the
applied oil paint would appear. Malevich used
both types of ground to achieve a greater vari-
ety in his surfaces.

The ground materials were examined visu-
ally in the areas of the well-preserved tacking
margins and in exposed areas on the surfaces
of the paintings. Malevich preferred white, off-
white, or slightly grayish grounds. An excep-
tion is an unusual ground that has the appear-
ance of either a thick glue, an emulsion, or
even glue in a pulp base. It imparts a very
smooth, brown, absorbent surface that resem-
bles a board more than a fabric support. In
addition, so much of the oil is leached from
the paints that the medium takes on the
appearance of a pastel. Malevich used this
unusual ground for *Peasants*, c. 1928 (fig. 5)

5. Kazimir Malevich,
Peasants, c. 1928,
oil on canvas
State Russian Museum,
Saint Petersburg

and *Complex Premonition (Half Figure in a Yellow Shirt)*, 1928–1932.[5] It appears that he knew this type of ground would produce the characteristics he sought. In *Peasants*, in particular, Malevich allowed much of this brownish ground to remain exposed, and, in addition, his underdrawing in both pencil and brush is easily visible (fig. 6). It seems unlikely that he intended to varnish this painting, as its character depends on the matte quality of the materials. However, in *Complex Premonition (Half Figure in a Yellow Shirt)* of the same period, he locally applied a surface coating to the paint layers. Here he carefully avoided the areas of exposed ground to retain the ground's matte character and draw attention to its contrast in surfaces.

The Paint Surface

Beyond the support and ground materials the artist's most essential tool is the paint surface. All of Malevich's paintings, whether on

6. Detail, fig. 5, showing underdrawing

fabric or panel, appear to have been painted with oil paint. Presumably he used commercially supplied materials, but there is no documentation of his purchases. Malevich manipulated his medium to achieve a far greater range of surface effects and textures than most of his contemporaries did. Although many areas of his paintings were, in fact, monochromatic, the paint itself became highly modulated and animated. His methods, however, were not limited to the use of conventional impasto or palette knife—the technique used by his contemporaries. Another indication of a fascination with the contrast of textures is the fact that he even occasionally signed his paintings by incising his name into the wet paint.[6]

On occasion, Malevich controlled his brush with such skill that he was able to manipulate paint sculpturally, creating planes and volume in the paint texture itself. For example, in the panel *Vanity Case* (fig. 2) he distinguished the three planes of the box by altering the texture and layering of paint to different degrees (fig. 7). Malevich gave form to the box by scratching through the paint surface to reveal lower levels of paint. He used this technique rather than the more traditional method of adding pigment or manipulating tone to indicate shadows and highlights. By using this method, the front plane of the painting reveals relatively less of the paint layer underneath than is seen on the surface plane that reaches back, which was handled with short, stippled strokes; the

top of the box was worked out in longer, broader strokes to differentiate the planes. Equally calculated handling is evident in *Peasant Woman with Buckets*, 1912. Here it is possible Malevich applied paint with a short, stiff brush to create a convincing sense of volume in the conical forms. Although both paintings reflect skill in applying paint to the canvas, the handling and effect he achieved in them are very different. The surface of *Vanity Case* (and its accompanying two panels, *Through Station. Kuntsevo* and *Cow and Violin*, both 1913) is deliberately rough and crudely textured compared to the surface of *Peasant Woman with Buckets*, which has a more refined, silklike quality. In both paintings cited above, and in many others, this paint manipulation also enhances the play of light on the surface of the painting. It is possible that Malevich intended to leave these four paintings unvarnished to highlight the brushwork. Today the varnished surfaces of the paintings impart a uniformity to the surface that Malevich had wanted to differentiate; as a result, the effect has been diminished.

It seems Malevich frequently leached oil out of his paints before applying them to the canvas, or he added driers. Again, while there is no documentation to support this assumption, visual examination and the appearance of many of his canvases in ultraviolet light strongly suggest such a technique. The black paint used for the head in *Suprematism. Female Figure*, c. 1928–1932 (fig. 17) may have been leached (it is very dry and almost granular in appearance); in addition, paintings with unusually wide cracks, for example, *Sportsmen*, c. 1928–1932, may have had driers added to individual paints. It is also possible that Malevich added medium or varnish to his paints as he worked. For the black horizontal bar in *Suprematist Painting*, before 1927 (cat. no. 65) (fig. 13), he may have had additional medium or varnish added to the paint, which increased the gloss. Using this technique, Malevich was able to model or flatten forms merely by controlling a single pigment. This approach is not unlike his careful working of drawing media in *Vertical Suprematist Construction*, c. 1920, in which he manipulated the graphite pencil to alter the blackness and line to differentiate the two halves of the circle. This technique became slightly more sophisticated in *Verti-*

7. Detail, fig. 2, showing textures and layers of paint

cal Construction/Suprematist, c. 1920, as he contrasted the interior of the diamond that was formed by the velvet quality of the graphite with the waxy, crayon perimeter. In *Girls in the Field*, c. 1928 (fig. 8), he handled the black paint in the head of the central figure (fig. 9) in much the same way, adding varnish to the paint applied to the lower half of the right side of the face.

Malevich consciously manipulated paints to produce glossy and matte effects; he also recognized that certain paints had inherent characteristics that could be exploited for his purposes. Again, *Girls in the Field* illustrates this technique. The head to the far left is divided in half vertically so that the left side is matte and the right side is glossy. Rather than producing this effect with applied varnish, Malevich may have used lead white on the left side and zinc white, which fluoresces strongly in ultraviolet light, on the right side.[7] While Malevich may not have understood the chemical distinctions between lead white, which produces a chalky mixture when it dries, and zinc oxide white, which produces a hard, brittle surface,[8] it is likely that he understood the characteristics of these materials well enough to modulate an otherwise indistinct surface.

Malevich's preoccupation with the expressive potential of the paint was by no means limited to his figurative work. As with *Girls in the Field*, in his white-on-white suprematist paintings of 1917 and 1918 he juxtaposed what appears to be lead white with zinc white. This juxtaposition, of course, emphasized both the contrast between a gloss and a matte surface as well as their tonal variations. There may also be slight paint additions to the whites,[9] but the major difference in surface appearance seems to stem from the choice of white paint rather than significant additions of color. Additional medium or varnish may also have been a factor in variation of surface gloss. However, whether it was the choice of paint or the altering of the pigment, Malevich's focus was certainly on surface effect. The subtlety with which he deployed these materials is especially apparent in the suprematist series: in *Suprematist Painting*, 1917–1918 (cat. no. 59), he painted the background in matte white and the forms in glossy white paint, and in *Suprematist Painting*, 1917–1918 (cat. no. 60), he did the opposite.[10] The contrast must have been very

striking when these paintings were exhibited side by side in Moscow in 1919.[11]

The rich, textural interplay of the paint surfaces in his white paintings demonstrates Malevich's careful devotion to surface. It is likely, however, that the concept of the monochromatic shapes was actually formulated during the creation of his earlier works. In his early work, Malevich frequently painted a white background up to drawn lines on the ground; essentially, he was creating a white-

8. Kazimir Malevich, *Girls in the Field*, c. 1928, oil on canvas
State Russian Museum, Saint Petersburg

9. Detail, fig. 8, showing black paint where varnish has been added

on-white image. This technique is in contrast to most artists' approach, which is to paint in the colored forms first. In *Suprematist Painting*, 1915 (cat. no. 50) (fig. 10), Malevich allowed some ground to remain exposed, and

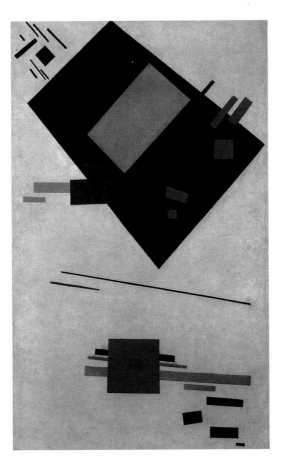

10. Kazimir Malevich, *Suprematist Painting*, 1915, oil on canvas (cat. no. 50) Stedelijk Museum, Amsterdam

11. Detail, fig. 10, showing ground exposed

it is among the best examples of this technique. His sequence was to draw the shapes on the white ground in pencil, paint the white background up to the designated lines, and subsequently paint in the colored forms. In the area around the lower red square he left the ground exposed on the two horizontal bars (fig. 11). Here again, the step preceding the application of color was white-on-white.

As a skilled colorist, Malevich was able to manipulate color by both juxtaposing and layering tones; he understood that the application of color should be neither minimized nor ignored. He was interested in the interaction between complementary colors, which can be observed in his frequent juxtaposition of red and green; conversely, he also layered colors in a more subtle technique. This layering of color is evident as the blue paint emerges from under the green grassy areas in *Haymaking*, c. 1928 (fig. 12). Here he scratched into the top layer of paint to reveal the lower layer that had already dried. This layering is also emphasized in the pail, painted in blue over a dried red layer, which is held by the central figure. The red undertone in the pail is not eliminated, however; a sliver of color peeks through at the edges, which intensifies the blue by creating an aureole around the pail.

The widespread presence in many of his paintings of drying cracks (which are the result of multilayer applications of paint without allowing sufficient time for lower layers to dry before adding subsequent layers) and the frequent evidence of his working into the wet paint suggests that Malevich worked rather quickly. His artistic process can be followed by examining his method of producing the straight edges on his suprematist works. As an early precursor to the masking-tape method used much later by Frank Stella (b. 1936), Malevich apparently produced a sharp line by placing a card adjacent to the area he wanted to delineate and then feathered strokes off the card onto the canvas. Although we presume his goal was only to achieve a clean delineation between two color areas, Malevich frequently created an additional textural element, for he rarely allowed the underlying paint to dry and hence pulled it up when he removed the card after applying the colors. We can speculate whether he overlooked the relief he had created or, instead, actually welcomed this "ac-

12. Kazimir Malevich,
Haymaking, c. 1928,
oil on canvas
State Tretiakov Gallery, Moscow

tive" touch. Thus, in addition to his conscious manipulation of paint, this effect may be identified as a kind of unconscious byproduct. Although these effects are most pronounced in Malevich's oil paintings, they can also be observed in his gouaches. In these, in attempting to "white out" a change, he often added a new stroke that strengthened the form. This same technique is used in his oil paintings, but not as a remedial step. It is a deliberate additional stroke for emphasis, and it results in a redefinition of forms.

Conservators and art historians in general have debated whether pentimenti, or artists'

changes, were actually meant to be seen. As a painting ages and paint layers become increasingly transparent, pentimenti frequently emerge with greater clarity. In our examination of Malevich's paintings, x-radiographs enabled us to observe where Malevich altered elements or even changed entire compositions.

There is no question that in some paintings the changes were intended to cover the original image, as was the case with the head that can be seen under the house in *Red House*, c. 1932,[12] and which is visible only in x-radiographs. Similarly, the initial composition beneath *White Square on White*, 1918, has been revealed through x-radiographs.[13]

It could also be argued that Malevich may have been intrigued by the emerging images as he painted. In *Suprematist Painting*, before 1927 (cat. no. 65) (fig. 13), which reveals the ghost of an earlier image through the transparency of the white paint (fig. 14),[14] and in *Suprematism*, 1915 (cat. no. 54) (fig. 15), both options present themselves. Although now quite distinct, the changes in *Suprematist Painting* (cat. no. 65) were not likely meant to be seen. In the 1915 *Suprematism* (cat. no. 54), however, the cracks in the upper layers

and many of the alterations that define the lower layers were probably visible soon after they were painted (fig. 16), as they are typical of results that occur when a paint layer is applied over another that has not yet fully dried. The manner in which Malevich applied the top layers of paint teases the eye with the shapes or hints of color from the previous layer and actually invites the viewer to notice the changes.

In *Suprematism. Female Figure*, c. 1928–1932 (fig. 17), the drying cracks that appear over the small, ghostlike figures on either side of the central figure probably emerged soon after Malevich made the changes. Through the cracks clear indications of the colors of the figures underneath can be seen (figs. 18, 19). The visible impasto of the earlier image is hardly masked; in fact, its existence implies that the changes were not immediate. Sufficient time had to have elapsed for the thick lower paint layer to dry. Although the transparency of the top layer has no doubt increased over time, the lingering images suggest that Malevich intended or at least accepted their presence. He knew the changes were visible and yet chose not to obliterate

13. Kazimir Malevich, *Suprematist Painting*, before 1927, oil on canvas (cat. no. 65) Stedelijk Museum, Amsterdam

14. Fig. 13, viewed in transmitted light

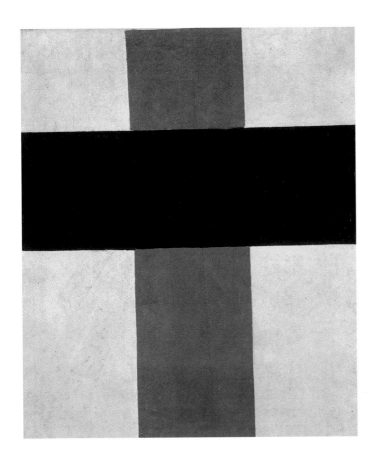

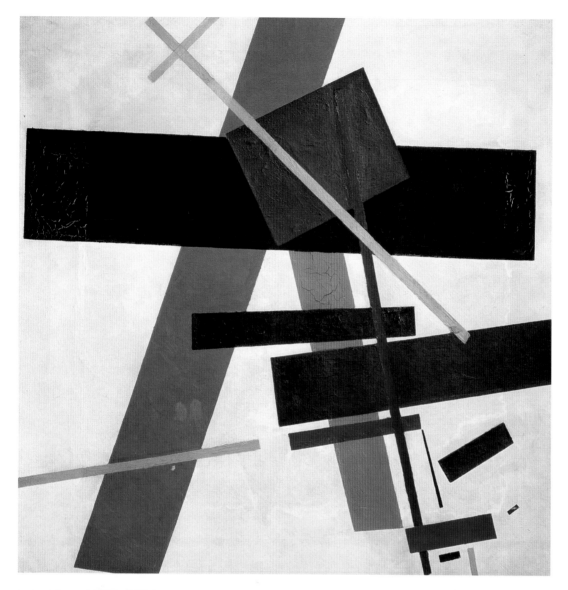

15. Kazimir Malevich,
Suprematism, 1915,
oil on canvas (cat. no. 54)
State Russian Museum, Saint
Petersburg

16. Detail, fig. 15, showing
the cracking in the left area
revealing colors in the
underlayer

17. Kazimir Malevich, *Suprematism. Female Figure*, c. 1928–1932
State Russian Museum, Saint Petersburg

18. Schematic drawing of fig. 17, showing locations where color remnants and original figures are visible through the cracks

19. Detail, fig. 17, showing original figure on the lower right side of the central figure

these images or to reintegrate the work. I suggest, therefore, that on these paintings he allowed the cracks to remain and the images to emerge, even revealing the initial intent to portray the figures in color. These pentimenti serve both as a record of the painting process and as a poignant reminder of the solitude of the central figure. In this painting, Malevich used technique as an expressive tool.

The Surface Coating

In many ways the surface coating of a painting is the most difficult area of study because it is not always possible to differentiate an artist-applied coating from one that was added by someone else. The surface coating generally serves one of two functions—either to protect the paint layer or, more frequently, to saturate it. Malevich seems to have exploited the second practice in an unconventional way. Far from using a surface coating merely to saturate colors, he manipulated the gloss-matte relationship in his paintings by applying varnish locally. Malevich lamented the difficulty of achieving weight on a form;[15] local varnish was one means of dealing with

this problem. Focusing on particular paintings, where it appears that he carefully controlled the surface coating, has enabled us to better understand how he utilized the effects of varnish.

Among the earliest examples of Malevich's use of a surface coating are the gouaches he painted during 1908 and 1909. He later adapted the traditional gouache materials and methods to his oil paintings. In gouache, a medium with limited surface characteristics, an artist frequently depends on the addition of a coating of water-based gum or egg white to vary the gloss,[16] a coating that, in turn, affects the saturation and ultimately the sense of depth and form. In *Self-Portrait*, c. 1908–1909 (fig. 20), Malevich carefully reinforced some of the forms in the background with a transparent coating. For example, he articulated the shape of the body of the nude figure on the right (fig. 21) by carefully applying the coating with fine strokes, which highlight the nude's back. He subsequently painted over the coating with additional gouache to enliven the interplay of surface and form. Clearly, he understood that the contrast of saturated and unsaturated paint would enhance the modeling of the form.

Such controlled manipulation of the coating is less frequently seen in oil paintings than in gouaches because the artist has many more opportunities to alter the gloss by experimenting with the oil paints themselves. One can add a drier, more or less medium, or varnish to the paint, or, conversely, leach oil out of it. Certain pigments with varying absorptive qualities can produce particular surface characteristics. The paint layer can be coated either locally or uniformly. Because Malevich carefully chose his materials and his paintings have received good care, his original intent for surface appearance is still easily recognizable.

It appears that, as a result of his experience in using gouache, Malevich frequently chose a water-based material, possibly egg white or more likely a gum, to coat some of his paintings locally even while he continued to work on them.[17] This practice is apparent in *Haymaking* (fig. 12), where the coating was applied over the central figure's black hair and the blue sky was subsequently partially laid in over the coating.

Apparently, Malevich did not use a traditional natural resin varnish in his local appli-

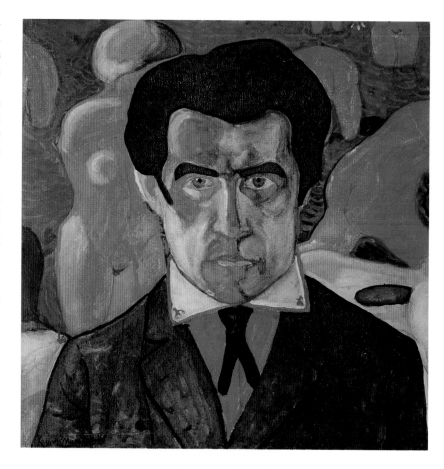

20. Kazimir Malevich, *Self-Portrait*, c. 1908–1909, gouache and varnish on paper
State Tretiakov Gallery, Moscow

21. Detail, fig. 20, showing fine brushstrokes of a coating highlighting the nude's back

cations of coating. Viewed in ultraviolet light, these paintings do not produce the characteristic fluorescence of a resin coating, and they have not yellowed as paintings with an aged natural resin varnish film would have. Moreover, the paintings have a satin finish rather than a high-gloss shine, and the presence of small bubbles may indicate the surface tension that can build up between a water-based material and a layer of oil paint.

Malevich juxtaposed coated and uncoated paint surfaces. This juxtaposition can be seen in *Three Female Figures*, c. 1928–1932 (fig. 22), where he has selectively coated certain areas (fig. 23), or in *Peasant Woman*, c. 1928, where he applied a coating exclusively to the black paint on the figure's hands and feet. He appears to have achieved somewhat similar effects by contrasting leached and unleached areas of paint with coated areas, and, on occasion, he may have even added extra medium or possibly varnish to paints to increase the gloss.

Until the late 1920s Malevich left most of his finished paintings unvarnished. He relied more on the character and handling of the paint itself to differentiate the surfaces. It was in the later figurative images that he began

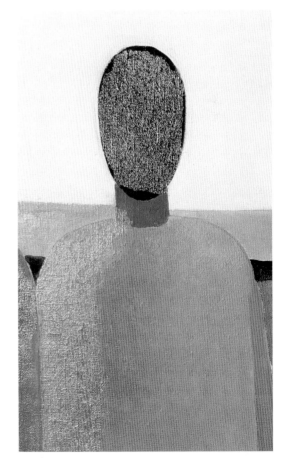

more extensively to manipulate coated and uncoated areas and to focus on gloss-matte relationships.

The stripes in *Red Cavalry* represent many variations of surfaces. By using his understanding of the characteristics of each pigment, Malevich alternated gloss-matte bands without applying varnish. In *Going to the Harvest: Marfa and Vanka*, c. 1928 (fig. 24), however, he used a locally applied coating on the figures and the background (fig. 25). Ultraviolet light reveals that he has probably alternated zinc white and lead white in the largest figure: the proper left arm is painted with zinc white (which imparts greater inherent gloss) (fig. 26); the proper right arm (painted with lead white) is more matte. In the area between the arms, the back of the larger figure is painted with lead white at the top proper left shoulder and then moves into an area of zinc white as it blends into the black paint. It is noteworthy that Malevich used both a surface coating and selected pigments to achieve a variation in glossiness in a single painting.

Although Malevich generally used coatings to differentiate small forms and to manipulate the paint itself in larger areas of a painting, there are some exceptions. *Girl with a Comb in Her Hair*, 1932–1933, observed with ultraviolet light, shows fluorescence in the face, suggesting that lead white was used for highlights while the rest of the face is painted with zinc white. *Three Female Figures* (figs. 22, 23) is also of interest because of the artist's effective use of a coating. Here the

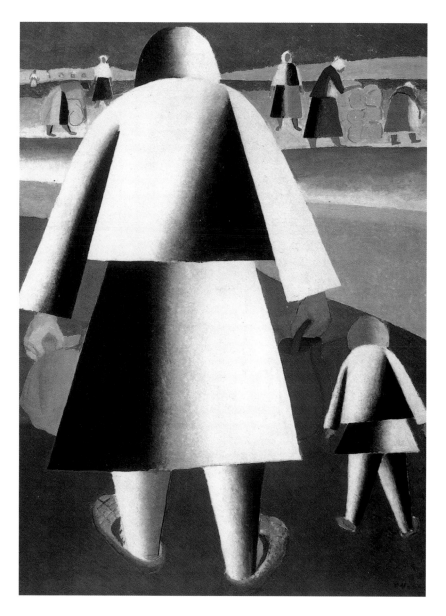

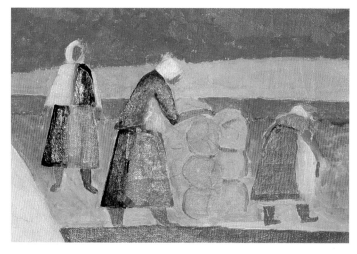

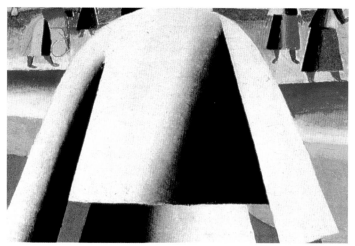

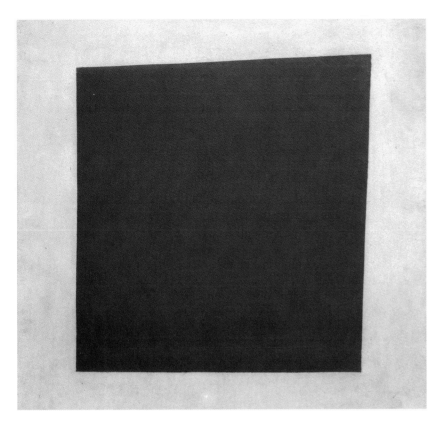

24. Kazimir Malevich, *Going to the Harvest: Marfa and Vanka*, c. 1928, oil on canvas
State Russian Museum, Saint Petersburg

25. Detail, fig. 24, showing three women in upper right, viewed in raking light

26. Detail, fig. 24, showing arms of largest figure viewed in raking light

27. Kazimir Malevich, *Red Square (Peasant Woman. Suprematism)*, 1915, oil on canvas
State Russian Museum, Saint Petersburg

28. X-radiograph, detail of fig. 27, showing lower left corner

black head on the right is coated almost uniformly while the figure's torso is coated only on the proper right side to flatten and also emphasize the form. X-ray fluorescence reveals that the same pigments were applied on both sides of this figure.[18] This finding suggests that the tonal variation we see is due to the carefully controlled saturation of the coating material.

Conclusion

Despite all Malevich's preparatory sketches and complex discourses on theory, his mature painting method reflects a culmination of technical experimentation that evolved over a period of time. Nearly all the paintings in the exhibition that I had an opportunity to examine closely had compositional alterations. The clearest demonstration of the artist's evolved process can be seen in *Red Square (Peasant Woman. Suprematism)*, 1915 (fig. 27), where Malevich explicitly invites the viewer to witness his development of the painting. Although these changes are readily apparent to the naked eye, they are further enhanced by an x-radiograph (fig. 28), which reduces the image to black and white and eliminates the distraction of color. The composition was

initially conceived as a near-perfect square with four right angles; under magnification, pencil lines that served as underdrawing can be seen at the lower left-hand corner, and infrared reflectography confirms that these lines extend around the "perfect" square. Malevich deliberately distorted the square by extending the top right corner. Rather than carefully blending in the paints, he chose the same pigment but altered his handling of it; while the bulk of the square was painted in stiff, long diagonal strokes, the addition—or distortion—was produced with softer, rounded, less directionally oriented strokes. By calling attention to the distortion, Malevich was clearly engaging the viewer in the act of completing the painting.

Although Kazimir Malevich is not unique among his contemporaries in his careful selection of materials to achieve a specific appearance in his paintings, they provide a rare opportunity to observe the artist's intent. For many years Malevich's paintings were exposed to limited exhibition and handling; they remained in storage with little intervention from restorers. Thus their appearance remains closer to the artist's intent than conservators usually encounter.

Beyond what these paintings reveal about Malevich and his technique, they become a touchstone in considerations of paintings by other artists that exhibit unusual techniques. They also serve to remind us of the conservator's responsibility for integrating scholarship with conservation treatments and studies.

Understanding that an artist's choice of materials is not random plays a crucial role in determining conservation treatments. It is important to recognize that the application of varnish is inherent to an artist's technique and that the desired appearance of a painting or a selective matte-gloss surface is often a deliberate effort by the artist. Care must be taken to preserve the artist's intention and effects. Most important, understanding the reason for artists' choices of materials enables us to place their art in a much broader context.

NOTES

When the paintings for the exhibition *Kazimir Malevich, 1878–1935* began to arrive at the National Gallery of Art, Washington, in the summer of 1990, I was drawn to them because of my interest in early Soviet painting. I had no idea how intrigued I would become with the artist and his extraordinary use of materials. My interest was encouraged by Angelica Zander Rudenstine, consulting curator of the exhibition at the National Gallery of Art. She catalyzed dialogue between conservators Lucy Belloli and Charlotte Hale at the Metropolitan Museum of Art, New York, and with Olga Klenova at the State Russian Museum, Saint Petersburg, and Elisabeth Bracht of the Stedelijk Museum, Amsterdam. I owe gratitude as well to Marla Prather, curator of twentieth-century art, National Gallery of Art, who coordinated the exhibition in Washington.

1. Kazimir Malevich, "From Cubism and Futurism to Supremacism: The New Realism in Painting," in *Essays on Art, 1915–1928*, trans. Xenia Glowacki-Prus and Arnold McMillin, ed. Troels Andersen, vol. 1 (Copenhagen, 1971), 25.

2. The exhibition was held at the National Gallery of Art, Washington, 16 September–14 November 1990; the Armand Hammer Museum of Art and Cultural Center, Los Angeles, 28 November 1990–13 January 1991; and the Metropolitan Museum of Art, New York, 7 February–24 March 1991. See *Kazimir Malevich, 1878–1935* [exh. cat., Armand Hammer Museum of Art and Cultural Center] (Los Angeles, 1990).

3. For a critical discussion of the extraordinary shortages in urban areas during the Civil War, see Daniel R. Brower, "The City in Danger," in *Party, State, and Society in the Russian Civil War*, ed. Diane P. Koenker, William G. Rosenberg, and Ronald Grigor Suny (Bloomington, Ind., 1989), 58–80.

4. Where ambiguity may occur with similar titles, the cat. no. from exh. cat. Los Angeles 1990 is given.

5. In addition to *Peasants* and *Complex Premonition*, Olga Klenova, conservator of paintings at the State Russian Museum, Saint Petersburg (personal communication, 1989), observed this ground on several other Malevich paintings.

6. Examples of signatures by scratching into the paint can be seen in two State Russian Museum paintings, *Composition with Mona Lisa*, 1914, and *Sportsmen*, c. 1928–1932.

7. E. René de la Rie, "Fluorescence of Paint and Varnish Layers," part 1, *Studies in Conservation* 27 (1982), 1–7. De la Rie, head of the scientific research department, National Gallery of Art, Washington, looked at the paintings in ultraviolet light with me and assisted me in reaching these conclusions. Unfortunately, we were unable to perform pigment analysis while the paintings were at the National Gallery of Art, to confirm this visual interpretation.

8. Maximillian Toch, *The Chemistry and Technology of Mixed Paints* (New York, 1907), 23. Barbara H. Berrie, conservation scientist, National Gallery of Art, provided this reference (personal communication, 1990).

9. Elisabeth Bracht, conservator of paintings, Stedelijk Museum, Amsterdam (personal communication, 1990), noticed these additions when treating the paintings.

10. Lucy Belloli and Charlotte Hale, conservators of painting, Metropolitan Museum of Art, New York (personal communication, 1990), observed ultraviolet fluorescence, which again suggests that the glossy areas are zinc oxide white and the matte areas are lead white.

11. It is tempting to speculate that Aleksandr Rodchenko (1891–1956), whose black paintings were included in the same show, may have also utilized similar matte-gloss relationships.

12. Alexander Selivanov, scientist, State Russian Museum, Saint Petersburg (personal communication, 1991), showed me x-radiographs of *Red House*, revealing the first image. The intention to cover the original image is also the case in *Still Life*, 1910.

13. In 1991, James Coddington, conservator of paintings, Museum of Modern Art, New York, showed me x-radiographs of this painting, revealing the first image.

14. Elisabeth Bracht, conservator of paintings, Stedelijk Museum, who made the transmitted light photograph available to me (see fig. 14), confirmed these changes in *Suprematist Painting* (cat. no. 65).

15. Kazimir Malevich to M. V. Matyushin, May 1913, in *The Artist, Infinity, Suprematism*, trans. Xenia Hoffmann, ed. Troels Andersen, vol. 4 (Copenhagen, 1978), 203.

16. Shelley Fletcher, head of paper conservation, National Gallery of Art, personal communication, 1990.

17. These observations are all based on visual interpretation. No analytical work requiring samples was undertaken while the paintings were at the National Gallery of Art.

18. X-ray fluorescence spectroscopy, a nondestructive procedure, was performed by Suzanne Quillen Lomax, organic chemist, scientific research department, National Gallery of Art, using a Kevex 0750A spectrometer.

Table 1
Works of Kazimir Malevich Examined by Author

Date	Title	Location	Medium	Catalogue No.
c. 1908–1909	*Self-Portrait* (fig. 20)	State Tretiakov Gallery, Moscow	gouache and varnish on paper	12
1911	*Peasant Women at Church* (fig. 3)	Stedelijk Museum, Amsterdam	oil on canvas	23v
1911–1912	*The Woodcutter*	Stedelijk Museum, Amsterdam	oil on canvas	23r
1912	*Peasant Woman with Buckets*	Museum of Modern Art, New York	oil on canvas	25
1913	*Cow and Violin*	State Russian Museum, Saint Petersburg	oil on wood	32
1913	*Through Station. Kuntsevo*	State Tretiakov Gallery, Moscow	oil on wood	31, misnumbered 30
1913	*Vanity Case* (fig. 2)	State Tretiakov Gallery, Moscow	oil on wood	30, misnumbered 31
1914	*Composition with Mona Lisa*	Private collection	graphite, oil, and collage on canvas	41
1915	*Red Square (Peasant Woman. Suprematism)* (fig. 27)	State Russian Museum, Saint Petersburg	oil on canvas	51
1915	*Suprematism* (fig. 15)	State Russian Museum, Saint Petersburg	oil on canvas	54
1915	*Suprematist Painting* (fig. 10)	Stedelijk Museum, Amsterdam	oil on canvas	50
1917–1918	*Suprematist Painting*	Stedelijk Museum, Amsterdam	oil on canvas	58
1917–1918	*Suprematist Painting*	Stedelijk Museum, Amsterdam	oil on canvas	59
1917–1918	*Suprematist Painting*	Stedelijk Museum, Amsterdam	oil on canvas	60
1918	*White Square on White*	Museum of Modern Art, New York	oil on canvas	61
c. 1920	*Vertical Construction/ Suprematist*	Stedelijk Museum, Amsterdam	graphite pencil and black crayon on paper	151
c. 1920	*Vertical Suprematist Construction*	Stedelijk Museum, Amsterdam	graphite on paper	150
before 1927	*Suprematist Painting* (fig. 13)	Stedelijk Museum, Amsterdam	oil on canvas	65
c. 1928	*Girls in the Field* (fig. 8)	State Russian Museum, Saint Petersburg	oil on canvas	71
c. 1928	*Going to the Harvest: Marfa and Vanka* (fig. 24)	State Russian Museum, Saint Petersburg	oil on canvas	70
c. 1928	*Haymaking* (fig. 12)	State Tretiakov Gallery, Moscow	oil on canvas	69
c. 1928	*Peasant Woman*	State Russian Museum, Saint Petersburg	oil on canvas	73
c. 1928	*Peasants* (fig. 5)	State Russian Museum, Saint Petersburg	oil on canvas	82
1928–1932	*Complex Premonition (Half Figure in a Yellow Shirt)*	State Russian Museum, Saint Petersburg	oil on canvas	80
c. 1928–1932	*Sportsmen*	State Russian Museum, Saint Petersburg	oil on canvas	75
c. 1928–1932	*Suprematism. Female Figure* (fig. 17)	State Russian Museum, Saint Petersburg	oil on canvas	81
c. 1928–1932	*Red Cavalry*	State Russian Museum, Saint Petersburg	oil on canvas	77
c. 1928–1932	*Three Female Figures* (fig. 22)	State Russian Museum, Saint Petersburg	oil on canvas	79
c. 1932	*Red House*	State Russian Museum, Saint Petersburg	oil on canvas	84
1932–1933	*Girl with a Comb in Her Hair*	State Tretiakov Gallery, Moscow	oil on canvas	87
1932–1933	*Girl with a Red Staff*	State Tretiakov Gallery, Moscow	oil on canvas	88

Catalogue numbers are from *Kazimir Malevich, 1878–1935* [exh. cat., Armand Hammer Museum of Art and Cultural Center] (Los Angeles, 1990)

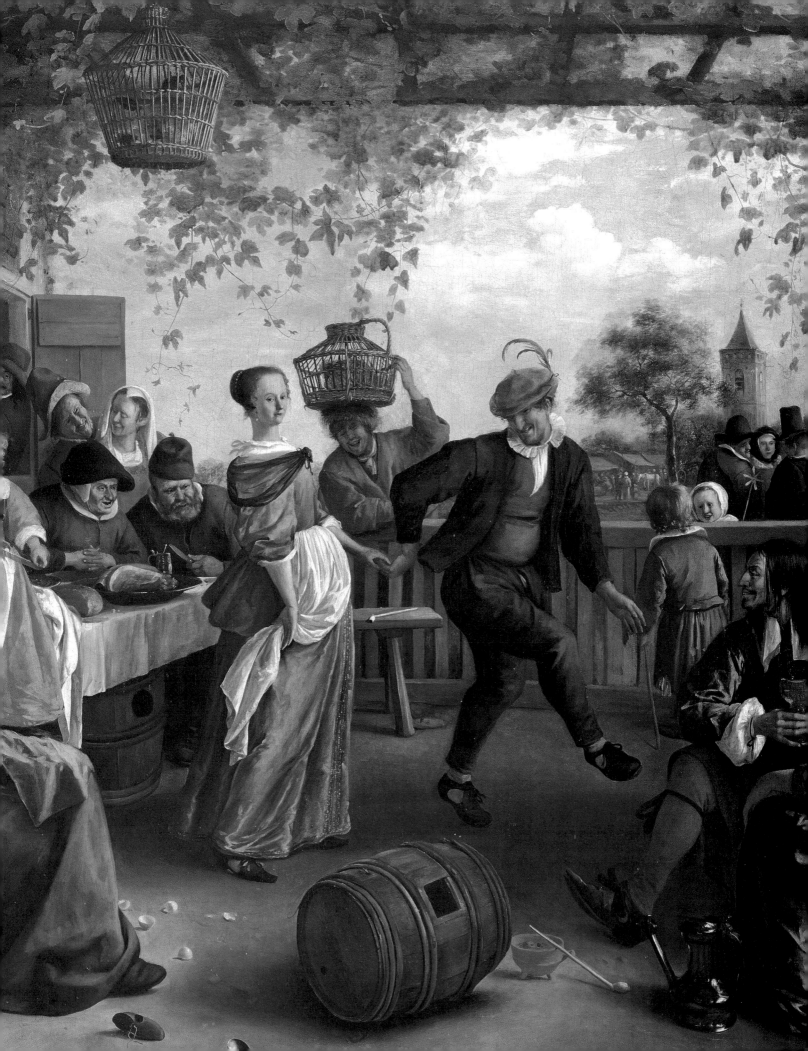

MICHAEL PALMER and E. MELANIE GIFFORD

Jan Steen's Painting Practice: The Dancing Couple *in the Context of the Artist's Career*

Study of *The Dancing Couple* by Jan Steen (1626–1679), a major work from the middle of Steen's prolific career, was prompted by preparations for the exhibition *Jan Steen: Painter and Storyteller*.[1] We also studied many of Steen's works in other museums (table 1).

The first part of this essay, a consideration of *The Dancing Couple* (fig. 1) in the context of Steen's painting practice throughout his career, focuses on issues of his handling of paint. This new information gives insight into how Steen was able to direct his audience toward the narrative and symbolic themes of his paintings. The second part of the essay reports on the materials and techniques Steen used in *The Dancing Couple*. Any research into Steen's technique must build on Marigene H. Butler's technical study of ten paintings in the collections of the Philadelphia Museum of Art.[2] The analysis of the materials of *The Dancing Couple* offers interesting comparisons to that research. Extensive new conclusions on the pigments Steen used throughout his career, however, must await publication of research being undertaken in conjunction with the exhibition.[3]

Part One: Steen's Painting Practice

For comparison with *The Dancing Couple*, a work painted during Steen's Haarlem period of the 1660s, we studied paintings from all periods of Jan Steen's career and here discuss seven in addition to *The Dancing Couple*, 1663. These are in chronological order: *The May Queen*, c. 1648–1651 (fig. 2a, b); *The Leiden Baker Arend Oostwaert and His Wife Catharina Keyzerswaert*, c. 1658 (fig. 3a, b); *Rhetoricians at a Window*, c. 1663–1665 (fig. 4a, b); *The Music Lesson*, signed and dated 1667 (fig. 5a, b); *The Doctor's Visit*, c. 1667 (fig. 6a–e); *Moses Striking the Rock*, c. 1670–1671 (fig. 7a–c); and *The Garden Party*, signed and dated 1677 (fig. 8a–d). Details of *The Dancing Couple* are illustrated in the second part of this essay.

Within the group of paintings we examined, some aspects of Steen's painting practice vary from one period to another; such variations could be related to changes in Steen's aesthetic goals over time or could have been the result of practical factors such as a change of suppliers of painting materials after a move to a new city. However, other features of Steen's technique occur throughout his career, but not in every work; it is likely that these features were inspired by aesthetic or technical qualities Steen sought for individual works.

Painting Supports

Steen used both canvas and wood panel as painting supports throughout his career.[4] *The Dancing Couple* is one of his larger paintings, and the choice of a canvas support is consistent with his practice. Like many

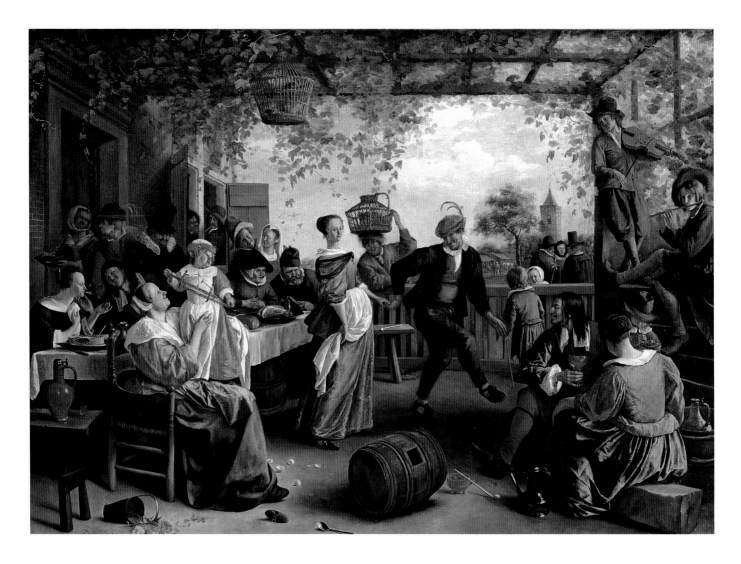

northern artists of the period, Steen tended to use panels for smaller works (his panels rarely exceed a maximum dimension of 65 cm) and canvas for larger paintings. The weight and cost of wood panels may have been a consideration, and the choice often reflected the scale of the planned work: the smoother surface of a panel facilitated the more detailed handling that would typically be required for small-scale compositions. Interestingly, at the beginning of his career Steen painted a number of large-format panel paintings, such as *The May Queen* (fig. 2)[5] and the pendant pair *The Fat Kitchen* and *The Lean Kitchen*, both c. 1650.[6] Later in his career he painted just a few very large panels. The largest later panels are major works, such as *The Effects of Intemperance*, c. 1663–1665, and *Esther before Ahasuerus*, c. 1668–1671.[7] Possibly the choice of panel support in itself lent these works a greater importance.

Preparation of the Support

In choosing the preparations for his painting supports, Steen preferred light-color grounds, typically light gray, tan, or a pinkish color. A number of different ground structures have been observed on his paintings, but a light gray double ground, which was used in *The Dancing Couple*, has been most frequently found. Such a preparation is typical for Dutch panel paintings of the seventeenth century, where a lower layer of chalk in glue serves to even the surface of the panel, and an oil-based upper layer of lead white, usually toned with earth colors and black, modifies the white color of the priming.[8] This ground was observed on *The May Queen* (fig. 2)[9] and on most of the other panel paintings examined. Less typically, Steen also used this structure on some canvases, including *The Dancing Couple*.[10]

1. Jan Steen, *The Dancing Couple*, signed and dated 1663, oil on canvas
National Gallery of Art, Washington, Widener Collection 1942.9.81

Table 1
Paintings of Jan Steen Examined by the Authors

Date	Title	Location	Museum Inv. No.	Braun No.
c. 1648–1651	*The May Queen* (fig. 2)	Philadelphia Museum of Art	J.513	26
c. 1650–1652	*The Polisher*	Rijksmuseum, Amsterdam	391	72
c. 1654–1656	*Landscape with Inn and Skittles Players*	Philadelphia Museum of Art	517	49
c. 1658	*The Leiden Baker Arend Oostwaert and His Wife Catharina Keyserswaert* (fig. 3)	Rijksmuseum, Amsterdam	A-390	102
c. 1659–1660	*Woman at Her Toilet*	Rijksmuseum, Amsterdam	A4052	109
c. 1660–1664	*Drinking Couple*	Rijksmuseum, Amsterdam	C233	138
1663	*The Dancing Couple* (fig. 1)	National Gallery of Art, Washington	1942.9.81	180
c. 1663–1665	*Prayer before the Meal*	Philadelphia Museum of Art	J.514	100
c. 1663–1665	*Rhetoricians at a Window* (fig. 4)	Philadelphia Museum of Art	J.512	217
c. 1663–1665	*The Sick Woman*	Rijksmuseum, Amsterdam	C230	259
c. 1664–1668	*Merry Homecoming*	Rijksmuseum, Amsterdam	A389	166
c. 1665–1667	*Merry Company*	Rijksmuseum, Amsterdam	C231	134
c. 1665–1668	*The Supper at Emmaus*	Rijksmuseum, Amsterdam		122
c. 1665–1668	*Saint Nicholas Feast*	Rijksmuseum, Amsterdam	A385	199
1667	*The Music Lesson* (fig. 5)	Corcoran Gallery of Art, Washington	26.171	279
c. 1667	*The Doctor's Visit* (fig. 6)	Philadelphia Museum of Art	J.510	315
c. 1667–1669	*The Mocking of Ceres*	Private collection		A-30
c. 1668–1670	*The Return of the Prodigal Son*	Private collection		307
c. 1670	*Self-Portrait*	Rijksmuseum, Amsterdam		266
c. 1670–1671	*Moses Striking the Rock* (fig. 7)	Philadelphia Museum of Art	J.509	370
1671	*Sacrifice of Iphigenia*	Rijksmuseum, Amsterdam	A3984	342
c. 1671–1672	*Prinsjesdag*	Rijksmuseum, Amsterdam	A384	276
1677	*The Garden Party* (fig. 8)	Private collection		373
n.d.	*The Fortune Teller* (attr. to Steen)	Philadelphia Museum of Art	W'02-1-21	43
n.d.	*Merry Company* (copy after the Rijksmuseum painting)	Philadelphia Museum of Art	515	216

Estimated dates are based on research by Mariët Westermann, *The Amusements of Jan Steen: Comic Painting in the Seventeenth Century* (Zwolle, 1997), and the organizers of the 1996 exhibition *Jan Steen: Painter and Storyteller*

Braun numbers are from the catalogue raisonné by Karel Braun, *Alle tot nu toe bekende schilderijen van Jan Steen* (Rotterdam, 1980)

Steen's canvases, in fact, show a remarkable variety of ground structures, varying from a three-layered ground of gray and tan over orange to a single layer of a smalt-rich gray,[11] as well as more traditional Dutch canvas preparations with a gray or tan upper ground over a reddish priming.[12] The available data do not yet show any clear trends of ground structure that would enable us to place paintings in certain groups. It is possible that the more typical ground structures may have been provided by commercial artists' color makers selling prepared painting supports, while the more anomalous ground structures may reflect Steen's own preparations. All four of the tacking edges of *Moses Striking the Rock* (fig. 7), for example, are intact and unprimed. This finding tells us that the canvas was individually prepared in its present format. Conservation treatment records note that the ground appeared to have been forced through the canvas during application,[13] and on the x-radiograph broad arcs typical of the application of the ground

2a. Jan Steen, *The May Queen (The Charming Pentecostal Flower)*, c. 1648–1651, oil on wood panel
Philadelphia Museum of Art, John G. Johnson Collection J.513

with a knife can be seen (fig. 7b). Perhaps this somewhat unusual ground (a single layer of a middle gray-tan based primarily on smalt and calcium carbonate toned with smaller amounts of lead white, earth colors, and black)[14] reflects Steen's preparation in the studio of a support specifically intended for this work.

The majority of Steen's grounds are light in color, and the artist exploited the ground tone used in the preparation, preserving the colors of his thinly applied paints. The cool tone of *The Dancing Couple* clearly is influenced by a gray upper ground, while the warmth of the graceful late work, *The Garden Party*, is established by the pinkish tan of the ground seen through most areas of the painting.[15] The occasional darker grounds seem chosen to further a specific effect, such as the glow of firelight conveyed by a warm, reddish ground.[16] Moreover, occasionally Steen used a localized preparation. As described in

2b. Detail, fig. 2a, showing seated woman in foreground. The figure was painted into a reserve, and the background details (for example, blades of grass) were then painted up to and over the woman's skirt to integrate the figure into the composition

the discussion of *The Dancing Couple* in part two of this essay, his use of this preparation should be considered a modification of the ground's color rather than a design element, since it was laid down before the composition was laid out in the sketch. In a technique that has been observed in a few of Steen's paintings from the 1660s or later, including *The Dancing Couple* and *Moses Striking the Rock*, the artist laid down an additional pinkish layer in the area where he planned to paint the sky.[17] The contrast of the cool blue of the sky with this warm underlayer (rather than the cool ground) allowed the artist to achieve a range of effects simply by varying the handling of his paint so that the underlayer showed through to a greater or lesser degree.[18]

Painted Sketches and Underpaints

In virtually every painting studied, examination with a stereomicroscope (and sometimes with the naked eye) revealed a monochromatic painted sketch, which Steen used to lay out his composition on the primed canvas or panel. In contrast, of the paintings examined to date, no underdrawing has been observed either through the use of infrared reflectography of a number of works or through close examination with a stereomicroscope.[19] For Steen, as for many of his contemporaries, the painted sketch was the definitive stage at which the fully developed composition was set down on the primed support.[20] In this stage, Steen worked using a translucent brownish paint, both articulat-

ing details in a linear handling and establishing shadows with a broader, brushy wash of the same paint. He then painted the final image directly over the sketch, closely following the design.

In compositions such as *Moses Striking the Rock* (fig. 7), fidelity to a carefully developed plan was vital to organizing a complex, many-figured composition. In this painting, the occasional glimpses of the sketch through gaps in the final paint layers illustrate the care with which Steen followed the forms of the sketch while painting. The sketch was used deliberately in the final image only in rare areas, such as the shadows of the copper-colored dress of the woman drinking in the lower right foreground, where variations of tone were created by working the fluid final paint into thicker and thinner passages over the dark sketch below (fig. 7c).

In other paintings, Steen clearly exploited the sketch as a part of the final image, varying its appearance by the degree of finish in the final paint. In some works, the color of the sketch varies subtly from one area of the design to another. In other paintings, the artist's intention to use the sketch in the final image is clearly demonstrated in rare but pronounced variations in color. In *The Doctor's Visit* (fig. 6a), most of the sketch was executed in a brownish black or reddish brown. The skirt of the young patient, however, was instead sketched with a charcoal-colored paint. This underlying color strongly contributes to the cool tone of the shimmering white satin skirt (fig. 6b).

In only two of the paintings that we have examined to date, *The Baker Oostwaert* and *The Garden Party*, Steen expanded upon this preliminary stage of the painting process. Although he usually proceeded directly from painted sketch to final paint layers, in these two works Steen underpainted the image in a muted range of colors that prefigured the colors of the final image. This underpaint is more fully worked than the purely monochromatic sketches. Rather than those mostly linear brush drawings, it is a vigorously brushed painting in color.

In *The Baker Oostwaert*, the texture of the forceful brushstrokes of this underpaint can still be seen through the surface paint layers (fig. 3b).[21] The flesh in the highlighted area of the baker's forearm was underpainted in a grayer flesh tone, his ruddy hand with a

distinctly brown tone, his blue trousers with a blackish tone, and his shirt with a range of white and gray, worked wet-into-wet. Steen seems to have proceeded boldly at this stage, then refined the image in the final layer. The heavy contrasts and fairly dark colors of the underpaint were softened in the final painting, and drapery folds were painted on a finer scale. Where the baker's shirt swelled out past the horn behind him in the underpaint, Steen narrowed the form in the final painting. Steen may have prepared the composition with a monochromatic sketch as in most other paintings (there is a layer that may correspond to such a sketch in one paint cross section, taken from the breads on the left of the composition);[22] but, if a sketch is present, it is now completely obscured by the paint layers.

The Garden Party is more instructive, however, as the structure incorporates a sketch as well as a colored underpaint. It is a late painting with a light, almost rococo effect; its loose handling allows all layers of the painting to be seen easily with the stereomicroscope. Over the pinkish ground (described earlier), Steen laid out the composition with a brown monochromatic sketch, then worked up the sketch with colored underpaints. As in *Baker Oostwaert*, the underpaint of *The Garden Party* was applied rapidly, and Steen refined the image in the final paint, often narrowing the forms (fig. 8b). The final paints, which often lie over fair, almost pastel tones, are less muted than those used by Steen in many of his paintings, and they contribute to the bright character of *The Garden Party*. Satin materials, depicted in the costumes of the musician and the seated lady, have a denser quality than Steen's usual rendering of satins, where light, thinly dragged paint often lies directly over the dark sketch. As only two examples of colored underpaints in paintings from different periods of Steen's career have been observed by the authors, it is difficult to explain his very infrequent use of the technique; it does, however, seem consistent with his occasional modifications of the usually brown monochromatic sketch to accommodate light-colored passages, as in *The Doctor's Visit* (fig. 6), where Steen varied the color of isolated areas of the sketch. We may imagine that he saw a range of options for his preparatory design, from a simple monochromatic

3a. Jan Steen, *The Leiden Baker Arend Oostwaert and His Wife Catharina Keyzerswaert*, c. 1658, oil on panel
Rijksmuseum, Amsterdam A-390

3b. Detail, fig. 3a, viewed in raking light and illustrating brushstrokes of underpaint visible through surface paint

4a. Jan Steen, *Rhetoricians at a Window*, c. 1663–1665, oil on canvas
Philadelphia Museum of Art, John G. Johnson Collection J.512

4b. Detail, fig. 4a, showing right background figure, which is executed primarily in the painted sketch

sketch, through some variation of color, to a fully worked underpaint.[23]

The Handling of Paint

The degree to which Steen's monochromatic sketch (or the underpaint, where present) plays a role in the finished image depends in large part on the handling of final paint layers. Steen's oeuvre includes fully worked surfaces, which give only incidental glimpses of the sketch below, as well as loosely worked paintings that exploit the sketch as an integral part of shadows. Steen's later paintings tend to be more loosely handled; but, within any one painting, Steen varied the degree of finish as one of the conventions he used to suggest both distance and the relative importance of figures to the scene. In a comparatively solidly worked painting such as *The Dancing Couple*, the more distant figures such as the trio behind the fence (fig. 9) were painted in a flat, schematic way that established the primacy of the finished foreground figures.

This convention of cursory, schematic background figures appears in so many paintings that there can be no doubt that Steen painted these figures. Nor should their handling be considered inferior or haphazard by comparison with the major figures. In the more loosely treated *Doctor's Visit* where Steen used the browns of the sketch as the shadow tones throughout most of the painting, he employed the same convention of rendering lesser figures in a more schematic manner. In a deliberate choice of technique, Steen's fluent, varied handling of the foreground focuses the viewer's attention on a figure such as the young patient (fig. 6c), while the background figures, such as the maid opening the door (fig. 6d), are solidly painted in a limited tonal range, relegating them to a secondary level. In fact, an important element to the story—the suitor entering the doorway—is painted with slightly greater detail than the maid standing beside him. Clearly Steen used the practice to establish a hierarchy, not only of position within the composition but of importance to the narrative.[24]

In *The Garden Party*, painted ten years later, in 1677, both the underpaint and final paint layers are so loosely handled that the sketch and pinkish ground serve as an occasional midtone through much of the final

5a. Jan Steen, *The Music Lesson*, 1667, oil on canvas
Corcoran Gallery of Art, Washington,
W. A. Clark Collection 26.171

image. The primary figures are rendered in the greatest detail; here, Steen's vivid wet-into-wet technique builds the texture of the paint itself into details such as the decoration of the seated woman's shoe (fig. 8c). Steen subordinated figures in the middle ground, such as the couple standing in the doorway, with his characteristically flat and schematic rendering. The most distant figures placed beyond the lawn and behind the railing are painted in an extremely abbreviated manner, both in the underpaint and final paint layers.

In *Rhetoricians at a Window* (fig. 4), in which Steen described the fall of daylight into a dark room, some of his most pronounced manipulations of the degree of finish are illustrated.[25] Steen's goal in varying the degree of finish was not only to rank the relative importance of the figures but also to use the play of light to create a rational space in a shallow composition. The brushy brown-black sketch over the gray ground can be seen throughout much of the finished paint-

5b. Detail, fig. 5a, showing the lady's foot and illustrating how the final layer of foreground paint carefully skirts the foot, creating a halo

ing. Over the sketched composition Steen painted with three distinctly different degrees of finish to indicate the three distances at which he had placed the figures. At the lowest level of finish, the most distant figures seem almost incomplete. The ghostly figure on the right in the background is hardly more than the painted original sketch, which Steen left visible when he brushed the black paint of the dark interior closely around the face (fig. 4b). However, the figure drinking in the left background, which gives the same impression, is actually a pentimento. After the sketch had already been covered by the background paint, Steen re-created the impression of a brown-black sketch dragged over the gray ground by painting that figure in a thinly brushed paint over the black of the background. At an intermediate level of finish, the two men in the middle, like many of Steen's secondary figures, are solidly and schematically painted and completely cover the sketch underneath. The solid handling suggests that the light falls more strongly at this location than it does on the dim interior figures, but the limited tonal range depicts them farther from the window in relation to the two foreground figures.

The two nearest figures, brought to the most finished state, are nonetheless handled loosely to achieve variations of light and shade and of paint texture. Here the middle tones are solidly painted, but the brown sketch shows through in the shadows, and in light passages the gray ground contributes to the cool tone of the thinly handled paint. This variety of touch makes the two men in the foreground seem more rounded than the background figures; combined with the trompe l'oeil placement of the figures' arms leaning on or across the windowsill, this handling of paint creates a convincing rendering of form. Finally, Steen painted the remainder of the foreground with a plasticity that brings

these elements even closer to the viewer. In creating the bricks below the window, he pushed the paint into a rough texture, mimicking the surface of the bricks; the vines, painted onto an otherwise finished painting, seem to hang in front of the window frame.

Painting Sequence

Some of the most interesting observations of this study concern the order in which Steen painted the sections within a painting. Careful examination of the surface with a stereomicroscope reveals minuscule overlaps of paint that document the painting sequence. The discussion of *The Dancing Couple*, in the second part of this essay, illustrates such examinations further.

Like many of his contemporaries, Steen worked in a logical sequence in the majority of his paintings, closely following the monochromatic sketch while painting from the background of the composition to the foreground.[26] As he painted the background, he carefully skirted the figures that would be placed in front, leaving an opening, or reserve, for each. After the background paint had dried, he painted the middleground, fitting the figures into the reserved areas of the background and leaving new reserves, in turn, for the foreground figures, which he painted last. On occasion, the strokes of background paint curving around the contour of the reserved opening create the impression of a halo around the finished form, as in the emphatic light rear wall behind Steen's self-portrait in *The Doctor's Visit* (fig. 6e).

In a small number of the paintings we examined, however, including *The Dancing Couple*, Steen followed an alternative painting sequence, which can be described as major to minor. Here, Steen painted major foreground figures before any other details, then filled in the rest of the scene, working from background to foreground, painting up to and then around the completed figures. While this procedure would not be surprising in a portrait, where the sitter's schedule dictates the order of painting, it is more unexpected in history or genre paintings, where the rendering of space takes on more importance.[27]

Recognizing which system Steen followed in a specific painting often is possible only after careful examination of the surface with a stereomicroscope. Brush strokes that halo

the forms (as described above) are not inherent evidence of a specific painting sequence. Even in compositions that were painted from background to foreground, for example, Steen still added such refinements as the final layer of the floor around completed figures. This procedure, too, can halo a form in a way that somewhat disrupts the reading of space, as, for example, around the foot of the lady with a lute in *The Music Lesson* (fig. 5b). Whether he painted from the background and worked forward, or began with the major figures, Steen frequently returned to certain areas, reinforcing contours to clarify the reading of space. He often revised a contour that had been disrupted when an element added later in the painting sequence overlapped it. Conversely, where he had been overly cautious and left too large a space between figure and background, the gap itself could create a halo. His late painting, *The Garden Party*, shows many of these gaps between figures and setting (fig. 8d) as well as Steen's repeated reworkings of the contours to fill in these openings. These reworkings, often in an imperfectly matched paint, can also give the impression of a halo of paint setting off a form from its background. Such halos, originating in these several ways, seem to be a hallmark of Steen's oeuvre. Given the frequency of their occurrence, the fact that this impression sometimes disrupts the rendition of space does not seem to have been of great concern to him.

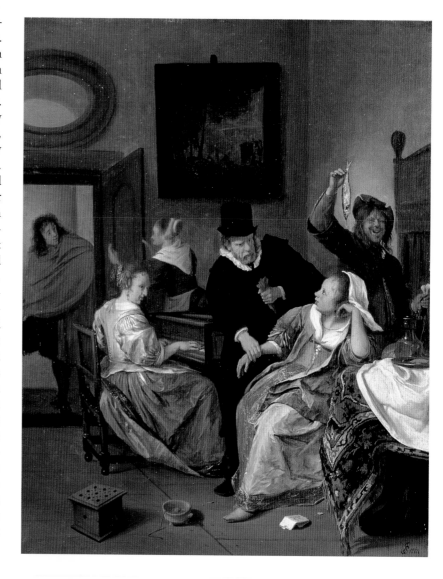

6a. Jan Steen, *The Doctor's Visit*, c. 1667, oil on panel
Philadelphia Museum of Art, John G. Johnson Collection J.510

6b. Detail, fig. 6a, showing the charcoal-gray sketch in patient's skirt, which contributes to the cool tonality of the garment

6c. Photomicrograph of detail, fig. 6a, showing the patient's face. The importance of this key figure to the story is conveyed by the detailed handling

6d. Photomicrograph of detail, fig. 6a, showing the maid's face. This secondary figure, which is set back in the composition, was handled in a schematic manner

6e. Detail, fig. 6a, showing the hat of Steen's self-portrait. The impression of a halo was created by brushing the background paint around the painted sketch to establish the reserve for the figure

Under what considerations Steen painted a given work from background to foreground, or from major to minor elements, is not yet entirely clear, but complexity of the design and the relative scale of the major elements (usually figures) to the rest of the composition seem to have been determining factors. Paintings with complex compositions that include many figures were almost always executed from background to foreground. The few paintings in which we have observed a painting sequence beginning with the major elements tend to be compositions with only a few figures or in which the major figures far outweigh the minor figures in scale and narrative importance.

In the landscape composition *The May Queen* (fig. 2), Steen painted methodically from background to foreground and with this sequence convincingly integrated the figures into the open-air setting. He laid in the landscape first, leaving reserves for the figures. Next he indicated the general forms of the architecture and foliage in a softly brushed technique; working wet-into-wet, he refined the loose indications of form with sparingly applied detail such as highlights on the nearer leaves or the textured paint of mortar defining a few separate bricks. After the background had been completed, Steen laid in the figures, slightly overlapping the background at the edge of the reserves. Finally, he painted the foreground in front of the figures, slightly overlapping them; small details such as the blades of grass that overlap the skirt of the seated woman in the foreground (fig. 2b) integrate the figures into the space of the landscape.[28]

Moses Striking the Rock (fig. 7) is more than a landscape scene; it is a complex composition with many figures. A logical painting sequence was important for a clear reading of the space and the subject, and here, too, Steen worked from background to foreground. In this painting, Steen toned the ground with an additional pinkish layer under the area of the sky (described earlier); he then laid out the intricate composition in a detailed brown sketch. Faithfully following the sketch, he painted the sky and base tones of the landscape first, leaving reserves for figures such as the camel rider wearing a turban. In painting the figures of closely grouped peripheral characters, Steen worked methodically, painting the more distant figures with reserves to accommodate the closer figures that would overlap them.[29] In this populous biblical history painting Steen needed an orderly working method to maintain the clarity of the space and his narrative.[30]

The Dancing Couple is representative of the small number of paintings we examined in which Steen began by painting major elements of the composition, usually figures, and finished by filling in the setting around those completed elements.[31] The evidence on which we based our evaluation of the painting sequence is described further in part two

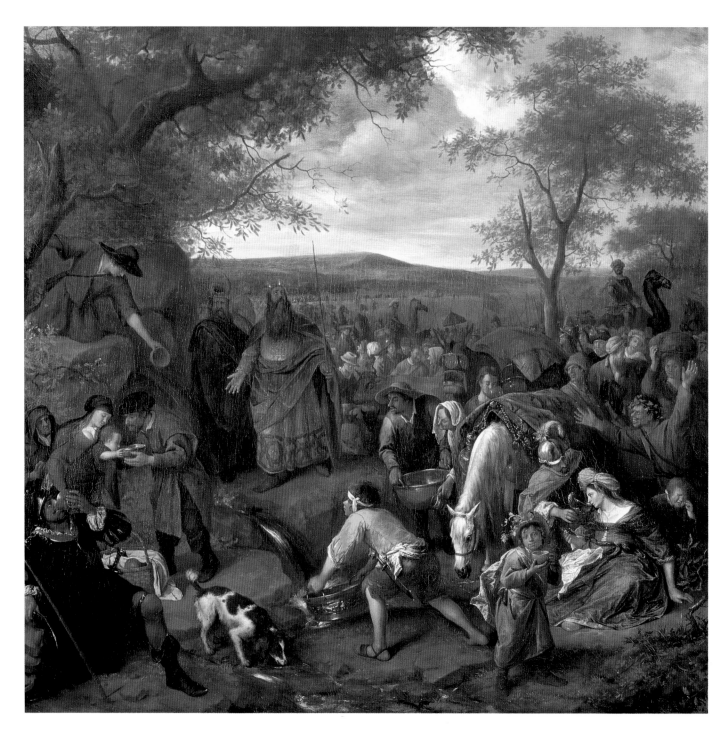

7a. Jan Steen, *Moses Striking the Rock*, c. 1670–1671, oil on canvas

Philadelphia Museum of Art, John G. Johnson Collection J.509

of this essay. In *The Dancing Couple* the major elements completed first include not only the foreground figures (the woman and child on the left, the seated woman and man holding a goblet on the right, and the dancing couple themselves), but also the large empty barrel. The barrel is, of course, large and structurally important to the composition, but it is also an iconographic element referring the viewer to the moralizing emblem used in Roemer Visscher's *Sinnepoppen*: "A full barrel doesn't resound."[32] The fact that the empty barrel, with its suggestion that those who have the most to offer refrain from empty talk, figures at this very first stage of the composition is evidence of the central importance of the moral message to Steen's conception of *The Dancing Couple*. Smaller-

scale iconographic details such as the spilled flowers and broken eggshells, which suggest the transience of worldly pleasures, must not have appeared in the painted sketch, since they were applied over the first paint layer of the floor. They were not, however, late additions but were probably intended from the start; the final paint layer of the floor was applied after the flowers and eggshells and carefully skirts each small detail. Interestingly, the child blowing bubbles on the right, another reference to the brevity of worldly pleasures, seems to be a true pentimento added after that part of the painting had been completed and provides evidence that Steen expanded on his planned theme.

The few paintings in which Steen executed the principal figures first may offer an insight into his working method. It is

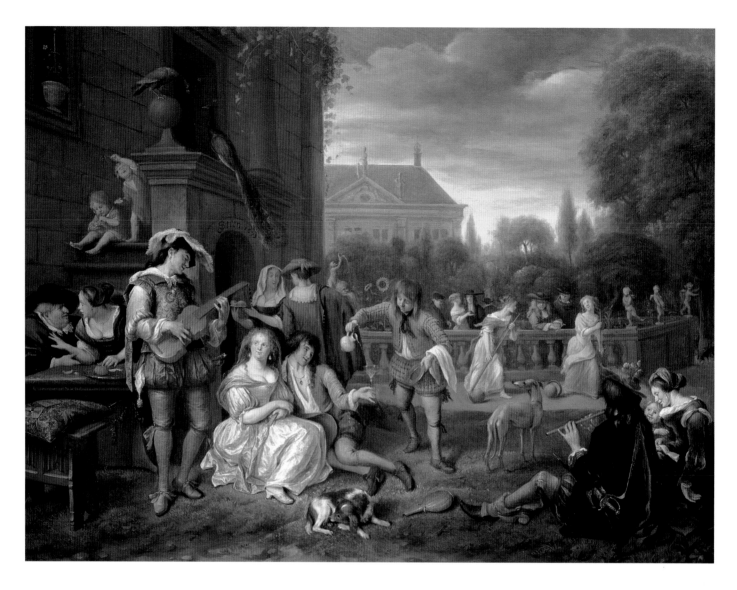

possible that Steen sketched out the composition, then painted the large, most important figures from live models, and filled in lesser figures and the setting in a procedure analogous to portrait painting. Other figures, then, may have been painted from studio drawings or invented by the artist. Variations between the lighting of the major and secondary figures, which help to focus the viewer's attention, may have resulted in part from this procedure.[33]

Part Two: A Technical Examination of *The Dancing Couple*

Surface examination of the painting with the stereomicroscope provided much useful information concerning the painting techniques Steen used in *The Dancing Couple*.[34] In addition, a limited number of microscopic samples were taken for pigment analysis to gain insight into how paint layers were built up. Table 2 gives sample information and site descriptions for the four cross sections, and table 3 gives locations and analysis results for the thirteen pigment dispersions taken. Figure 10 shows the sample locations on the painting. Analytical techniques used for this study included polarized light microscopy and scanning electron microscopy–energy dispersive x-ray spectroscopy.[35]

8a. Jan Steen, *The Garden Party*, 1677, oil on canvas
Private collection, Belgium

8b. Detail, fig. 8a, showing child blowing bubbles at left. The ruddy pink underpainted arm is visible outside the contours of the final paint

8c. Photomicrograph of detail, fig. 8a, showing seated woman's shoe and illustrating the use of a wet-into-wet technique to achieve rich detail in the final image

8d. Photomicrograph of detail, fig. 8a, showing the shoulder (red area with black dots) of youth in the foreground pouring wine. A portion of a background figure is visible in the upper right corner. Steen left a considerable gap between the figures. The impression of a halo around the foreground youth is created by the green underpaint visible in the dark region between the two figures

9. Detail, fig. 1, showing the group of three figures outside the fence and illustrating the schematic manner in which Steen painted these minor figures

Preparation of the Canvas

The Dancing Couple is typical of the larger canvas paintings that began to dominate Steen's oeuvre from the 1660s. The canvas is a medium-weave fabric with nine threads per centimeter horizontally and eleven threads per centimeter in the vertical direction. Tacking margins have been trimmed on all sides. While the canvas is cusped on the upper and lower edges, only slight cusping survives on the right edge and even less on the left edge,

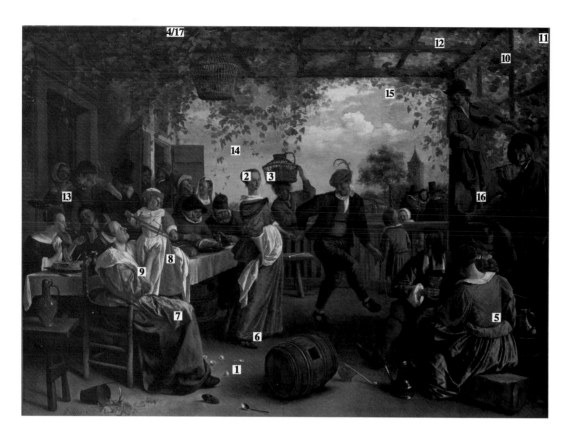

10. Fig. 1, showing locations of cross sections and pigment dispersion samples (see tables 2 and 3)

Table 2
Paint Cross Sections Taken from *The Dancing Couple*

Cross Section Sample No.	Site Description	Figure Reference
1	From edge of loss in floor near eggshells to the right of the seated woman's (child in lap) foot	11–13
2	Edge of loss near the proper right eye of the dancing woman	17a, b
3	Dark shadow region on the bottom of the basket sitting atop head of male figure in central background	14
4	Yellow-green foliage to the right of the hanging basket (edge of loss near top edge of painting)	22

See figure 10 for sample locations

Concordance between sample location reference and National Gallery of Art, scientific research department sample number: 1=R705; 2=R706; 3=R707; 4=R708

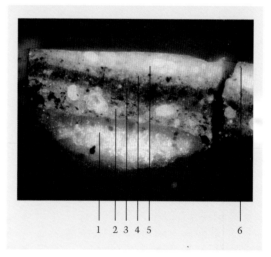

1 2 3 4 5 6

suggesting that the image area has been trimmed.

The canvas was prepared with a type of double ground found in several of Steen's paintings (for example, fig. 11). First, the texture of the canvas was smoothed with an inexpensive semitranslucent ground of calcium carbonate. Isotropic brown earths were added sparingly to tone the stark whiteness of the preparation. This ground was covered by a second, more opaque layer consisting of

11. Photomicrograph of cross section, sample 1, taken through the floor in the foreground near the eggshells and showing

1. lower chalk ground with isotropic brown earths (based upon analyses of dispersed samples)

2. light gray upper ground (lead white, calcium carbonate, quartz, red and yellow iron oxides, isotropic earths [brown], charcoal black, and bone black) (inferences based upon EDS analyses)

3. brown monochromatic, painted sketch (umber, isotropic earths, lead white, calcium carbonate, smalt, azurite, bone black, and charcoal black) (inferences based upon EDS analyses)

4. dark pinkish brown, lower layer of foreground (lead white, iron silicate earths, iron oxides, quartz, calcium carbonate, and bone black) (inferences based upon EDS analyses)

5. light pinkish brown, upper layer of fore-ground (lead white, iron oxides, iron silicate earths) (inferences based upon EDS analyses)

6. pinkish brown final modeling detail visible on far right (lead white, iron oxides, iron silicate earths) (inferences based upon EDS analyses)

12. EDS spectrum collected from a dark particle (backscattered mode) of sample 1 located in the upper ground layer (layer 2 in cross section shown in fig. 11). In point analyses of several such particles the use of bone black was inferred from the detection of calcium (Ca), phosphorus (P), oxygen (O), and carbon (C). Other elements detected are contributions from the surrounding particle matrix

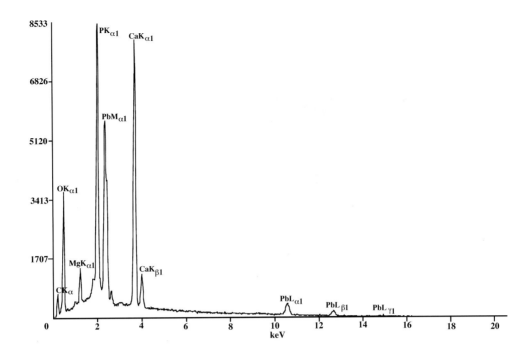

13. EDS spectrum collected from a general area (5,000x) of sample 1, showing the monochromatic, painted sketch (layer 3 in cross section shown in fig. 11). The use of umber was inferred from the detection of manganese (Mn) in addition to iron (Fe) and oxygen (O). The detection of Mn and O alone during point analysis of some particles further supports this inference, as manganese oxide is a common constituent of umber. Lead white, calcium carbonate, bone black, azurite, smalt, charcoal black, and earths may be inferred from other elements detected

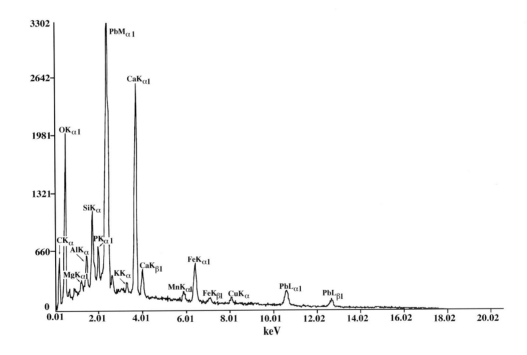

a mixture of lead white, calcium carbonate, quartz, charcoal black, bone black (fig. 12), isotropic earths (brown), and red and yellow iron oxides.[36] The thickness of the upper ground layer varies considerably. In some areas it is so thin as to be virtually nonexistent. The upper ground layer, when viewed in cross section, appears as a light to medium gray layer. Although executed in gray paint, it sometimes appears slightly gray-brown when seen through abrasions or losses. This apparent color change is probably due to viewing the layer through the surface coating and any staining that may have resulted over

Table 3

Analysis Results of Dispersed Pigment Samples from *The Dancing Couple*

Sample No.	Site Description	Pigments Found
5	Green midtone in dress of seated woman in lower right corner	lead-tin yellow smalt indigo azurite[a] red iron oxide lead white calcium carbonate[a]
6	Light pink in fold at bottom of dress worn by dancing woman	lead white calcium carbonate[a] red iron oxide
7	Blue midtone in apron of seated woman holding child in lap	smalt indigo lead white calcium carbonate[a] red iron oxide yellow lake[a]
8	Dark orange dress of child in lap of seated woman	vermilion smalt (very pale) lead white calcium carbonate[b]
9	Yellow highlight in blouse of seated woman holding child	lead-tin yellow lead white calcium carbonate[b] smalt[b] red iron oxide[b]
10	Dark, gray-green foliage in upper right corner	smalt azurite[c] lead-tin yellow yellow iron oxide red iron oxide[a] yellow lake[a] bone black lead white calcium carbonate[a]
11	Light, gray-green foliage in upper right corner	smalt azurite[b] lead-tin yellow yellow iron oxide[a] yellow lake[a] bone black isotropic earths (brown) red iron oxide[a] lead white calcium carbonate[a]

Table 3 (continued)

Sample No.	Site Description	Pigments Found
12	Light, greenish white foliage in upper right corner	smalt azurite[c] lead-tin yellow yellow lake[a] yellow iron oxide[a] red iron oxide[a] lead white calcium carbonate[a]
13	Blue in dress worn by woman holding bowl (left side of painting)	indigo smalt (very pale) red iron oxide[a] lead white
14	Pink layer (ground modification) in sky	lead white calcium carbonate[a] red iron oxide red lake smalt[a] indigo[b]
15	Blue paint used for sky	lead white calcium carbonate[a] smalt red iron oxide[b]
16	Blue in stockings worn by violin player	smalt indigo azurite[a] red iron oxide bone black lead white calcium carbonate[a]
17	Upper ground layer: site left from the removal of cross section (sample 4)	lead white calcium carbonate yellow iron oxide isotropic earths (brown) charcoal black bone black

See figure 10 for sample locations

Concordance between sample location reference and National Gallery of Art, scientific research department sample number:
5=T1107; 6=T1108; 7=T1109; 8=T1110; 9=T1111; 10=T1112; 11=T1113; 12=T1114; 13=T1115; 14=T1116; 15=T1117; 16=T1118; 17=T1119

a. Minor amounts of this pigment were noted
b. Trace amounts of this pigment were noted
c. Amount of azurite found to be less than the amount of smalt

time. It is unclear whether Steen applied one or both grounds himself or bought a prepared canvas from an artists' color maker. He did, however, take into account the effect of the surface color of the upper ground on the tone of the painting. Anticipating the cool tonality that the gray ground underlying his thin paints contributes, he modified the ground color in the upper part of the canvas. In the area that was to become the sky, Steen laid down a pink layer consisting of a mixture of lead white, calcium carbonate, red lake, red iron oxides, smalt, and trace amounts of what is believed to be indigo.[37] This layer can be seen in the cross section taken through the flesh of the dancing woman's face (see discussion below on painting sequence and handling, fig. 17a, b). Figure 17a is a photomicrograph of the cross section using reflected visible light, while figure 17b shows the same cross section photographed with visible light fluorescence. The latter lighting mode makes the pink ground modification appear distinct from the pink flesh layer. While a warm layer under the blue sky may seem counterproductive, it allowed Steen to vary effects in the sky easily. Where his paint was applied thickly, the sky is clear blue and the clouds are white; where he dragged paint thinly over the pink layer, the grayish mauve that resulted suggests shadowed clouds. In addition, portions of the upper right (for example, under the standing violin player and portions of the trellis) were blocked out using a light, cream-color paint that, like the pink layer, was placed directly on the upper ground layer.[38] Here, this cream-color layer created the tonality of filtered light (that is, light passing through leaves) rather than light from the open sky.

The Monochromatic Painted Sketch

Although examination has found no evidence of underdrawing, Steen had a clear impression of the composition, for the pink and cream-color ground modifications coincide roughly with the present area of the sky and trellis. Whether he relied on a compositional drawing in the early stages or had sketched the general outlines in a material such as chalk, which would no longer be visible, Steen's compositional plan was laid out primarily in the subsequent stage—the painted sketch. Over the gray ground, with

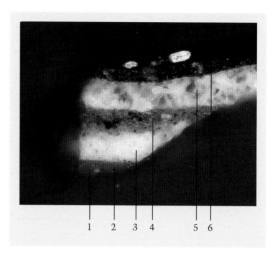

its patches of pink and cream where the sky and musicians were to appear, Steen outlined most details of the composition in a loosely applied paint that ranges from reddish brown to brown-black. In samples the paint appears as a brownish colored layer that consists of a mixture of umber (fig. 13),[39] bone black, charcoal black, lead white, calcium carbonate, smalt, and azurite. This essentially monochromatic sketch can be seen in the cross section taken from the foreground near the eggshells (fig. 11) and in a cross section taken through the bottom of the basket on the man's head (fig. 14).

The monochromatic sketch is visible in gaps between figures and objects (such as the chairs and barrel) and the surrounding foreground and/or background. In some passages, such as the garments of the violinist, the sketch contributes to the finished image. It is also noteworthy that the curled piece of

14. Photomicrograph of cross section, sample 3, taken through the bottom of the basket resting on the head of the man just outside the fence (center of painting) and showing

1. lower chalk ground with isotropic brown earths (inferences based upon EDS analyses)

2. light gray upper ground (lead white, calcium carbonate, yellow iron oxide, isotropic earths [brown], charcoal black, and bone black) (based upon analyses of dispersed samples)

3. pink layer (ground modification) in sky (lead white, calcium carbonate, red iron oxide, red lake, smalt, and indigo) (based upon analyses of dispersed samples)

4. brown monochromatic, painted sketch (umber, isotropic earths, smalt, azurite, lead white, calcium carbonate, bone black, and charcoal black) (inferences based upon EDS analyses)

5. sky (lead white, calcium carbonate, smalt, and red iron oxide) (based upon analyses of dispersed samples)

6. dark brown-black, shadowed area of basket bottom (umber, red iron oxides, yellow iron oxides, vermilion, smalt, bone black) (inferences based upon EDS analyses)

15. Detail, fig. 1, showing the empty barrel with the curled piece of wood (arrow). The curled wood was created in the monochromatic painted sketch, and it is painted directly on the upper ground layer. Both foreground paint layers carefully skirt the curl

16. Composite x-radiograph, fig. 1, showing the figures of the dancing woman and the dancing man in reserve in the x-ray opaque paint of the sky. Reworkings of the arm and hat of the dancing man are also visible

wood protruding from the upper left of the barrel (fig. 15) is from the monochromatic sketch. All layers of the floor skirt this detail, leaving it as a visible part of the final appearance of the barrel.

Painting Sequence and Handling

Steen followed the monochromatic sketch closely as he covered it almost completely with the paint we now see. As discussed in the first part of this essay, examination with a stereomicroscope, x-radiographs, and analysis of paint cross sections are illuminating in evaluating the sequence in which Steen painted his works. Most of his paintings were executed in an orderly sequence, working from the background of the composition to the foreground. However, Steen took a dif-

ferent approach in a small number of works, including *The Dancing Couple*. Here, rather than working methodically from background to foreground, he turned his attention immediately to the major elements of the composition. Only after completing the major elements did he proceed to fill in the rest of the painting following the more typical background to foreground order.

Steen first laid in the blue sky layer, leaving empty areas in reserve for the figures of the dancing couple (figs. 16, 17) and the musicians on the right. Major supporting members of the trellis were also left in reserve in the blue sky layer. Possibly at the same time, the architectural structure on the left was blocked in using a brown base tone that left reserves for figures.

Before painting the rest of the scene, how-

17a. Photomicrograph of cross section, sample 2, taken through the flesh of the dancing woman's face (edge of small loss to the proper right eye) and showing

1. lower chalk ground with isotropic brown earths (inferences based upon EDS analyses)

2. light gray upper ground (lead white, calcium carbonate, yellow iron oxide, isotropic earths [brown], charcoal black, and bone black) (based upon analyses of dispersed samples)

3. pink layer (ground modification) in sky (lead white, calcium carbonate, red iron oxide, red lake, smalt, and indigo) (based upon analyses of dispersed samples)

4. pink flesh layer (lead white, red lake, red iron oxide, quartz) (inferences based upon EDS analyses)

It is noteworthy that the blue sky paint layer is absent, demonstrating that the figure was left in reserve in this layer

17b. Photomicrograph of cross section, sample 2, in visible light fluorescence mode (Leitz filter cube I3), showing the pink ground modification layer as distinct from the pink flesh layer. The layers are

1. lower ground

2. upper ground

3. pink layer (ground modification) in sky

4. pink flesh layer

ever, Steen completed the major figures—the dancing couple, woman in green, man holding a goblet at the right, seated woman on the left with the child on her lap, and even the large empty barrel in the central foreground. Where these elements overlap, they were completed in order of importance; for example, the paint of the woman in green is overlapped by that of the man behind her and the stone on which she sits. The seated woman and child with the toy at the left were treated as a unit and were painted at the same time. Only after completing these elements to his satisfaction did Steen fill in the rest of the scene. The violinist, flutist, and major elements of the trellis were painted into reserve areas that were left in the sky. On the left, the background figures were painted into reserve areas in the base tone used for the architecture. The artist continued working from background to foreground, carefully skirting the already placed major figures and barrel. For example, in the background to the right central region are two children on either side of a fence with three adults grouped farther back. These figures were painted in a back-to-front sequence, ending with the foremost child in front of the fence rail. The paint of the child's costume, however, overlaps that of the man holding a goblet on the right (one of the major compositional figures already painted in the first stage).

In the foreground, where only the barrel had been painted at the same time as the major figures, a first layer of color was laid in continuously around the barrel. Elements such as the brazier, pipe, eggshells, and flowers were then painted on top of this first layer of foreground: that is, spaces were not reserved for these details. A second foreground layer was then laid in, carefully skirting these details (fig. 18). Since the barrel and major figures had already been completed, their edges are overlapped by both layers of the foreground. This overlap is visible in the upper left of the barrel and is particularly noticeable around the legs of the dancing man, although a later revision covered the overlap on the leg. After all figures (both major and minor) had been completed, final details of the background (such as the mortar in the brickwork at the left, the surface on the fence on which the flutist sits, and the second layer of foreground) were filled in around them.

To accommodate this unorthodox painting sequence and still render a legible space, Steen frequently returned to complete elements and to revise the contours. If, in filling in the scene, his background paint overlapped a completed figure, he repainted the contour of the figure against the background. The leg of the seated man holding a goblet on the right is an example of such a revision (fig. 19). As discussed earlier, another convention Steen followed throughout his career is that background figures were painted in a characteristically flat and schematic way. The abbreviated rendering of the figure farthest from the viewer, outside the main focus of the painting, contrasts with the fully modeled forms to which our attention is drawn. The group of three figures outside the fence (fig. 9) illustrates this technique.

As he painted *The Dancing Couple*, Steen revised details of the composition more than once, sometimes amending or enriching the painting's meaning.[40] The dancing man was first planned in the monochromatic sketch

18. Detail, fig. 1, showing brazier and pipe in foreground. The layer of the second foreground paint carefully skirts the objects, creating a halo that is especially visible along the pipestem

19. Detail, fig. 1, showing the leg of the seated man holding a goblet and illustrating the contour revision to the figure's leg by an overlapping area of background paint

to be bareheaded, with his arm upraised and holding a hat (fig. 20). Next, the man was painted with his arm lowered but still holding the hat. Finally, the hat in his hand was painted out and replaced by a feathered hat on his head. Other changes to the dancing man may relate to the underlying messages that Steen wished to convey.[41]

A central background figure is the man with the basket on his head. A cross section taken through the basket bottom contains a layer corresponding to the monochromatic sketch (fig. 14). Here, the sketch paint is over the pink underpaint layer, as it is in the

figures of the dancing couple. This finding suggests that Steen originally intended to place something here and defined it using the monochromatic sketch. The sketched design, however, was then covered with the blue sky paint (although the x-radiograph and microscopic examination confirm that the blue sky paint left the dancing couple in reserve), suggesting an early change of composition. A figure holding a glass aloft was painted over the blue sky and is visible as a pentimento (fig. 21). This figure was later revised to the one we now see: the man balancing a caged fowl on his head, making a pun on the sexual undercurrent of the dance.[42] The monochromatic, painted sketch can also be seen in the cross section from the floor in the foreground near the eggshells (fig. 11). A spectrum of the painted sketch obtained using energy-dispersive x-ray spectroscopy (EDS) is shown in figure 13. On the right-hand side of the painting, the young boy blowing bubbles is a reference to the transience of thoughtless pleasures. As it is painted over the completed fence in the background, this iconographic detail is also a pentimento, added as an afterthought.

In his depiction of the village fair with its mingling of social classes, Steen wove these moralizing references throughout the foreground of his painting. He successfully focused the viewer's attention on this part of the painting and its subliminal messages through a variety of techniques: the fluent execution of the primary figures (which he painted first), in contrast to the solidly painted, schematic treatment of the peripheral figures, as well as the more emphatic lighting on those primary figures. If, as we suggested earlier, Steen painted the major figures from life, this procedure could also have contributed to the variation in lighting.

The Palette

No anachronistic pigments have been found in *The Dancing Couple* (table 3); that is, the pigments Steen used are typical of Dutch seventeenth-century paintings and provide no indication that Steen's preference for materials differed from those of his contemporaries.[43] Although there are a few areas of bright colors, particularly in some of the garments, the overall color scheme is muted, consistent with many other works by Steen.

Fourteen different pigments were identified in analyses of the dispersed samples and the cross sections examined.[44] Three blue pigments were found: smalt, azurite, and indigo. Smalt is the most extensively used of the three blue pigments, as it was found in eleven of the thirteen dispersions. In the dark orange dress worn by the child on the lap of the seated woman (sample 8), the smalt is very pale (to the point of being nearly colorless) and may have been added for its siccative properties. Smalt also occurs in the yellow highlight paint in the blouse of the woman holding the child (sample 9). Here the paint consists of a mixture of lead-tin yellow and lead white with admixtures of calcium carbonate, smalt, and red iron oxide. The blue sky paint (sample 15) contains only smalt with lead white, while other blue paints (samples 13 and 16), in addition to smalt, contain either azurite or indigo, or both. In each case, however, smalt is found in greater amounts than either azurite or indigo. The pink layer below the sky (sample 14) is a mixture of predominantly lead white with some calcium carbonate, red iron oxide, and red lake. Smalt and minor amounts of indigo were used to cool the tonality of the warm pink paint. Red iron oxide was found in every dispersion except two: the upper ground layer (sample 17; no red pigments occur in this layer) and the dark orange dress of the child in the lap of the seated woman (sample 8). The paint used for the child's dark orange dress consists of vermilion with admixtures of lead white, calcium carbonate, and smalt. Yellow pigments found in the samples are lead-tin yellow, yellow iron oxide, and yellow lake.[45]

Most notable is the absence from the palette of any green pigment. The color green (light through dark) features prominently in *The Dancing Couple*, and, in every case (see samples 5, 10, and 12), the paints are the result of mixing blues and yellows: smalt, azurite, indigo, lead-tin yellow, yellow iron oxide, and yellow lake. Steen understood the properties of his materials and created a wide range of values by manipulating the ratios of the individual constituents, thus avoiding the use of problematic green pigments. Many other seventeenth-century painters also exhibited knowledge of problems associated with green pigments. In fact, Samuel van

20. Detail, computer assembled infrared reflectogram, fig. 1, showing the various reworkings of the dancing man's arm and hat

21. Ultraviolet photograph of detail, fig. 1, showing the man with the caged fowl on his head and illustrating that the figure was once depicted holding the glass aloft. Ultraviolet photography reveals linear strokes of overpaint used to hide the pentimento of the raised arm that must have become visible over time

Hoogstraten, writing in the late 1600s, warned against the use of green pigments such as verdigris and green earth.[46] Harshness, discoloration, and paleness were among the problems he cited. The green paints used in

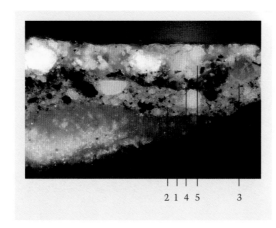

2 1 4 5 3

The Dancing Couple reveal the most complex pigment mixtures of the colors used for the painting (table 3).[47]

Foliage in the painting is varied both in color and value. The manner in which this variety was created is noteworthy. Some leaves are executed in either dark or light gray-green paints made from the mixtures described above. Other areas of foliage range from yellow-green to light green-white to a faint, transparent brown-green or tan. Analyses of dispersed samples taken from the gray-green paints (sample 10) and the light green-white paint (sample 12) reveal that each contains essentially the same pigments. In

certain instances, for example, in the tan-colored leaves, the leaves were painted in a single, thick paint layer. More often, however, Steen created foliage through a buildup of paint layers. By controlling the values and opacity of the individual layers, he could model form and achieve the desired range of colors. The use of glazes or scumbles (thinly dragged semiopaque paints) over dark and light layers gave the desired effect. A cross section taken through yellow-green foliage at the top edge of the painting (fig. 22) shows this technique. The uppermost layer of the cross section is a semitransparent yellow paint consisting of large agglomerates of lead-tin yellow (fig. 23) distributed throughout a matrix of pale smalt (admixtures of yellow lake, lead white, tin oxide, isotropic brown earths, red iron oxide, iron silicates, and bone black are present). This semitransparent yellow layer lies directly over a darker, opaque gray-green paint that influences the appearance of the former. The gray-green paint consists of a mixture of lead-tin yellow, smalt, bone black, charcoal black, calcium carbonate, and red iron oxides. Although they were not sampled, it is likely that the ephemeral-appearing tan foliage elements were created using the more transparent constituents of the basic pigment mixture described above.[48]

Conclusion

Jan Steen's skills as a painter have often been underrated, yet beautifully handled passages, such as the face of the young patient in *The Doctor's Visit* (fig. 6c), reveal a gifted artist completely comfortable with his medium. For many years conventional wisdom characterized Steen as an artist whose work was as slovenly as the chaotic households he depicted. Recent research has suggested that this reputation is unjustified. By integrating self-portraits into his paintings, Steen consciously conflated himself with his artistic persona, creating a larger-than-life protagonist for his witty stories of human foibles. By the nineteenth century, fastidious writers found this character unseemly and had built Steen's reputation as a tavern-owning drunkard who turned out paintings to keep away his creditors. Steen is now recognized as an important artist, a painter of engaging, moralizing stories.[49] But his unsavory reputation probably underlies the lingering evaluation of Steen as a careless practitioner, even among those who acknowledge his mastery of the subjects in his paintings.

Our research has established that Steen was an accomplished artist whose primary emphasis was on the narrative of his paintings. His focus on his subject often took precedence over elegance of presentation or even an entirely logical rendition of pictorial space. His conscious manipulation of the degree of finish in his paintings, in which masterfully handled primary figures contrast with schematic secondary figures, directs the viewer's attention to the focal point of his story. In some cases he adopted a painting sequence that seems unusual for a history painter; he placed the major figures and symbolic elements before even beginning to paint the setting. This practice could create a certain dislocation in the rendering of space, but Steen accepted these anomalies in order to sustain the focus of those works. Although he was a gifted artist, Jan Steen chose not to emphasize the visual effects of his paintings but to focus on the narrative; he used his vigorous technique in the service of that narrative.

NOTES

We are grateful to the Circle of the National Gallery of Art, Washington, for underwriting the costs of travel and analytical supplies that made this project possible. Our research has benefited from discussions with our colleagues Arthur K. Wheelock Jr. and H. Perry Chapman, during their preparation of the exhibition *Jan Steen: Painter and Storyteller*, and with Mariët Westermann, Rutgers University.

A debt is also owed to Marigene H. Butler, head of conservation, and to Katherine Crawford Luber, curator of the Johnson Collection, for permission to examine eight paintings at the Philadelphia Museum of Art, and to conservators Mark Tucker, Teresa Lignelli, Stephen Gritt, and the late David Skipsey for their assistance and comments during the examinations. All the paint samples on file were made available to us, and we carried out additional analysis on a small number of those samples.

Dare Hartwell allowed us to study *The Music Lesson* at the Corcoran Gallery of Art, Washington; Joaneath Spicer and Eric Gordon facilitated our examination at the Walters Art Gallery, Baltimore, of the privately owned *Mocking of Ceres*; and through the generosity of the private owners, we were able to examine *The Return of the Prodigal Son* and *The Garden Party* in the conservation department of the National Gallery of Art. Though we were not able to examine it in person, we received valuable information on the important early picture, *The Lean Kitchen*, c. 1650, from Anne Ruggles, fine arts conservator of the National Gallery of Canada, Ottawa, who shared with us technical dossiers and carried out new examinations to answer our questions.

Finally, we are grateful to Martin Bijl and Manja Zeldenrust, heads of conservation at the Rijksmuseum, Amsterdam, and to the staff of the Rijksmuseum's conservation department, Hélène Kat, Michel van de Laar, Laurent Sozzani, and Gwen Tauber, for the opportunity to examine with them eleven paintings at that museum. Karin Groen, of the Central Research Laboratory for Objects of Art and Science, Amsterdam, examined with us the paint samples she had taken from a number of these paintings. We have continued to exchange information with the Rijksmuseum staff during the preparation of this essay. The first results of Martin Bijl's research appear in his essay in the 1996 exhibition catalogue.

1. The exhibition was held at the National Gallery of Art, Washington, 28 April–18 August 1996, and the Rijksmuseum, Amsterdam, 21 September 1996–12 January 1997. H. Perry Chapman, Wouter Kloek, and Arthur K. Wheelock Jr., eds., *Jan Steen: Painter and Storyteller* [exh. cat., National Gallery of Art] (Washington and Amsterdam, 1996). See especially Martin Bijl, "The Artist's Working Method," 83–92.

2. Marigene H. Butler, "Appendix: An Investigation of the Technique and Materials Used by Jan Steen," in Peter Sutton, *Jan Steen: Comedy and Admonition*, special issue of the *Philadelphia Museum of Art Bulletin* 78, nos. 337–338 (1982–1983), 44–61.

3. In addition to our analysis of *The Dancing Couple* and of some samples from paintings in the Philadelphia Museum of Art, analyses by Ashok Roy, scientific department, National Gallery, London, of paintings at the National Gallery, and by Karin Groen, of paintings at the Rijksmuseum, Amsterdam, are currently under way.

4. Broad conclusions on supports used by Steen were drawn from a study of the catalogue raisonné by Karel Braun, *Alle tot nu toe bekende schilderijen van Jan Steen* (Rotterdam, 1980).

5. *The May Queen* measures 75.9 x 61.6 cm. See catalogue entry in Sutton 1982–1983, 9.

6. *The Fat Kitchen* (private collection, The Hague; Braun 27) and *The Lean Kitchen* (National Gallery of Canada, Ottawa, inv. no. 9014; Braun 28) measure 71 x 91.5 cm and 69.5 x 91.8 cm, respectively.

7. *The Effects of Intemperance* (National Gallery, London; Braun 250) and *Esther before Ahasuerus* (State Hermitage Museum, Saint Petersburg; Braun 291) measure 76 x 106.5 cm and 106 x 83.5 cm, respectively.

8. For a discussion of such grounds in the context of the early works of Rembrandt van Rijn, see Ernst van de Wettering, "Painting Materials and Working Methods," in Josua Bruyn, Bob Haak, S. H. Levie, Pieter J.J. van Thiel, and Ernst van de Wettering, *A Corpus of Rembrandt Paintings*, vol. 1 (Dordrecht and Boston, 1982), 11–33.

9. Identification of the ground as a single layered structure used for *The May Queen* was published by Butler 1982–1983, 52, based on microscopic examination of paint cross sections. The authors recently analyzed one of the original paint cross sections using scanning electron microscopy with energy-dispersive x-ray spectroscopy. This analysis revealed the presence of a chalk-containing lower layer, which could not be perceived by light microscopy.

10. This ground structure also was observed on paint samples taken from the *Sacrifice of Iphigenia*, dated 1671. Karin Groen, paint analysis notes of 20 September 1994, filed at the conservation department, Rijksmuseum, Amsterdam. What appears to be the same structure was observed in a stereomicroscopic examination of the privately owned *Mocking of Ceres*, examined in the conservation laboratory, Walters Art Gallery, Baltimore.

11. These grounds are found on *Landscape with Inn and Skittles Players* and *Moses Striking the Rock*, respectively; see Butler 1982–1983, 52.

12. This layering structure was observed through the stereomicroscope on both the *Saint Nicholas Feast* and *The Music Lesson*.

13. Marigene H. Butler, head, conservation department, Philadelphia Museum of Art, conservation examination report, 9 October 1980.

14. Butler 1982–1983, 52.

15. The ground of this painting was observed during examination with a stereomicroscope; since no paint samples were taken, the ground cannot be further characterized.

16. Based on examination with low magnification in the exhibition *Jan Steen: Painter and Storyteller*, such an effect can be seen in *Twelfth Night*, 1662 (Braun 159), Museum of Fine Arts, Boston.

17. Gwen Tauber, conservation department, Rijksmuseum, personal communication, 15 March 1995, also found such a layer in *Erysichthon Selling His Daughter*, 1658–1661 (Rijksmuseum, inv. no. A-2572; Braun 258).

18. Bijl (1996, 87) points out that the effect is reminiscent of the work of landscape painters of the period. It is harder to prove, however, that this technique was derived specifically from Steen's father-in-law, Jan van Goyen. Technical study of works by van Goyen and Salomon van Ruysdael have not revealed such a localized layer. Instead, the warm tone exploited in the skies of those tonal landscapists can be seen throughout the entire painting, which is prepared with a warm ground or a translucent ground through which the color of the support is visible. See E. Melanie Gifford, "Style and Technique in Dutch Landscape Painting in the 1620s," in *Historical Painting Techniques, Materials, and Studio Practice*, ed. Arie Wallert, Erma Hermens, and Marja F.J. Peek (Leiden, 1995), 140–147; and E. Melanie Gifford, "Jan van Goyen en de technick van het naturalistische landschap," in *Jan van Goyen*, ed. Christiaan Vogelaar [exh. cat., Stedelijk Museum De Lakenhal] (Leiden, 1996), 70–79.

19. These findings do not, of course, eliminate the possibility that some preliminary notations were made in a drawing medium such as light-color chalk, which cannot be observed by infrared reflectography, but such a drawing would be of limited use on Steen's light-color grounds.

20. See van de Wettering 1982, 20–24, for a discussion of such sketches in the early works of Rembrandt van Rijn. We have chosen to use the descriptive term "monochromatic painted sketch" rather than the historical term "deadcoloring," to avoid confusion between this stage and the colored underpaints we have occasionally observed.

21. *The Baker Oostwaert* is dated c. 1658 on the basis of an inscription on the reverse. Martin Bijl, conservation department, Rijksmuseum, who cleaned this painting in 1994–1995, brought the underpaint to our attention. See also Bijl 1996, 86.

22. Karin Groen, paint analysis notes, December 1994, conservation department files, Rijksmuseum, Amsterdam.

23. The appearance of Steen's colored underpaints may be inferred from some of his most loosely painted works. His *Self-Portrait as a Lutenist*, c. 1663–1665, at the Fundación Thyssen-Bornemisza, Madrid (*Jan Steen*, cat. no. 25), was examined with low magnification in the galleries of the exhibition *Jan Steen: Painter and Storyteller*. Although this is a finished painting, most of the sketchy surface was painted in one sitting, wet-into-wet.

24. In discussion, Mariët Westermann suggested that the degree of finish also serves to distinguish social classes. See also Westermann, "Steen's Comic Fictions," in Chapman, Kloek, and Wheelock 1996, 67.

25. In his catalogue essay, Bijl 1996, 89–90, expresses a somewhat different interpretation of our examination of this painting. While he feels that the painting's technique is unusual within Steen's practice, we believe that it typifies the artist's deliberate manipulation of the degree of finish.

26. For discussions of standard practices in Dutch painting sequence, see van de Wettering 1982 and Gifford 1995.

27. Examination with low magnification in the Jan Steen exhibition galleries of two small 1665 portraits by Steen, *Portrait of Gerrit Gerritsz Schouten* and *Portrait of Geertruy(?) Gael, Second Wife of Gerrit Gerritsz Schouten*, private collection (*Jan Steen*, cat. nos. 29a and 29b, respectively), shows a painting sequence in which the background was filled in after the figures had been completed.

28. Examination of *The Fortune Telle*r revealed that the foreground figures are painted on top of a completed landscape rather than integrated into reserves, a finding that raises the possibility of a collaboration between a landscape specialist and a figure painter here. The handling of the setting, in elements such as the foliage and the masonry of the buildings, is crisper, with a more defined touch than the same elements in, for example, *The May Queen*. The middle-ground and distant figures, which are integrated into the landscape following standard Dutch landscape painting procedures, seem more fluently handled than the foreground group. After these foreground figures had been painted onto the landscape, they were roughly integrated into the space with a grayish green paint distinctly different in pigment mixture from the original green lying below them, furthering the impression of a figure painter cleaning up his addition to a completed landscape. For a discussion of issues of collaboration in landscape painting, see Gifford 1995. The foreground figures in *The Fortune Teller* seem more crudely executed than those in the other works by Steen that we have examined. Since neither the landscape nor the major figures are entirely consistent with Steen's handling, it is possible that this collaboration is not a work by Steen.

29. Only in final details of distant foliage did Steen break this strict order of painting. An aureole around the head of the camel, for instance, is the base tone of the landscape (which had been painted with a reserve for the animal) left visible where the foliage details skirt the head. This example illustrates yet another painting procedure that can give the appearance of a halo.

30. We had the opportunity to compare our examinations of an autograph painting by Steen, the *Merry Company* at the Rijksmuseum, and a close copy at the Philadelphia Museum of Art. Both works were painted from background to foreground, closely following a brown monochromatic sketch; the slight variations between the two are noteworthy. The Rijksmuseum painting gives evidence of decisions made during the creative process: the painting sequence varies on occasion from a strictly logical background to foreground order, and there are numerous passages in which the painter returned to refine contours. In the Philadelphia Museum painting, however, there are no hesitations and few revisions. The entire composition, including a few changes from the model (such as the incorporation of a bird-cage by the window) was planned in the painted sketch, and the background to foreground painting sequence was strictly followed.

31. This procedure was also observed in *The Sick Woman*, and recent examinations with low magnification in the galleries of the Steen exhibition have revealed other examples, including *In Luxury Beware*, 1663 (Kunsthistorisches Museum, Gemäldegalerie, Vienna; Braun 179; *Jan Steen*, cat. no. 21) and *The Worship of the Golden Calf*, c. 1673–1677 (North Carolina Museum of Art, Raleigh; Braun 351; *Jan Steen*, cat. no. 47).

32. "Een vol vat en bomt niet," Roemer Visscher, *Sinnepoppen* (Amsterdam, 1614), cited in Arthur Wheelock Jr., *Dutch Paintings* (Washington, 1995), 366–367.

33. Our thoughts on this issue were clarified during a discussion session on Steen's technique, which we offered at a proseminar held in the Steen exhibition. We benefited from comments by a number of colleagues and particularly appreciated Aneta Georgievski-Shive's observation that anatomical irregularities in minor figures might suggest that only major figures were painted from life.

34. X-radiography and infrared reflectography (IRR) were also used to examine *The Dancing Couple*. These investigative techniques revealed details about pentimenti, such as the repositioning of the arm and hat of the dancing man. X-rays and infrared reflectograms are on file in the paintings conservation department, National Gallery of Art.

The x-radiograph was made at an exposure of 25kv and 50ma for 6 seconds. The infrared reflectogram was made using a Kodak platinum silicide camera configured to 1.5–2.0 µm and using a Nikon 55 mm macro lens. The video signal was collected with a Perceptics Pixelbuffer board and Signal Analytics I P Lab Spectrum software. Each individual image is an average of eight frames. The multiple images were assembled into a composite reflectogram in Adobe Photoshop on a Macintosh Quadra 700 computer. We are grateful to Carol Christensen and Stuart Wolffe of the painting conservation department of the National Gallery of Art for sharing the results of their examinations.

35. Analysis was carried out by Michael Palmer. Cross sections were embedded in Ward's Bio-Plastic, a polyester-methacrylate copolymer, and ground at right angles to the stratigraphy. Pigment dispersions were mounted in Cargille Melt-Mount ($n=1.662$). Polarized light microscopy was carried out using Leitz Orthoplan and Leica DMRX microscopes in both incident and transmitted configurations. Scanning electron microscopy–energy-dispersive x-ray spectroscopy (SEM–EDS) was performed on the four cross

sections using a JEOL JSM6300 electron microscope fitted with an Oxford Link Pentafet x-ray detector and Oxford Link eXL II x-ray analyzer. Examination of the cross sections was facilitated by using an Oxford Tetra backscattered electron detector. The backscattered electron detection mode yields gray level contrast differences that correlate to Z values (that is, atomic number) for elements detected. This method allows for visual distinctions among pigments or particle types of varying elemental composition and helps in making decisions concerning the selection of sites for EDS analysis. Pigment standards (subsets of the E. W. Forbes Collection) in the National Gallery of Art scientific research department were used as references for light microscopic identifications of the dispersed samples. EDS spectra were processed using Desktop Spectral Analyzer (DTSA) software developed by the National Institute of Standards and Technology. SEM–EDS particle identifications are inferences based upon elements detected.

36. The identification of brown earths was based upon analyses of dispersed samples. The identification of bone black was confirmed by the detection of phosphorus (P), calcium (Ca), oxygen (O), and carbon (C) during SEM–EDS analyses of the cross sections. See fig. 12, EDS spectrum collected from sample 1 (NGA R705).

37. The identity of the dyelike blue in the pink ground modification of the sky and elsewhere in the painting as indigo was not confirmed through microchemical analysis or any instrumental analytical technique. All samples where the colorant was observed were permanently mounted, thus making chemical analysis impossible. The areas sampled, however, are original to the painting, and the attribution is not questioned. Indigo, rather than Prussian blue (which postdates Steen), is the logical inference. Indigo has been identified as part of the palette for other paintings by Steen. See Butler 1982–1983, 44–61. Indigo was also observed in the bedcurtain of *The Sick Woman*. See analysis notes, Groen, 6 September 1994, on file in the conservation department, Rijksmuseum, Amsterdam.

38. The light, cream-colored paint used to block out the area discussed does not appear (when viewed at low magnifications on the painting itself) to be the same paint used for the clouds. The layer was not sampled for analysis.

39. Both siliceous iron earths and manganese oxide were detected in the brown paint layer using SEM–EDS. See fig. 13, EDS spectrum collected from sample 1 (NGA R705).

40. For discussions of the moral messages conveyed by the iconographic symbols in *The Dancing Couple*, see catalogue entries by Wheelock 1995, 363–369; and in Chapman, Kloek, and Wheelock 1996, 163–165.

41. The collar worn by the dancing man has been interpreted by Wheelock 1995 as being larger than in the first version (as seen in the x-radiograph, fig. 16) painted by Steen. This enlargement would strengthen Wheelock's suggestion that the peasant is attempting to play the role of a sophisticate. Another interpretation, however, is that the x-radiograph shows two versions of the same collar superimposed; the collar was moved when the shoulder and arm were lowered.

42. Eddy de Jongh, "Erotica in vogelperspectief: De dubbelzinningheid van een reeks 17de-eeuwse genrevoorstellingen," *Simiolus* 3 (1968–1969), 22–74.

43. For further discussions of Steen's palette, see Butler 1982–1983; and Bijl 1996, 83–92; for a discussion of pigments generally used in the seventeenth century, see David Bomford, Christopher Brown, and Ashok Roy, *Art in the Making: Rembrandt* (London, 1988), 21.

44. Each small sample taken for analysis was prepared as a permanent mount for optical microscopy. As the paints used to create images in *The Dancing Couple* were assumed to be oil based, no medium analysis was performed. A linseed oil medium was identified by John Mills, scientific department, National Gallery, London, in samples from paintings by Steen in the John G. Johnson Collection, Philadelphia Museum of Art. One sample from *The Fortune Teller* (a painting whose attribution is questioned [see note 28]) had a palmitate-stearate ratio more typical of walnut oil. See Butler 1982–1983, 46.

45. Some dispersions contain transparent, yellow-brown, isotropic flakes. In each case, the flakes lack any discernible topography and exhibit none of the particulate qualities that would link them with isotropic earths. The presence of yellow lake was inferred from these observations. Confirmation of the identity of the flakes through analytical chemical techniques was not possible, as the widely dispersed particles could be observed only when mounted as permanent dispersions for optical microscopy. Yellow lakes are known to have been used in seventeenth-century Dutch paintings. See Butler 1982–1983; and Bomford, Brown, and Roy 1988.

46. Samuel van Hoogstraten, *Inleyding tot de hooge schoole der schilder konst* (Rotterdam, 1678; reprint, 1969), 221.

47. The green paints used in Steen's paintings at the Philadelphia Museum of Art are also complex mixtures of various blues, yellows, whites, and blacks. See Butler 1982–1983, 48. It seems likely that using mixtures to make green was a common practice for Steen.

48. Butler 1982–1983 found that the transparent tan leaves in paintings by Steen are not necessarily the result of a faded or discolored yellow lake. For example, the tan leaves in Steen's *Moses Striking the Rock* were created using a mixture (in oil) of smalt, ultramarine, and calcium carbonate, where the latter accounts for 40 percent of the pigment content. Butler suggested that a preponderance of calcium carbonate, which is transparent in oil (due to similarities in refractive indices), yields a translucent paint. A similar paint mixture might possibly have been used for the tan leaves in *The Dancing Couple*.

49. H. Perry Chapman, "Jan Steen, Player in His Own Paintings," in Chapman, Kloek, and Wheelock 1996, 11–23.

Contributors

Barbara H. Berrie received a B.Sc. from Saint Andrews University in 1977 and a Ph.D. in inorganic chemistry from Georgetown University in 1982. She held a National Research Council associateship at the Naval Research Laboratory in Washington from 1982 to 1984. She then joined the scientific research department of the National Gallery of Art, where she is senior conservation scientist.

Mary Bustin earned a B.A. in fine arts from Exeter College of Art and Design in 1982 and a diploma in the conservation of easel paintings from the Courtauld Institute in 1986. Thereafter, she was assistant restorer at the Area Museum Service for South East England. She served as a Mellon Fellow in the painting conservation department at the National Gallery of Art from 1988 to 1989 and as a Culpeper Fellow from 1989 to 1991. She is now a painting conservator at the Tate Gallery.

Penelope Edmonds holds a B.A. degree in applied science in the conservation of cultural materials from the University of Canberra. She worked as a conservator at the Australian Museum, Sydney, before joining the National Gallery of Art as Mellon Fellow in object conservation from 1991 to 1994. Currently she is a senior conservator at the Museum of Victoria, Melbourne.

E. Melanie Gifford has been research conservator for painting technology at the National Gallery of Art since 1992. She also teaches microscopy in the Winterthur Museum/University of Delaware Program in Conservation, and the history of painting techniques at the University of Maryland. From 1978 to 1992 she was a painting conservator at the Walters Art Gallery, Baltimore, and served as head of painting conservation from 1985 to 1992. She received master's degrees in art history from Williams College in 1976 and in art conservation from the Cooperstown program in conservation of historic and artistic works in 1979. Her research focuses on the material and techniques of northern European painting from the fifteenth through the seventeenth century.

Lisha Deming Glinsman joined the National Gallery of Art in 1987 as a conservation scientist. She received a B.A. degree in chemistry from the College of Saint Rose, Albany, and has worked in industry and as a research chemist for the National Institute of Standards and Technology. She has published in *Archaeometry* and is a contributor to previous Conservation Research volumes.

Ann Hoenigswald holds a bachelor's degree in art history from the University of Pennsylvania and a master's degree in conservation training from the Intermuseum Conservation Association at Oberlin College. Since 1977

she has been a painting conservator at the National Gallery of Art. Her research interests include artists' materials and techniques with a focus on nineteenth-century and early modern artists.

Suzanne Quillen Lomax received a Ph.D. in organic chemistry from the University of Maryland in 1984, specializing in the photochemistry of iminium salts. Her postdoctoral research was with Frederick Lewis at Northwestern University. Since 1986 she has been the organic chemist in the scientific research department of the National Gallery of Art. Her areas of interest include the analysis of paint binders, the removability of surface coatings, and the discoloration of organic materials.

Michael Palmer earned a master's degree in botany from the University of Maryland in 1979 and then worked for the National Science Foundation in Washington. From 1980 to 1985 he served as a wood researcher at the Winterthur Museum in Delaware, where he taught wood anatomy and wood identification in the conservation training program. He joined the National Gallery of Art in 1985 as a conservation scientist. His work and research include the characterization of artists' materials using light microscopy and scanning electron microscopy.

Studies in the History of Art
Published by the National Gallery of Art, Washington

This series includes: Studies in the History of Art, collected papers on objects in the Gallery's collections and other art-historical studies (formerly *Report and Studies in the History of Art*); Monograph Series I, a catalogue of stained glass in the United States; Monograph Series II, on conservation topics; and Symposium Papers (formerly Symposium Series), the proceedings of symposia sponsored by the Center for Advanced Study in the Visual Arts at the National Gallery of Art.

[1] *Report and Studies in the History of Art*, 1967

[2] *Report and Studies in the History of Art*, 1968

[3] *Report and Studies in the History of Art*, 1969 [In 1970 the National Gallery of Art's annual report became a separate publication.]

[4] *Studies in the History of Art*, 1972

[5] *Studies in the History of Art*, 1973 [The first five volumes are unnumbered.]

6 *Studies in the History of Art*, 1974

7 *Studies in the History of Art*, 1975

8 *Studies in the History of Art*, 1978

9 *Studies in the History of Art*, 1980

10 *Macedonia and Greece in Late Classical and Early Hellenistic Times*, edited by Beryl Barr-Sharrar and Eugene N. Borza. Symposium Series I, 1982

11 *Figures of Thought: El Greco as Interpreter of History, Tradition, and Ideas*, edited by Jonathan Brown, 1982

12 *Studies in the History of Art*, 1982

13 *El Greco: Italy and Spain*, edited by Jonathan Brown and José Manuel Pita Andrade. Symposium Series II, 1984

14 *Claude Lorrain, 1600–1682: A Symposium*, edited by Pamela Askew. Symposium Series III, 1984

15 *Stained Glass before 1700 in American Collections: New England and New York (Corpus Vitrearum Checklist I)*, compiled by Madeline H. Caviness et al. Monograph Series I, 1985

16 *Pictorial Narrative in Antiquity and the Middle Ages*, edited by Herbert L. Kessler and Marianna Shreve Simpson. Symposium Series IV, 1985

17 *Raphael before Rome*, edited by James Beck. Symposium Series V, 1986

18 *Studies in the History of Art*, 1985

19 *James McNeill Whistler: A Reexamination*, edited by Ruth E. Fine. Symposium Papers VI, 1987

20 *Retaining the Original: Multiple Originals, Copies, and Reproductions*. Symposium Papers VII, 1989

21 *Italian Medals*, edited by J. Graham Pollard. Symposium Papers VIII, 1987

22 *Italian Plaquettes*, edited by Alison Luchs. Symposium Papers IX, 1989

23 *Stained Glass before 1700 in American Collections: Mid-Atlantic and Southeastern Seaboard States (Corpus Vitrearum Checklist II)*, compiled by Madeline H. Caviness et al. Monograph Series I, 1987

24 *Studies in the History of Art*, 1990

25 *The Fashioning and Functioning of the British Country House*, edited by Gervase Jackson-Stops et al. Symposium Papers X, 1989

26 *Winslow Homer*, edited by Nicolai Cikovsky Jr. Symposium Papers XI, 1990

27 *Cultural Differentiation and Cultural Identity in the Visual Arts*, edited by Susan J. Barnes and Walter S. Melion. Symposium Papers XII, 1989

28 *Stained Glass before 1700 in American Collections: Midwestern and Western States (Corpus Vitrearum Checklist III)*, compiled by Madeline H. Caviness et al. Monograph Series I, 1989

29 *Nationalism in the Visual Arts*, edited by Richard A. Etlin. Symposium Papers XIII, 1991

30 *The Mall in Washington, 1791–1991*, edited by Richard Longstreth. Symposium Papers XIV, 1991

31 *Urban Form and Meaning in South Asia: The Shaping of Cities from Prehistoric to Precolonial Times*, edited by Howard Spodek and Doris Meth Srinivasan. Symposium Papers XV, 1993

32 *New Perspectives in Early Greek Art*, edited by Diana Buitron-Oliver. Symposium Papers XVI, 1991

33 *Michelangelo Drawings*, edited by Craig Hugh Smyth. Symposium Papers XVII, 1992

34 *Art and Power in Seventeenth-Century Sweden*, edited by Michael Conforti and Michael Metcalf. Symposium Papers XVIII (withdrawn)

35 *The Architectural Historian in America*, edited by Elisabeth Blair MacDougall. Symposium Papers XIX, 1990

36 *The Pastoral Landscape*, edited by John Dixon Hunt. Symposium Papers XX, 1992

37 *American Art around 1900*, edited by Doreen Bolger and Nicolai Cikovsky Jr. Symposium Papers XXI, 1990

38 *The Artist's Workshop*, edited by Peter M. Lukehart. Symposium Papers XXII, 1993

39 *Stained Glass before 1700 in American Collections: Silver-Stained Roundels and Unipartite Panels (Corpus Vitrearum Checklist IV)*, compiled by Timothy B. Husband. Monograph Series I, 1991

40 The Feast of the Gods: *Conservation, Examination, and Interpretation*, by David Bull and Joyce Plesters. Monograph Series II, 1990

41 *Conservation Research*. Monograph Series II, 1993

42 *Conservation Research: Studies of Fifteenth- to Nineteenth-Century Tapestry*, edited by Lotus Stack. Monograph Series II, 1993

43 Eius Virtutis Studiosi: *Classical and Postclassical Studies in Memory of Frank Edward Brown*, edited by Russell T. Scott and Ann Reynolds Scott. Symposium Papers XXIII, 1993

44 *Intellectual Life at the Court of Frederick II Hohenstaufen*, edited by William Tronzo. Symposium Papers XXIV, 1994

45 *Titian 500*, edited by Joseph Manca. Symposium Papers XXV, 1994

46 *Van Dyck 350*, edited by Susan J. Barnes and Arthur K. Wheelock Jr. Symposium Papers XXVI, 1994

47 *The Formation of National Collections of Art and Archaeology*, edited by Gwendolyn Wright. Symposium Papers XXVII, 1996

48 *Piero della Francesca and His Legacy*, edited by Marilyn Aronberg Lavin. Symposium Papers XXVIII, 1995

49 *The Interpretation of Architectural Sculpture in Greece and Rome*, edited by Diana Buitron-Oliver. Symposium Papers XXIX, 1997

50 *Federal Buildings in Context: The Role of Design Review*, edited by J. Carter Brown. Symposium Papers XXX, 1995

51 *Conservation Research 1995*. Monograph Series II, 1995

52 *Saint-Porchaire Ceramics*, edited by Daphne Barbour and Shelley Sturman. Monograph Series II, 1996

53 *Imagining Modern German Culture, 1889–1910*, edited by Françoise Forster-Hahn. Symposium Papers XXXI, 1996

54 *Engraved Gems: Survivals and Revivals*, edited by Clifford Malcolm Brown. Symposium Papers XXXII, 1997

55 *Vermeer Studies*, edited by Ivan Gaskell and Michiel Jonker. Symposium Papers XXXIII*

56 *The Art of the Ancient Spectacle*, edited by Bettina Bergmann and Christine Kondoleon. Symposium Papers XXXIV*

57 *Conservation Research 1996/1997*. Monograph Series II, 1997

* Forthcoming